EDWARD HOPPER

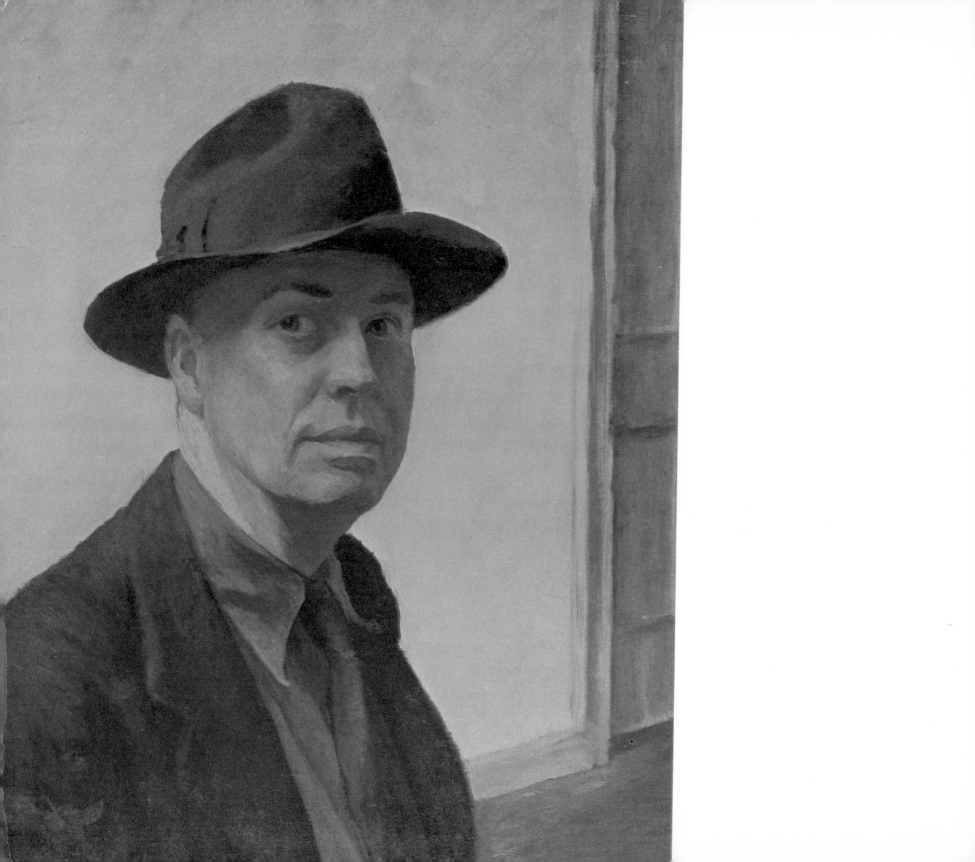

EDWARD HOPPER

NEW CONCISE N A L EDITION

TEXT BY LLOYD GOODRICH

HARRY N. ABRAMS, INC., PUBLISHERS, NEW YORK

DISTRIBUTED BY NEW AMERICAN LIBRARY

Title page plate :

SELF-PORTRAIT. *Undated. Oil, 26 × 22". Whitney Museum of American Art, New York City*
Bequest of Mrs. Edward Hopper

Library of Congress Cataloging in Publication Data

Hopper, Edward, 1882-1967.
 Edward Hopper.

 Bibliography: p.
 Includes index.
 1. Hopper, Edward, 1882-1967. I. Goodrich, Lloyd,
1897-
ND237.H75G6 1976 759.13 76-23494
ISBN 0-8109-2058-1

Library of Congress Catalog Card Number: 76-23494
Published in 1976 by Harry N. Abrams, Incorporated, New York

Printed and bound in the United States

CONTENTS

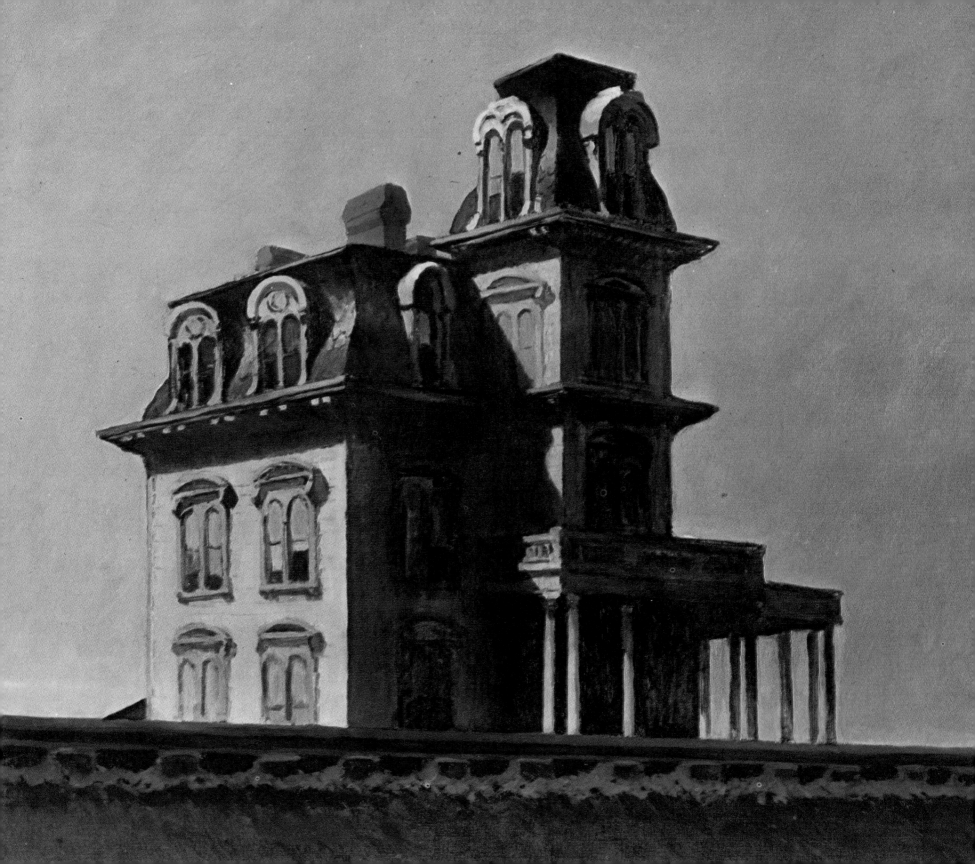

FOREWORD

When I first saw Edward Hopper's *House by the Railroad*, in 1926, I felt that a new vision and a new viewpoint on the contemporary world had appeared in American art. Through the years each successive work confirmed this conviction. When Hopper's new oils were first shown as a group, at the Rehn Gallery in 1927, an article I wrote on them for *The Arts* brought the first chance to talk at length with him and with his wife Jo, in their studio on Washington Square North. The editors of *The Arts* (Forbes Watson, Virgil Barker, and I) induced him to write several articles for the magazine.

In 1950 I had the privilege of organizing the Hopper Retrospective Exhibition at the Whitney Museum of American Art, and of writing a small book on him for the Penguin Press of England. In 1964 came the Whitney's second Retrospective. These and other projects over the years presented several opportunities to talk with Hopper about his work and life, and to record what he said. In the present book most of his statements and ideas (not drawn from his own writings and other sources) are based on these conversations.

In the middle 1940's the American Art Research Council, established by the Whitney Museum, with myself as Director, compiled a catalogue of Hopper's known works in all mediums. Rosalind Irvine, Secretary of the Council, assembled information from all sources: the Rehn Gallery's records; exhibition catalogues; published references and illustrations; information from museums and private owners; and personal examination of pictures. Edward and Jo Hopper cooperated fully, and made available a record of his oils, watercolors, and prints, kept by Jo Hopper over many years in four ledger volumes, with drawings by him. The information gathered by the Council has been invaluable in the preparation of this book.

After Edward Hopper's death in 1967, and Mrs. Hopper's the following year, it became known that she had left his remaining works and her own to the Whitney Museum—a magnificent bequest. The cataloguing of the works has revealed that the record kept by the Hoppers by no means included all his pictures, but only those exhibited or sold. The illustrations in this book include six oils, nine watercolors, and thirty-two drawings from Mrs. Hopper's bequest to the Whitney Museum, most of them previously unrecorded.

I wish to make grateful acknowledgment to the many individuals and institutions who

◄HOUSE BY THE RAILROAD. *1925 Oil, 24×29". The Museum of Modern Art, New York City. Anonymous gift*

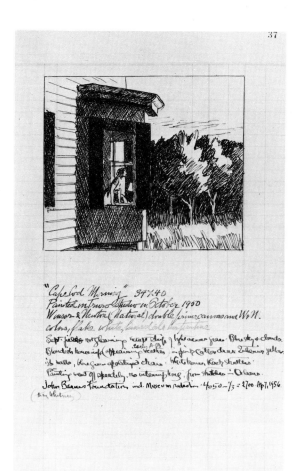

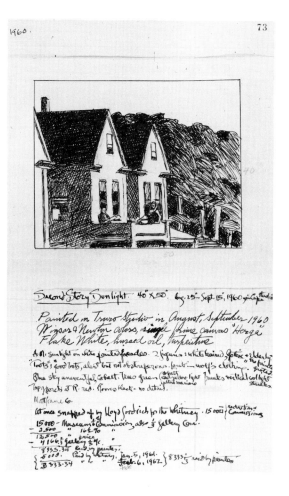

have made this book possible: to the owners of the works illustrated, for their permission to reproduce them; to the many other owners who have furnished information on works in their collections; to the Museum of Modern Art and the Addison Gallery of American Art, for permission to publish Hopper's statements of 1933 and 1939; to John Clancy, Director of Frank K. M. Rehn, Inc., the artist's gallery since 1924; to Alfred H. Barr, Jr., who was American Editor of "The Penguin Modern Painters" series; to Carl Zigrosser, former Curator of Prints and Drawings, and Kneeland McNulty, present Curator of Prints and Drawings, Philadelphia Museum of Art; to Alexander Eliot, Katharine Kuh, and Brian O'Doherty, for quotations from their conversations with Hopper; to Frances Manola, formerly of the Whitney Museum, who gave expert assistance in assembling the record of Hopper's works; and especially to my wife and fellow researcher, Edith Havens Goodrich.

8

L.G.

THE EARLY YEARS

IN A CAREER OF SIXTY YEARS, marked by unwavering integrity and steady growth, Edward Hopper created a series of unforgettable images of modern America. His art was based on the ordinary aspects of the contemporary United States, in city, town, and country, seen with uncompromising truthfulness. No artist has painted a more revealing portrait of twentieth-century America. But he was not merely an objective realist. His art was charged with strong personal emotion, with a deep attachment to our familiar everyday world, in all its ugliness, banality, and beauty.

The visual character of the twentieth-century United States is that of a highly industrialized nation, relatively young, in which the few survivals of the past exist side by side with the monuments of the machine age. American cities are to a large extent creations of the last hundred years. Except for a few old sections they are products not of a homogeneous culture but of the materialism and eclecticism of the industrial era. Hence their juxtaposition of unrelated styles, their lack of the unity and harmony of the older European cities. This architectural anarchy, together with wealth, engineering skill, and a restless energy that is always building, tearing down, and rebuilding, have produced the American city—in its combined spectacularity, monotony, and architectural disorder, among the most remarkable phenomena on the face of the earth.

On a smaller scale the same is true of the American suburb and small town, with their endless variations of derivative domestic architecture. And it is true also of the country, which even in the longer-settled East only rarely attains the order created by centuries of cultivation. The raw outskirts of towns yield to a countryside in which the evidences of a simpler rural past are overwhelmed by those of the industrialized present—factories, railways, superhighways, bridges, power lines. It is a landscape that has not yet fully assimilated the machine age, but to which sheer engineering often gives an unintended grandeur and beauty.

Such a land, such towns and cities, do not lend themselves easily as raw material for art. The American artist's picturing of America had been romantic from its beginnings. The painters of the Hudson River School devoted themselves to the wild and spectacular features of the continent—the wilderness, the mountains, the sea—and disregarded the

works of man. The early genre painters focused on rural life, and avoided the city and industrialism. This romanticism was continued in a more subjective vein by the generation of Inness, Ryder, and Blakelock. Even the naturalistic Winslow Homer turned his back on the city to paint nature and man at their most primitive. The American impressionists selected the idyllic aspects of our country; if they sometimes pictured New York, it was Fifth Avenue and not Seventh. Until the end of the nineteenth century few artists, aside from folk painters or the makers of "views" for popular prints, had attempted to picture the American city, and few had attempted an honest portrayal of the American land and what man had made of it. At the turn of the century the art world was in the hands of academic idealists who ignored the realities of the contemporary United States.

With the opening decade of the new century came a revolt against the academic establishment. A group of young realists, Robert Henri, George Luks, William Glackens, John Sloan, and Everett Shinn, turned to the everyday life of New York—its streets and crowds, its theaters and restaurants, its dancehalls and prizefights. Relishing low life as much as high life, they still were romantics to some degree, loving the city's glamor and human interest, and with a humor more genial than the drastic realism of a later generation. Nevertheless they shocked the conservatives, who dubbed them "Apostles of Ugliness." Their leader was the oldest, Henri, a stimulating force as both artist and teacher, and a doughty fighter for artistic independence. In alliance with other progressives, the Henri group led the war against academicism, culminating in the big Armory Show of 1913, which introduced modernism to the American public.

Most of the Henri group were interested primarily in human character and incident. For them the city was a background for humanity. Only Sloan, the most realistic of them, gave the city itself a leading role, on a par with his human actors. His New York paintings and etchings remained the most authentic portraits of the contemporary American scene until Edward Hopper began to picture it in a new way.

BOYHOOD AND YOUTH;
STUDY WITH HENRI

EDWARD HOPPER'S ARTISTIC BEGINNINGS were in the Henri camp. Seventeen years younger than Henri and eleven younger than Sloan, he was born on July 22, 1882, in Nyack on the Hudson River a few miles north of New York City. His ancestors, American for several generations, were of English and Dutch descent on his father's side, English with some Welsh on his mother's. His father, Garrett Henry Hopper, had a dry goods business. There were two children, Edward and a sister, Marian. The family lived in a modest old-fashioned house, later occupied by Miss Hopper until her death in 1965. The boy went to a local private school, then to Nyack High School. At this time the town had busy shipyards, turning out racing yachts, and here the boy spent many Saturdays, developing a liking for boats that lasted all his life. At about fifteen, with tools and lumber provided by his father, he built his own catboat. "It didn't sail very well," he recalled.

From the age of five he had liked to draw, and after he left high school his parents did not stand in the way of his studying art. However, they felt that a painter's career was insecure, so at seventeen he enrolled in a school for illustrators in New York. Next year he transferred to the New York School of Art, usually called the Chase School, where he studied illustration for another year.

But painting interested him more. By this time Henri had become the leading teacher in the school, and under him Hopper studied for about five years. Among his fellow students were several who were to make reputations long before he did: George Bellows, Rockwell Kent, Guy Pène du Bois, Walter Pach, Gifford Beal. Henri's great personal magnetism, his gift for making his pupils see things they had never seen before—not only in painting but in all the arts—and his constant emphasis on looking at the life around them, left a lasting impress on his students. His artistic viewpoint was still far from radical, based on the tradition of the great naturalists of the past: Velázquez, Hals, Goya, Daumier, and the pre-impressionist work of Manet and Degas. In technique, he encouraged direct painting, with a bold, broad brush.

Over twenty years later Hopper wrote of Henri: "No single figure in recent American art has been so instrumental in setting free the hidden forces that can make of the art of this country a living expression of its character and its people. . . . Of Henri's renown as a

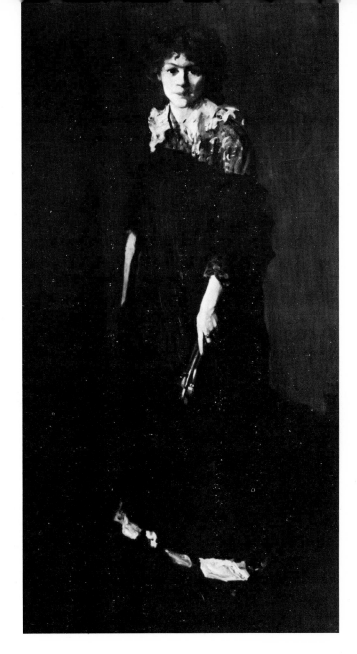

THE ART STUDENT
(Portrait of Josephine Nivison, later Mrs. Edward Hopper)
by Robert Henri. 1906. Oil, 77 1/4 × 38 1/8″
Milwaukee Art Center, Milwaukee, Wis.

11

teacher everyone knows; of his enthusiasm and his power to energize his students I had firsthand knowledge. Few teachers of art have gotten as much out of their pupils, or given them as great an initial impetus."

Henri's influence persisted for some years after Hopper left the New York School of Art in 1906; as he put it, he kept mentally referring everything he did to his former teacher. But with the years he came to realize increasingly the limitations of the Henri system, particularly its lack of attention to form and design, and to the fundamentals of technique. "It took me about ten years to get over Henri," he later said.

EUROPE

HOPPER HAD GROWN TO BE A TALL, well-built young man—over six feet—good-looking, and with a face strong in character: a fine high forehead, observant blue eyes, a full-lipped, sensitive mouth, and a determined chin. Thoughtful, deliberate, and somewhat shy, he was much given to silence, but his few words carried weight.

Like most of his generation he felt the call of France. In October 1906, aged twenty-four, he went to Paris, where he lived with a bourgeois French family on the Left Bank, on the rue de Lille near the rue de Bac. He had never studied French, but he taught himself to read easily, though not to speak with ease. Living quietly, he avoided Bohemia, read French literature, and instead of entering an art school, painted on his own.

Working outdoors along the Seine and in the parks, he painted streets, buildings, quais, and bridges in a style already quite different from Henri's dark old-masterish tonality—a style closer to impressionism, in its emphasis on light, its fresh vision, its blond color. "The light was different from anything I had ever known," he later said to Alexander Eliot. "The shadows were luminous—more reflected light. Even under the bridges there was a certain luminosity. Maybe it's because the clouds were lower there, just over the housetops. I've always been interested in light—more than most contemporary painters." But differing from academic American impressionism, there was a concentration on architectural form and an insistence on large masses, freely brushed in. All his Paris oils, he told me, "were painted on the spot and not touched afterwards."

Quite apart from these oil cityscapes were numerous drawings and watercolors of the life of Paris. His black-and-white drawings of the quais and their derelicts, aside from human interest, showed a simplified massive quality oddly suggestive of Seurat's drawings, and prophetic of Hopper's own later style. His watercolors of Parisian types—prostitutes, workmen, policemen, soldiers, concierges, café habitués, female and male—displayed broad humor and a gift for caricature, qualities that were to reappear only in a few etchings and in humorous drawings of a purely personal kind. There was also a series of bold posterlike watercolors of the Paris Commune of 1870–71, titled *L'Année Terrible*, perhaps intended as illustrations. These varied graphic works, most of which Hopper never showed or even mentioned in later years, reveal an attachment to French life unsuspected in an artist so completely devoted to the American scene.

Hopper's European stay was not all work. He always liked to travel, and he visited England, Germany, Holland, and Belgium (but not Italy). After about nine months abroad, he returned to America in the summer of 1907. Two years later he went abroad again for about six months, spent entirely in France, mostly in Paris. His third and last trip, for about four months in the summer of 1910, was to France and Spain, traveling and looking at pictures. He never crossed the Atlantic again; his travels were to be within the Western Hemisphere—the United States and Mexico.

In the years that Hopper was abroad, in his middle and late twenties, the Parisian art world was seething with revolutionary movements—fauvism, cubism, the beginnings of abstraction. He visited the big independent salons, the *Indépendants* and the *Salon d'Automne*, where so much advanced art was first shown, but he said that they "made no particular impression on me." (The same was somewhat true of quite a different young American abroad in those years, John Marin.) He was not even aware of Cézanne, who was being discovered by the avant-garde. Hopper saw a great deal of art in Europe, but the artists he admired most were those Henri had talked about, especially Goya, Manet, and Degas. Another former Henri student, Patrick Henry Bruce, led him to look at the impressionists; and there are parallels, perhaps coincidental, between Hopper's Paris cityscapes and those of Monet, Pissarro, and Sisley.

Yet it would be a mistake to underestimate Hopper's relation to European and, specifically, French art. He later paid tribute, in talking and writing, to the independent French tradition of the nineteenth century in painting and graphic art, particularly to Courbet, Daumier, Gavarni, Manet, Degas, Toulouse-Lautrec, and Méryon. But it was nineteenth-century French art, before the post-impressionists, that he respected. I have heard him contrast the substance and weight of Courbet with what he felt to be the "papery quality" of Cézanne. Similarly, of American painters he admired Eakins above all—"greater than Manet," he said.

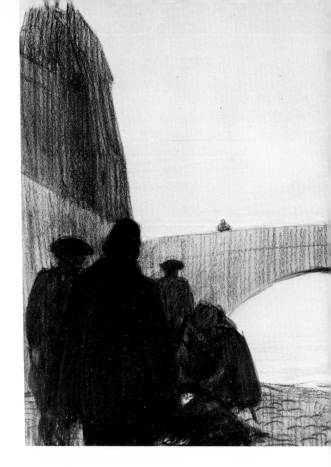

ON THE QUAI. *Probably 1906/7 or 1909*
Charcoal or black crayon with
touches of white, 13 × 10" (sight)
Whitney Museum of American Art, New York City
Bequest of Mrs. Edward Hopper

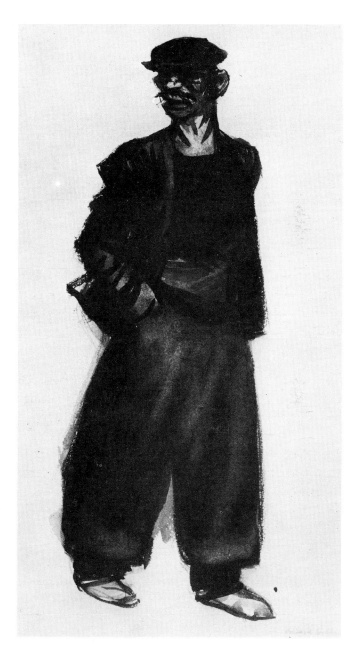

LE TERRASSIER
1906/7 or 1909. Watercolor, 11 7/8 × 6 1/4"
The Art Institute of Chicago, Chicago, Ill.
Olivia Shaler Swan Memorial Collection

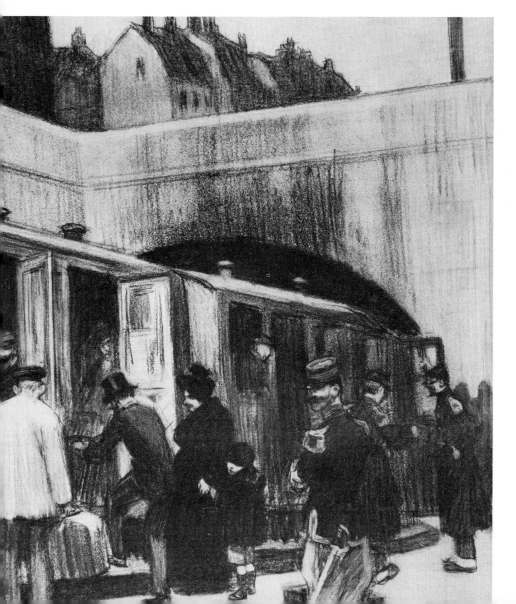

THE RAILROAD. *Probably 1906/7 or 1909*
Charcoal or black crayon with touches of white, 13 3/4 × 12" (sight)
Whitney Museum of American Art, New York City
Bequest of Mrs. Edward Hopper

L'ANNÉE TERRIBLE: ON THE ROOFTOPS
Probably 1906/7 or 1909. Watercolor, 14 1/2 × 13″
Whitney Museum of American Art, New York City
Bequest of Mrs. Edward Hopper

L'ANNÉE TERRIBLE: AT THE BARRICADES
Probably 1906/7 or 1909. Watercolor, 14 1/2 × 13″
Whitney Museum of American Art, New York City
Bequest of Mrs. Edward Hopper

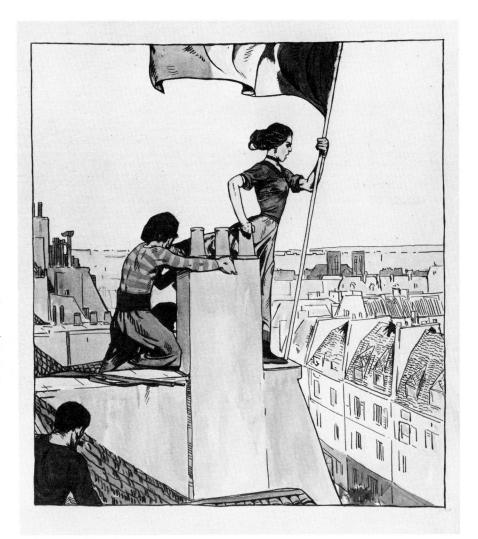

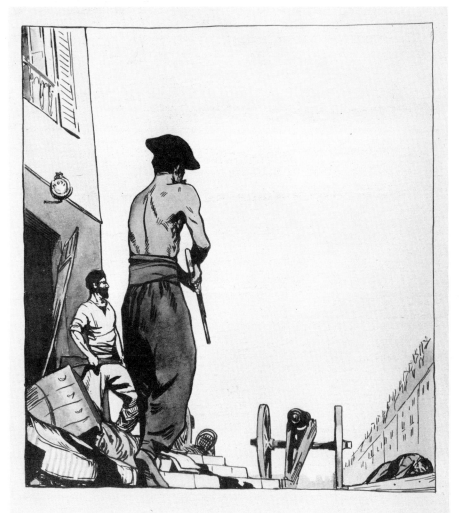

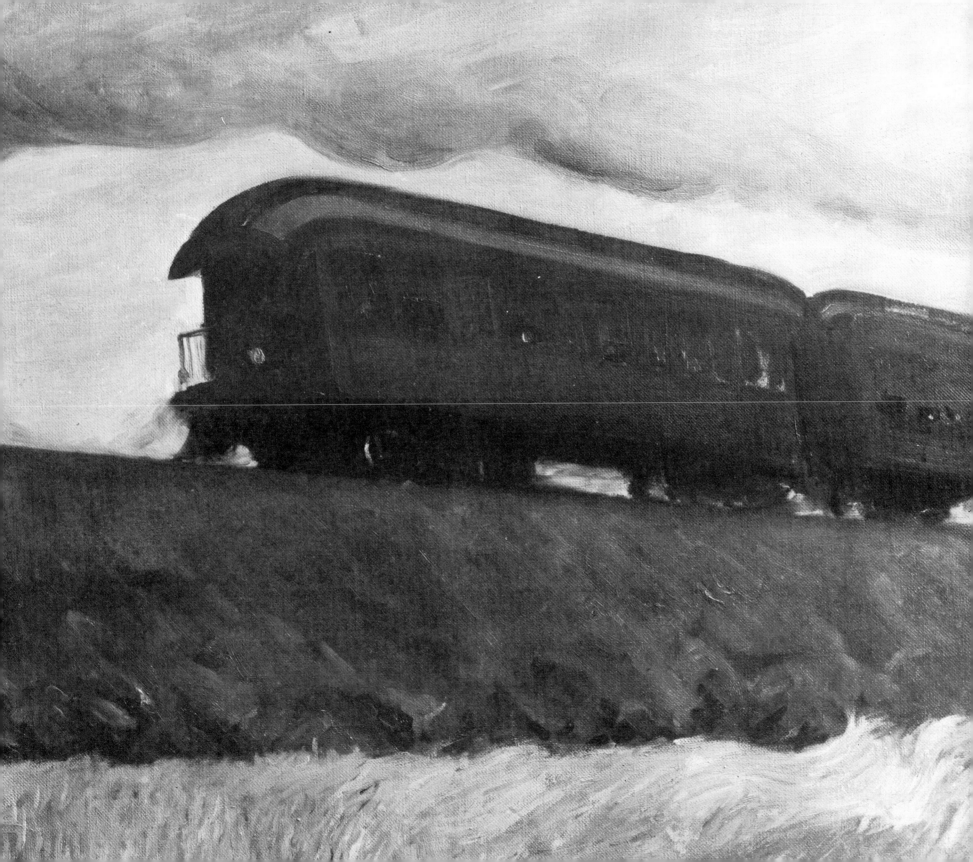

EARLY PAINTINGS

BACK HOME, DURING THE 1900's and 1910's, Hopper was painting aspects of the native scene that few others had attempted. As early as 1908, when he was only twenty-six, his subjects and viewpoint were in essence the same as later, though less developed. While sharing the general realistic outlook of the Henri group, his realism was more objective, less romantic. And he was interested in different things. *Tramp Steamer, Tugboat, The El Station*, and *Railroad Train*, all painted in 1908, were naïvely honest portrayals of essential features of modern life that few artists had pictured. They were quite devoid of obvious human interest. Their style was extremely broad and simplified, sometimes excessively so—a holdover of Henri's influence. But Henri's dark palette had been discarded, and Hopper was struggling to capture the light and color of outdoor America, so different from that of France. These paintings were still immature; their relation to his later paintings was that of an adolescent to an adult. But they were the work of a man who was trying to create his art out of actualities.

Years later, replying to a magazine which stated that he had found his direction when he saw Charles Burchfield's work, Hopper pointed out that he had been painting such subjects before his younger colleague painted at all. "In every artist's development," he wrote, "the germ of the later work is always found in the earlier. The nucleus around which the artist's intellect builds his work is himself, the central ego, personality, or whatever it may be called, and this changes little from birth to death. What he was once, he always is, with slight modifications. Changing fashions in methods or subject matter alter him little or not at all." "The only real influence I've ever had," he once said, "was myself."

Having to support himself by commercial art, Hopper could not devote his full time to painting, but he managed to spend several summers in the 1910's working along the New England coast, at Gloucester, Ogunquit, and Monhegan Island. These years showed a steady growth. His Gloucester paintings of 1912 were firmer in construction, and already marked by his characteristic angularity. A few years ago, looking at *Italian Quarter*,

18

Gloucester, of 1912, he recalled that Leon Kroll, who was working there that summer, remarked that the modernists would like the angles of the houses and rocks; but Hopper said that at the time he was still unaware of Cézanne and cubism: "The angularity was just natural to me; I liked those angles." A more emotional undertone appeared in *Corner Saloon* of 1913, a quiet melancholy that foreshadowed certain future moods.

These early paintings met with little success. They lacked the spectacularity and technical brilliance of other Henri pupils such as Bellows and Kent. Even Hopper's friends and former fellow students felt that they were "hard." At this time the American art world was dominated by the academicians, whose juries controlled the big exhibitions. There were as yet no non-academic organizations through which an independent artist could get his work before the public. Hopper exhibited, probably for the first time, in a show staged by a group of Henri students in March 1908 (a month after The Eight's famous exhibition), on the upper floor of the old Harmonic Club on West 42nd Street, where he showed several Paris pictures. He was included again, with a single French oil, in the big no-jury "Exhibition of Independent Artists" organized in April 1910 by Sloan, Henri, Davies, and Kuhn, in a rented building on West 35th Street. In the Armory Show of 1913 he exhibited an oil, *Sailing*, which was priced at $300 and sold for $250—his first sale of a painting, and the last for ten years. At first he submitted works regularly to the National Academy of Design and other conservative bodies, but after being rejected each time he stopped trying. While the precocious Bellows, who was the same age, received official prizes and became one of the youngest men ever elected to the Academy, Hopper could not even pass the Academy juries.

Because of this lack of opportunities to exhibit and sell, after 1915 Hopper was less active as a painter for about five years. Even when the founding of the Society of Independent Artists gave anyone a chance to exhibit on paying a modest fee, he showed only the first year, 1917. It has been written that he withdrew from the art world and became a recluse. He denied this vigorously, and doubtless it was exaggerated; in any case, he had never been a mixer. It has also been said that he gave up painting; but he said to me, "I never stopped painting." Yet it is true that few paintings of these years were seen until after his death (he said he destroyed a number of them).

Since leaving art school he had supported himself by commercial art, working in an advertising agency three or four days a week, and painting on his free days and during the summer. He admitted to me that he was good at commercial work, as he could draw the figure, which most commercial artists couldn't. He also did some illustrating, which he

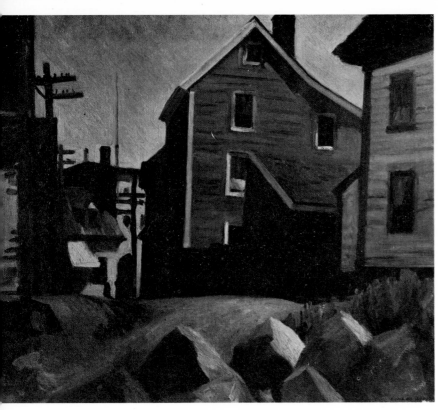

ITALIAN QUARTER, GLOUCESTER. *1912. Oil, 24 × 29″*
Whitney Museum of American Art, New York City
Bequest of Mrs. Edward Hopper

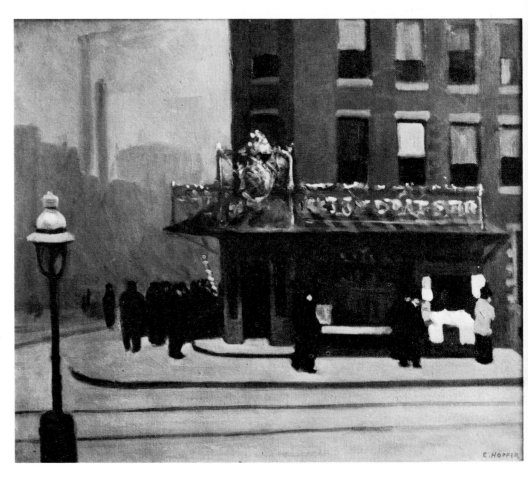

CORNER SALOON. *1913. Oil, 24 × 29″. The Museum of Modern Art,*
New York City. Abby Aldrich Rockefeller Fund

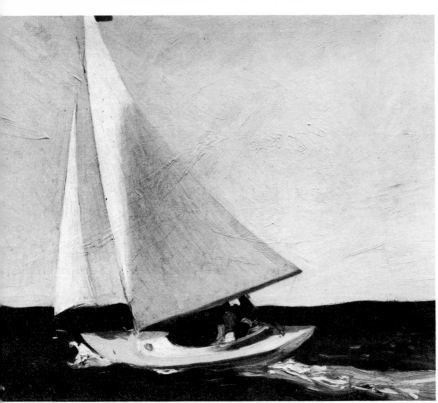

SAILING. *1912 or 1913. Oil, 24 × 29″ Collection Mr. and Mrs. James H. Beal, Pittsburgh, Pa.*

liked even less. "I was a rotten illustrator—or mediocre, anyway." He told me that he wasn't interested in drawing people "grimacing and posturing. Maybe I am not very human. What I wanted to do was to paint sunlight on the side of a house." "Sometimes I'd walk around the block a couple of times before I'd go in," he said to Alexander Eliot, "wanting the job for money and at the same time hoping to hell I wouldn't get the lousy thing." On the other hand, the illustrations that have been found among his drawings are honest, strong, and often humorous. Some future researcher may identify his illustrations in the magazines of the period, and reveal that they are not as bad as Hopper said. Nevertheless, those years of uncongenial work and apparent failure were a bitter period, of which he always spoke with reluctance.

WORKS OF THE 1920's

PRINTS

But Hopper had a stubborn will; though slow to develop, he could not be deflected. In 1915 he took up etching, and in the sixty-odd plates he made in the next eight years, especially the thirty or so between 1919 and 1923, he first said in a mature style what he had to say about the world he lived in.

In American printmaking this was the heyday of Whistlerian views of old Paris, the Grand Canal, or quaint New England villages. The emphasis was on charm, decorative pattern, technical proficiency, and subtleties of biting, wiping, and printing. Nothing like this could be found in Hopper's etchings. They presented everyday aspects of the contemporary world, mostly in the United States, with utter honesty, direct vision, and an undertone of strong emotion. In *American Landscape* a railroad track runs straight across the picture, with cows lumbering over it; beyond it are a stark wooden house and dark, melancholy woods against a blank, light-filled sky. Nothing more: yet the picture conveys the essence of one aspect of the American land truthfully and with penetrating feeling. *Evening Wind* expresses with exactness and intensity the sensation of a hot summer night in the city. Such images were directly out of reality, with little precedent in American art. The prints nearest to them were those of John Sloan; but while Hopper admired Sloan, his realism, like the older man's, was firsthand. These etchings, in their transformation of familiar reality into imagery charged with emotion, their strength of design, and their severe economy of means, were the work of a man who, within the limits of a black-and-white medium, had finally found himself.

They contained many themes that were later to be developed in paintings. The lights and shadows of the city at night, as in *Night in the Park* and *Night Shadows*. Railroads, lighthouses, pretentious suburban mansions, a lone apartment house on the outskirts of the city. And in several prints besides *Evening Wind*, a theme emerged that was to recur through the years—a nude woman in a city interior. On the other hand, there were

22

subjects that never reappeared. Several harked back to France, showing the lasting impression of his European experience; of these, *Les Deux Pigeons* revealed a surprising tender sensuality. Among the earliest plates two stemmed from the Spain of bullfights and Don Quixote and Goya; and several displayed a vein of caricature that recalled his Paris watercolors, but that was to have no successors in his work.

While his graphic style was his own, he was not ignorant of the past. His greatest admiration in prints (and later in painting) was Rembrandt. In etching he was deeply impressed by Charles Méryon, with whose brooding obsession with the buildings and the lights and shadows of Paris he felt an affinity.

His control of the etching medium did not come overnight. A friend and fellow etcher, Martin Lewis, gave him some technical advice, and the rest he learned for himself, by trial and error. His first plates were tentative; some he did not finish, and others he never tried to exhibit or sell. It was not until 1919, when he was thirty-seven, that he struck his stride. Even then he remained a careful, deliberate craftsman rather than an improvisor. In the set of his prints with all their available states, assembled at the Philadelphia Museum of Art by Carl Zigrosser with the cooperation of the artist and his wife, one can trace how the composition was first worked out quite completely in a drawing on paper: and then how the design, drawn in outline on the plate and then bitten, was adhered to throughout, without major changes, in a continuous process of securing substance and depth of tone. Several plates passed through seven or eight states of drawing and biting. His prints also included about a dozen drypoints, the best of which showed an equal ability to achieve his ends by this more direct technique.

Having bought a press and installed it in his studio, he did all his own proofing and printing. He had a healthy scorn for what he called "the graces of etching's methods," and used "the whitest paper I could get. The ink was an intense black that I sent for to Kimber in London, as I could not get an intense enough black here." The plates were wiped quite clean before printing, so that the result depended not on minor tonal effects but on essential line, form, and design.

The maximum number of prints from each plate was fixed by the artist at one hundred; but by no means all were printed up to this limit. After 1923 Hopper gave up making prints, except for one or two in the next few years. Evidently the mediums of oil and watercolor, which he had begun to use more in the early 1920's, seemed more rewarding to him. As time passed, his prints found their way into museums and private collections, and became recognized as classics of American printmaking. On the rare occasions when

23

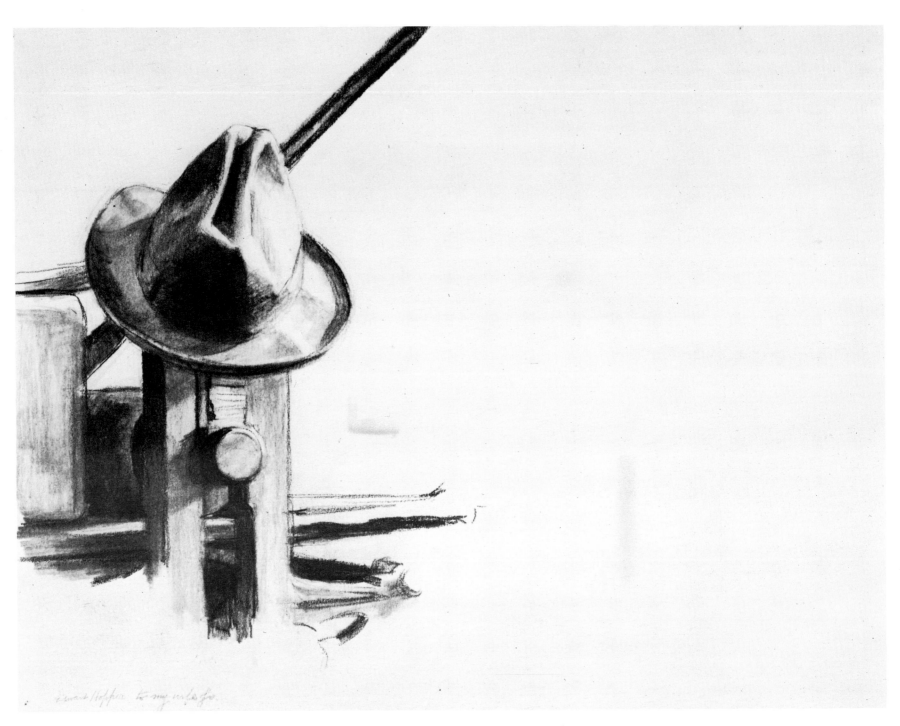

HOPPER'S HAT ON HIS ETCHING PRESS. *Undated. Black conté crayon, 11 × 15". Whitney Museum of American Art, New York City. Bequest of Mrs. Edward Hopper*

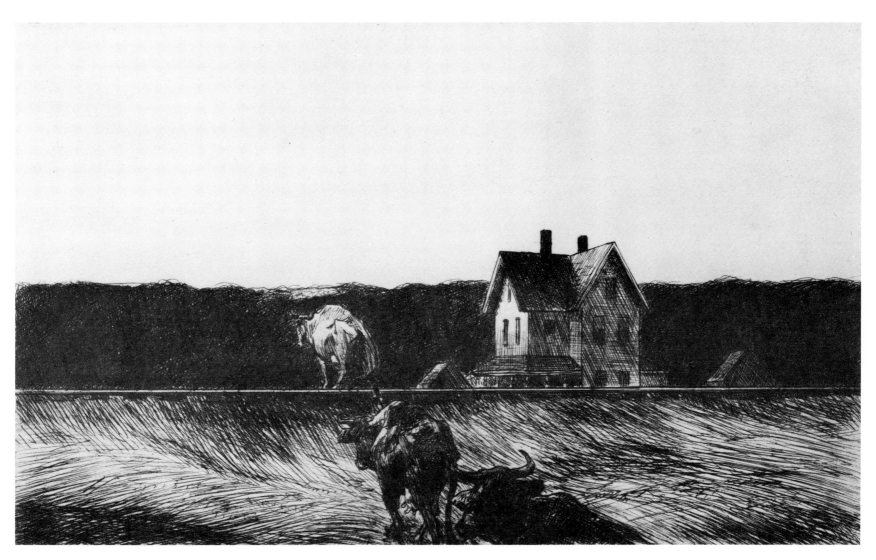

AMERICAN LANDSCAPE. *1920. Etching, 7 1/2 × 12 1/2"*

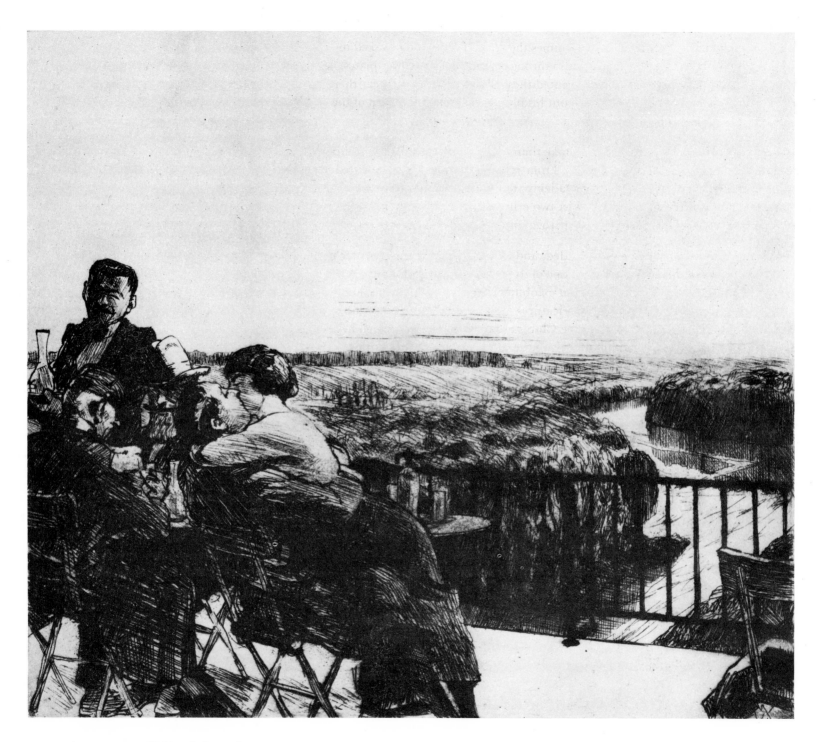

LES DEUX PIGEONS. *1920. Etching, 8 1/2 × 10"*

they appeared on the market, they fetched many times the ten or fifteen dollars asked in the 1920's. His etching press remained in his studio throughout his life, as did his plates, but in spite of urging by print lovers, he never printed these plates to anywhere near their full editions. Toward the end of his life, asked about his old hat hanging on an arm of the press, he said, "It's been there about twenty years."

Academic juries found Hopper's prints easier to take than his paintings; they were his first works to get into the big conservative exhibitions. From 1920 to 1925 he was represented regularly in print shows, even at the National Academy; and in 1923 he received two prizes. His printmaking was the subject of the first two critical articles about him, by his old friend and fellow student Guy Pène du Bois in 1922 and by Virgil Barker in 1924.

In 1918 the Whitney Studio Club had been founded, and it was soon the liveliest center in the country for independent artists. Hopper was one of its earliest members, and in January 1920 the Club gave him his first one-man exhibition, of his early Paris oils, and two years later, a show of his Paris watercolor caricatures. He was included in the Club's annual exhibitions of members' works. And in the Club's evening sketch class, which he attended regularly during the early and middle 1920's, he had an opportunity to draw from the nude. It was here that he did the many strong and vital drawings of the model that are among his finest graphic works. Almost all were of women—whether by his own preference or that of the managers of the class, is not known. These drawings revealed not only a thorough knowledge of bodily structure, but a gift for capturing momentary poses and gestures, and a feeling for the living, moving female body—qualities that, with all his continuing interest in the nude, were not always present in his finished paintings.

Drawing for etching "EAST SIDE INTERIOR."
1922. Black conté crayon, 7 3/4 × 9 7/8" (sight).
Whitney Museum of American Art,
New York City. Bequest of Mrs. Edward Hopper

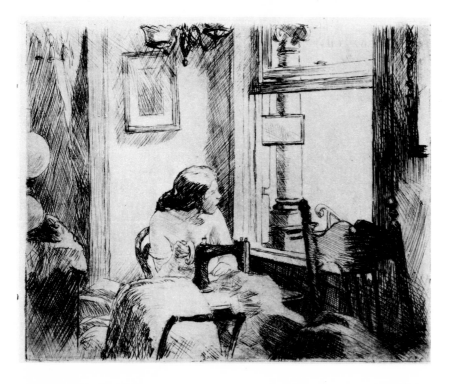

EAST SIDE INTERIOR.
First state. 1922. Etching, 8 × 10"

EVENING WIND. *1921. Etching, 7 × 8 3/8"* ▶

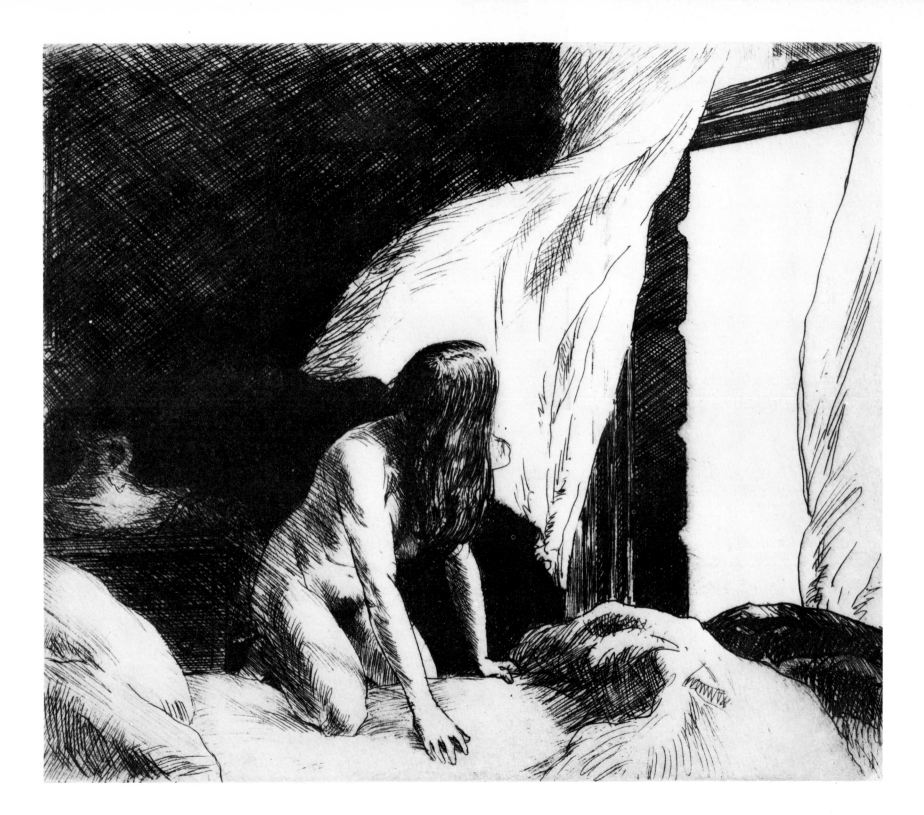

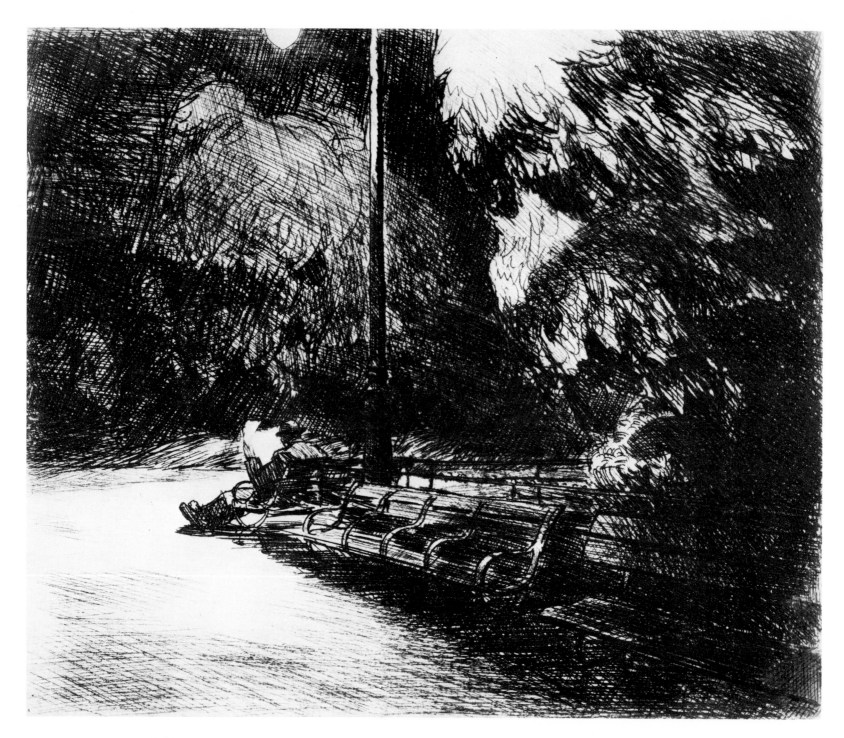

NIGHT IN THE PARK. *1921. Etching, 7 × 8 3/8″*

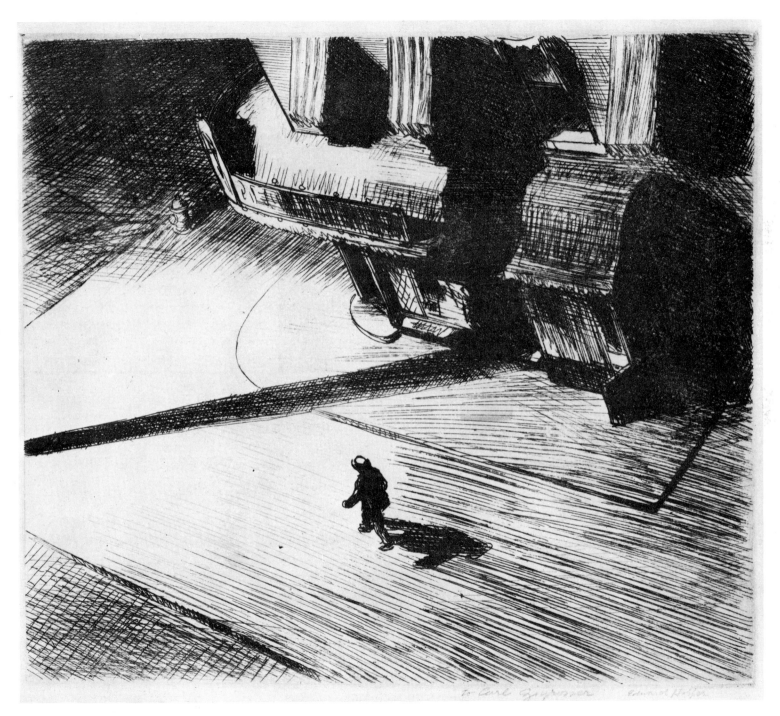

NIGHT SHADOWS. *1921. Etching, 7 × 8 3/8″*

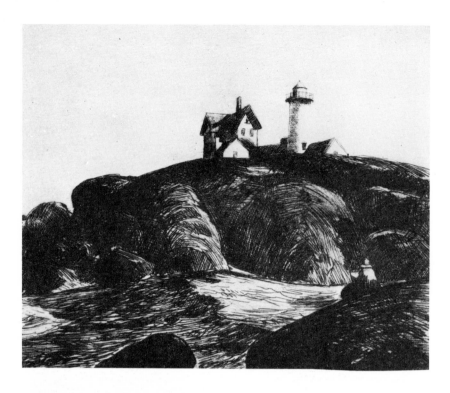

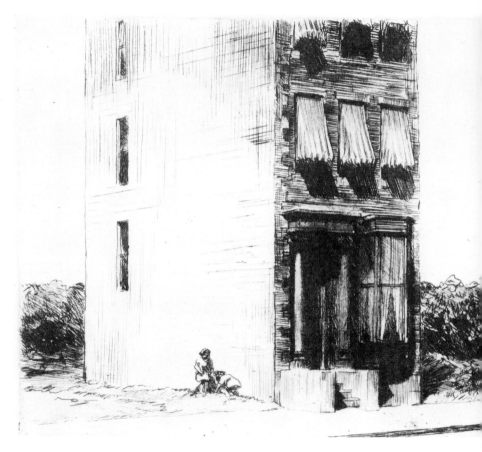

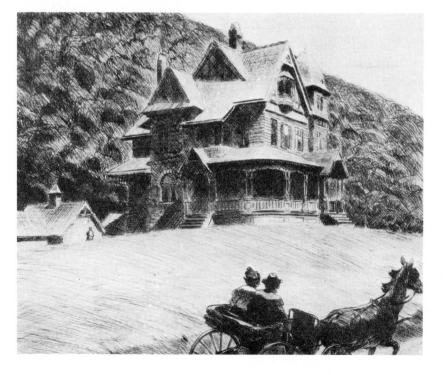

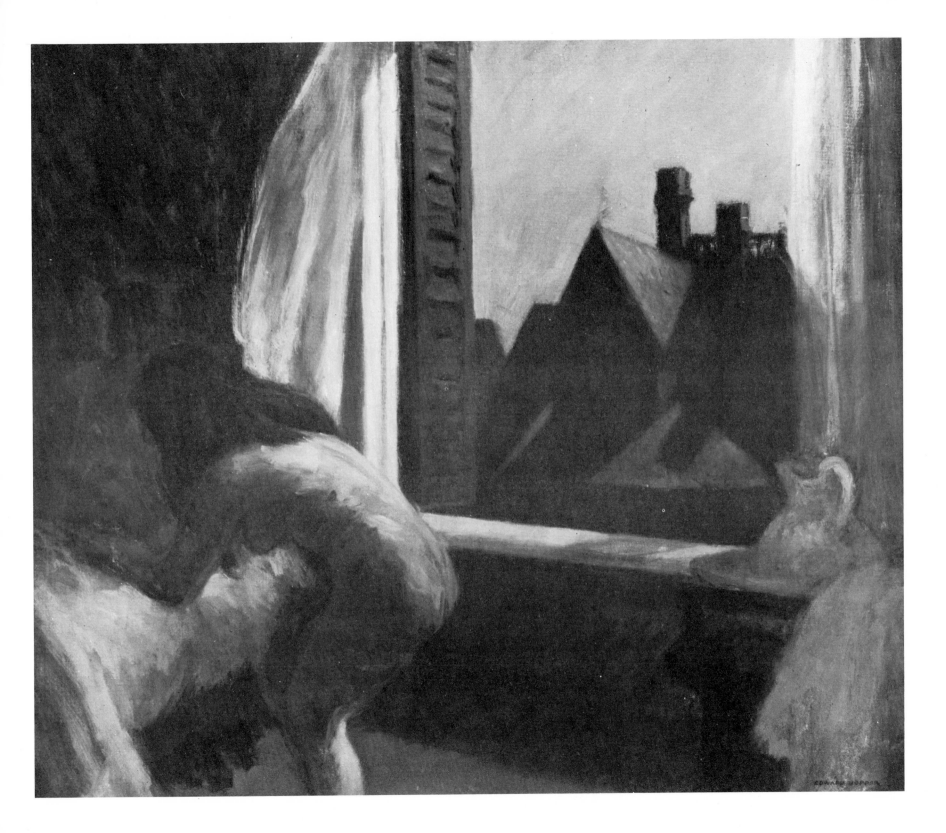

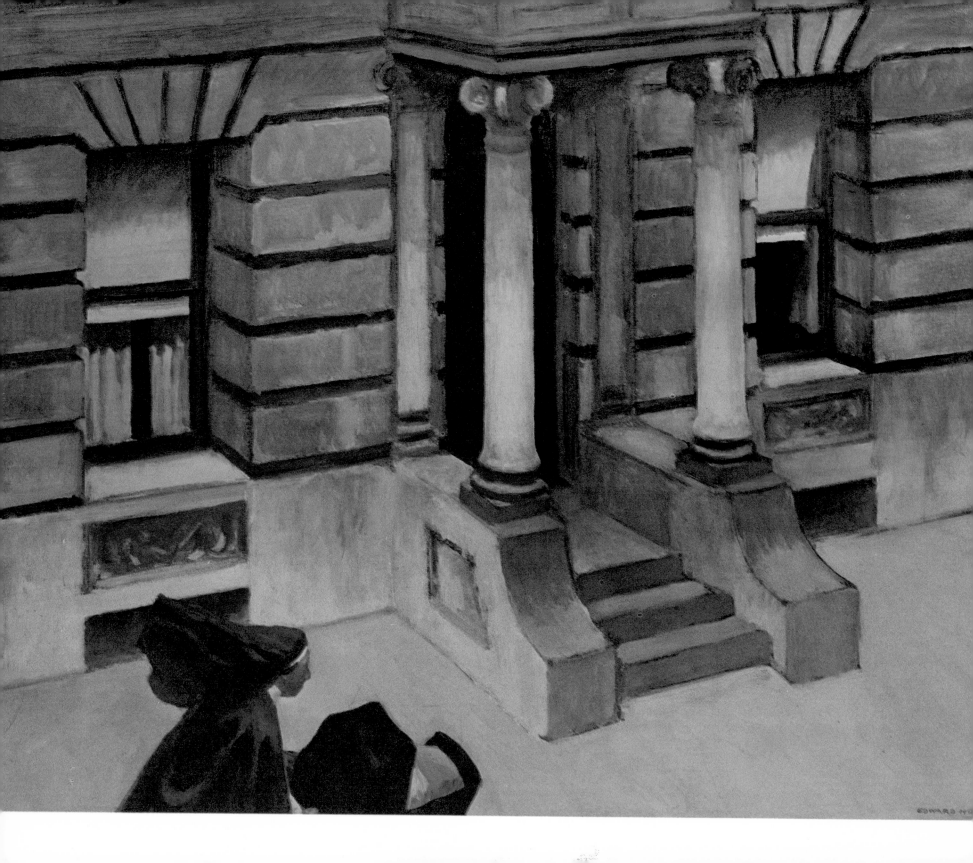

OILS AND WATERCOLORS

SUCCESS IN PRINTS AND GROWING recognition undoubtedly account for the fact that about 1920 Hopper began to paint more in oils, and with a new assurance. Compared to his paintings before 1915, these new oils were more mature in conception, picturing unhackneyed aspects of everyday America with greater definition and completeness. The human figure appeared more frequently. These gains can be seen as partly a result of his printmaking experience. *Moonlight Interior* developed the theme of the etching *Evening Wind* with a compositional sense new in his paintings. *New York Pavements* showed a growing ability to use urban actualities as material for art; the heavy masonry forms of the apartment house, viewed from above, produced his most striking design so far.

These paintings of the early 1920's culminated in *House by the Railroad*. It is a work of the utmost simplicity: a fantastic mansard-roofed house standing alone beyond tracks that cut across the foreground; not a tree or a bush; strong revealing sunlight, somber shadows, an empty sky—and a sense of utter loneliness. By boldness of concept and strength of presentation, Hopper had created a symbol of much of America—one of the enduring images in modern art.

In 1923 he began to work also in watercolor, a medium which he had not used creatively since his Paris days, but which he was accustomed to through commercial work. From the first he showed an affinity for it that was to make it one of his two major means of expression. Almost all his watercolors of the 1920's were done during summers in New England: four seasons at Gloucester, one at Rockland, Maine, and two at Cape Elizabeth, Maine. In these years his production, for the first and last time, became relatively large: of watercolors he considered good enough to show, about fifteen to twenty most summers, and about thirty-five in 1926. This burst of painting activity was unquestionably a response to growing success.

It was at Gloucester in 1923 that he embarked on the watercolors of houses and village streets that were to become his first generally known type of subject—for a while, one might say, his trademark. He liked the spare New England character of this seaside town; the white wooden houses and churches of the early years, their puritan severity sometimes relieved by jigsaw ornamentation; or the more ambitious flamboyant mansions of the late

◀ NEW YORK PAVEMENTS. *About 1924. Oil, 24 × 29" Collection Mr. and Mrs. Mortimer Spiller, Buffalo, N.Y.*

nineteenth century with their mansard roofs, wide-spreading porches, and jutting dormers and bow windows. But equally he liked the poorer rundown sections, the bare unpainted tenements, the jumble of sheds and privies, and the fishhouses and factories. Like every realist, Hopper loved character, and these varied structures were as exactly characterized as a portrait painter's sitters. And above all, he loved the play of sunlight and shadow on their forms, the way a white-painted clapboard wall looked under the baking summer sun.

Never before had the American small town been subjected to such candid scrutiny. When these watercolors were first shown, the general reaction, from critics and public, was that they were satire. We were not yet used to seeing such commonplace, and to some of us ugly, material used in art. But actually there was no overt satire. Hopper was painting an honest portrait of an American town, with all its native character, its familiar uglinesses and beauties. On the whole, his attitude was affirmative. He preferred American architecture in its unashamed provincial phases, growing out of the character of the people. It may be noted that he was embodying this preference in paint before our architectural historians discovered these neglected styles.

Since his boyhood in Nyack, Hopper had been attracted to everything connected with boats and salt water. As a young man he had painted along the New England coast as far north as Monhegan. This nautical bent found full expression in his watercolors of the 1920's. At Gloucester there was the waterfront, and a fleet of steam trawlers whose rusty, cluttered decks provided rich material. Two summers later he met more of them in Rockland harbor. On the rocky point of Cape Elizabeth he found Two Lights, with its Coast Guard station and cottages dominated by the 120-foot-high lighthouse; and farther north, Portland Head Light, the oldest on the Maine coast. All these structures had the functional beauty of things that have to do with the sea. The noble forms of the white lighthouse towers and the stark white buildings grouped around them, seen in the clear air and strong sunlight of Maine, inspired some of his best watercolors; and also three oils, *Captain Upton's House*, *Lighthouse Hill*, and *Lighthouse at Two Lights*—the last in particular one of his strongest paintings. It is noteworthy that though the exposed point at Two Lights was known for its spectacular surf (the kind of subject favored by Winslow Homer, who had lived and died only a few miles away, at Prout's Neck), Hopper concentrated on the man-made structures.

The watercolors of these years were practically all painted on the spot, and often finished in one sitting. They began with a pencil drawing, precise though not detailed; but from then on they were built with the brush. The medium was kept transparent, without gouache or Chinese white—hence their luminosity. Compared to his oils of the same years

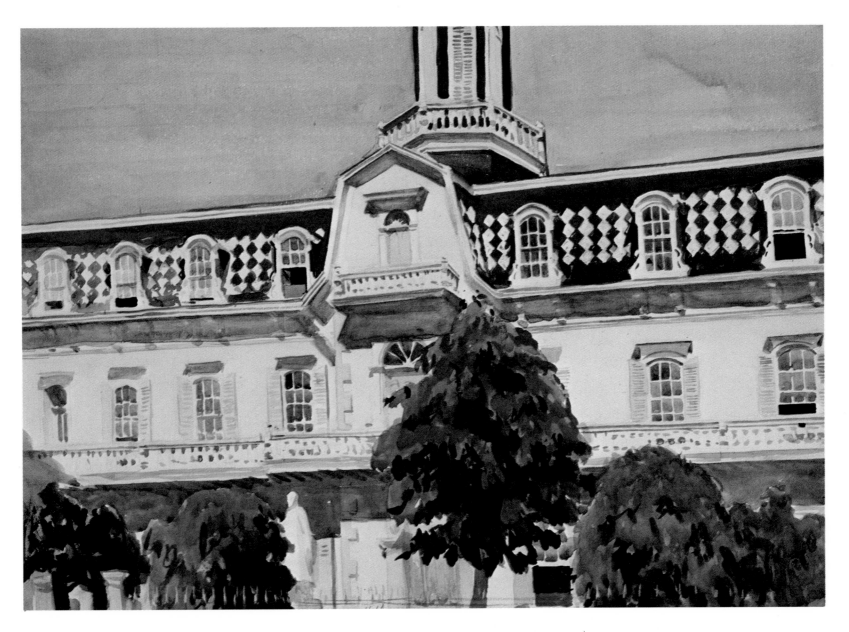

BUILDING, SOUTHWEST. *Probably 1925. Watercolor, 14×20" Whitney Museum of American Art, New York City Bequest of Mrs. Edward Hopper*

they were quite naturalistic, picturing the motifs with few changes—essentially portraits of places and buildings. But they were not the work of an ordinary sketch artist. Products of a fresh eye and of a sure hand recording visual sensations directly, they had a quality of utter authenticity. An instinctive rightness of composition showed in the best of them, which were as well designed, within their limits, as any of his later pictures. These early watercolors had a zest that his work did not always show; they still rank among his happiest achievements.

They met with prompt recognition. Out of the first group exhibited, at the Brooklyn Museum in 1923, the museum purchased *The Mansard Roof*—his first sale of a painting (not counting prints) since the Armory Show ten years earlier. Hopper had never had a dealer; now he hesitantly took a group of his watercolors to Frank K. M. Rehn of New York, who immediately accepted him—a gallery connection that lasted from then on. In November 1924 Rehn gave the first one-man show of his new watercolors. All eleven shown, and five more, were sold. In February 1927 a second show at Rehn's of recent oils and watercolors added to his reputation. From the late 1920's his paintings were represented regularly in the chief national exhibitions. The new Museum of Modern Art in 1929 included him in its first show of contemporary American art, "Paintings by Nineteen Living Americans"—a considerable honor. Four years later, in November 1933, the museum's Director, Alfred H. Barr, Jr., who had admired his art for some years, staged a full-scale retrospective exhibition that definitely established him as one of the leaders of American painting.

Full critical recognition began in the early 1920's. Among the first to write about him were Guy Pène du Bois, Helen Appleton Read, Virgil Barker, Duncan Phillips, Forbes Watson, and the present writer. The editors of *The Arts* (Watson, Barker, and myself) not only published articles about him but discovered that he himself could write extremely well, if persuaded; hence articles on two contemporaries he liked, John Sloan and Charles Burchfield. Hopper never enjoyed writing or wrote easily. "I sweat blood when I write," he said in a letter to Forbes Watson, "and a thing that you could probably do in a day would take me I am sure a week or two." But the final product had the thoughtfulness, concentration and substance of his painting.

One ironical byproduct of his growing reputation was that the National Academy of Design, which had rejected his paintings year after year when he really needed recognition, elected him an associate member in March 1932. (At the same meeting they turned down Maurice Sterne, who had been one of their most brilliant students.) The Academy had omitted to sound out Hopper beforehand, and he promptly declined the

honor. Forbes Watson had some fun with this incident in an editorial headed "The National Academy Club Leaps and Looks." Hopper was never a joiner; the only artists' organizations he belonged to were the Whitney Studio Club, the American Print Makers, and many years later the National Institute of Arts and Letters and the American Academy of Arts and Letters.

Like many self-made artists (Winslow Homer, for example) Hopper had been slow in reaching maturity. He was in his early forties before he began to express himself fully in painting. When he did, however, recognition came quickly and completely.

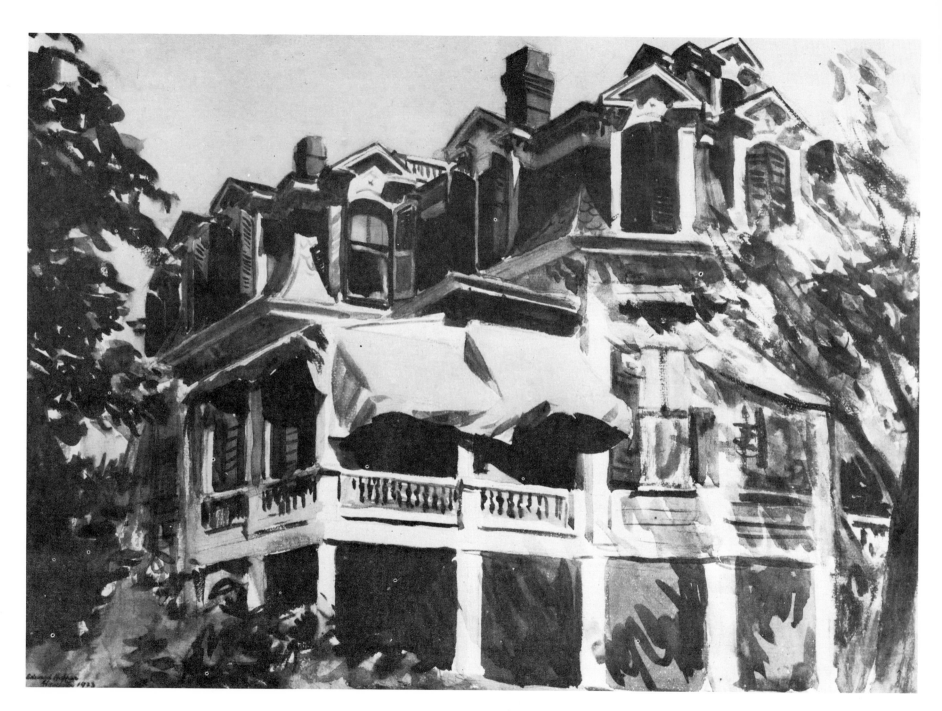

THE MANSARD ROOF *1923. Watercolor, 14 × 20" The Brooklyn Museum, Brooklyn, N.Y.*

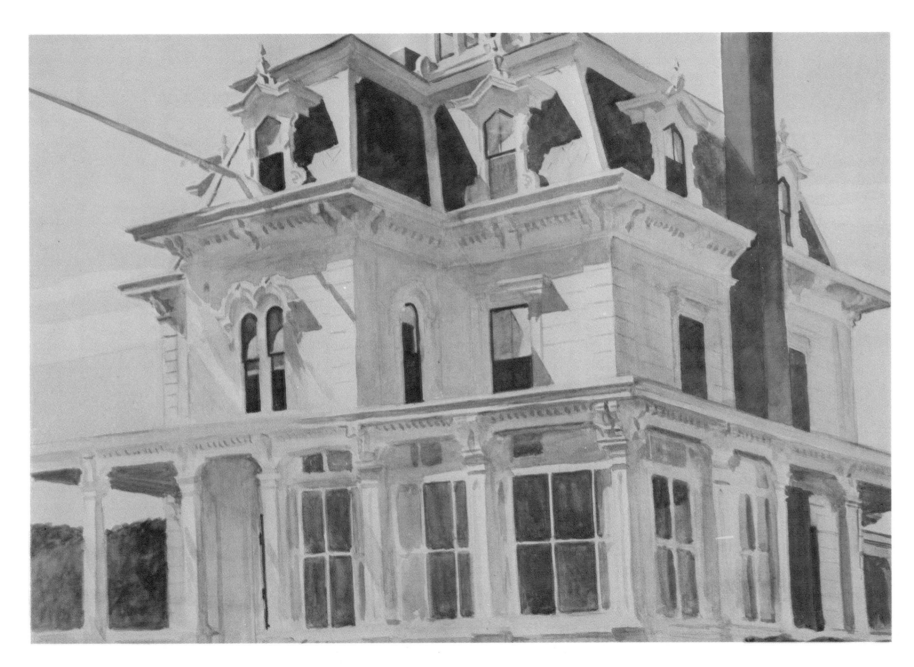

TALBOT'S HOUSE. *1926. Watercolor, 14 × 20″. Private collection*

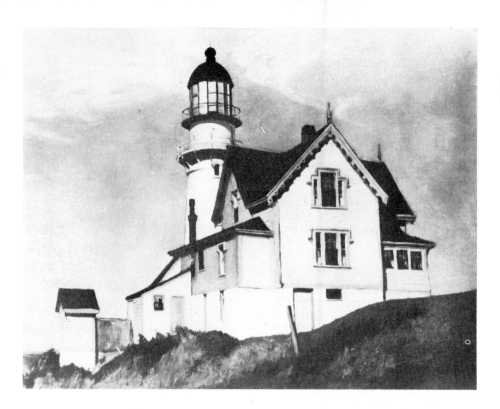

CAPTAIN UPTON'S HOUSE. *1927. Oil, 28 1/2 × 36".*
Collection Mrs. Yale Kneeland, Jr., Millbrook, N.Y.

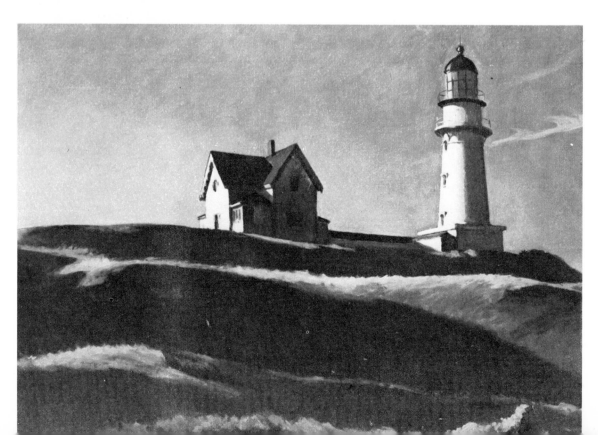

LIGHTHOUSE HILL. *1927. Oil, 28 3/4 × 40 1/8".*
Dallas Museum of Fine Arts, Dallas, Texas.
Gift of Mr. and Mrs. Maurice Purnell

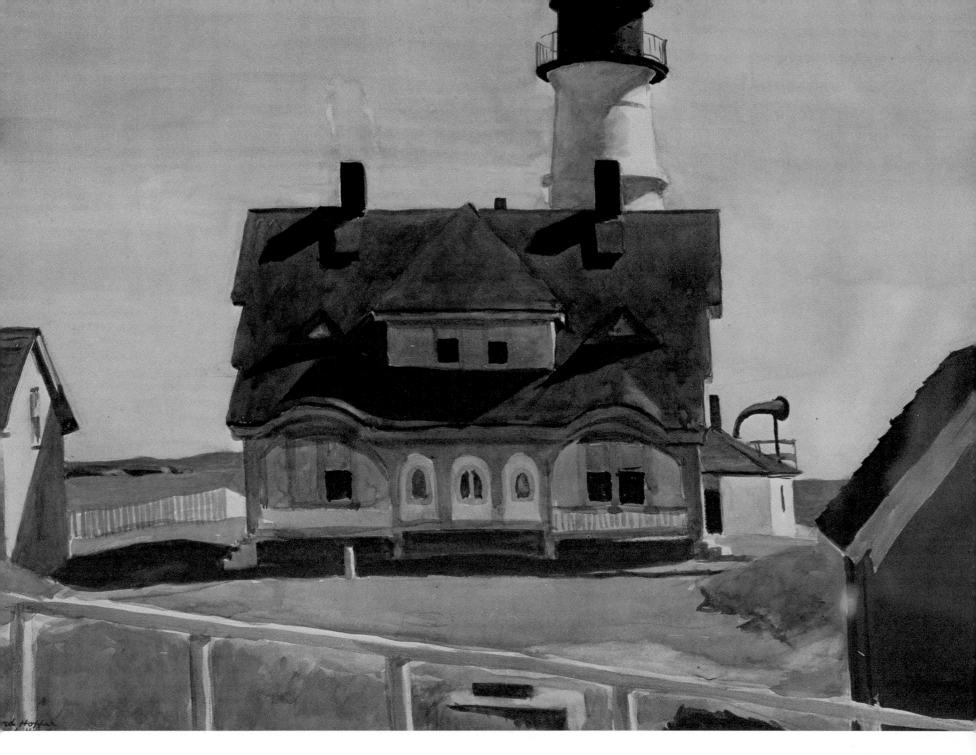

CAPTAIN STROUT'S HOUSE. *1927. Watercolor, 14 × 20″. The Wadsworth Atheneum, Hartford, Conn. The Ella Gallup Sumner and Mary Catlin Sumner Collection*

ADAMS' HOUSE. *1928. Watercolor, 16×25″. Wichita Art Museum, Wichita, Kan. Roland P. Murdock Collection*

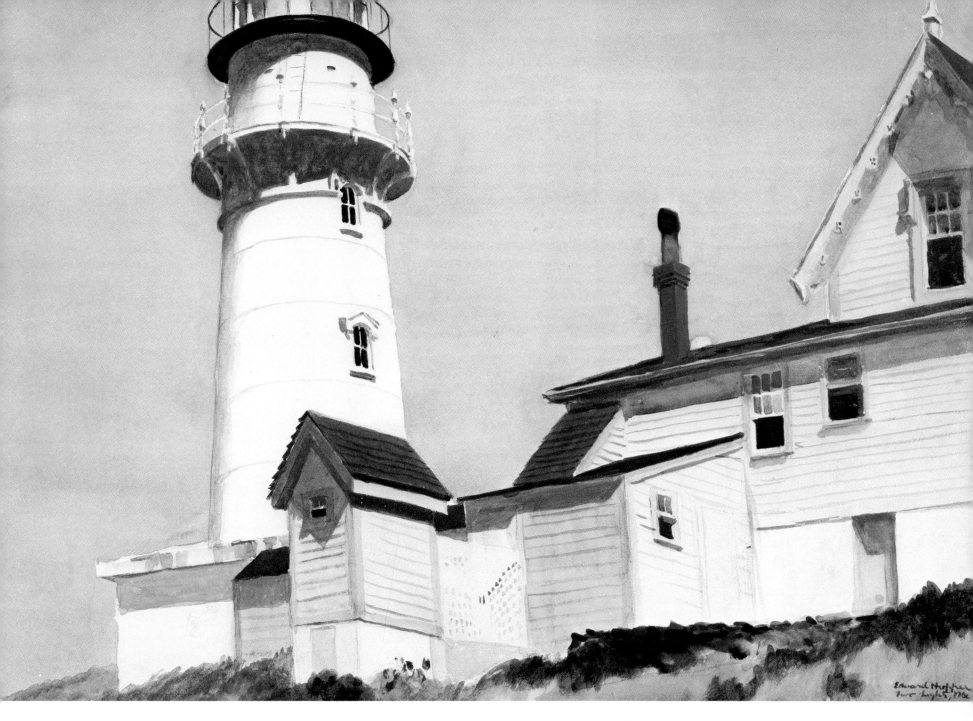

LIGHT AT TWO LIGHTS *1927. Watercolor, 14×20″ Collection Dr. and Mrs. Irving Frederick Burton, Huntington Woods, Mich.*

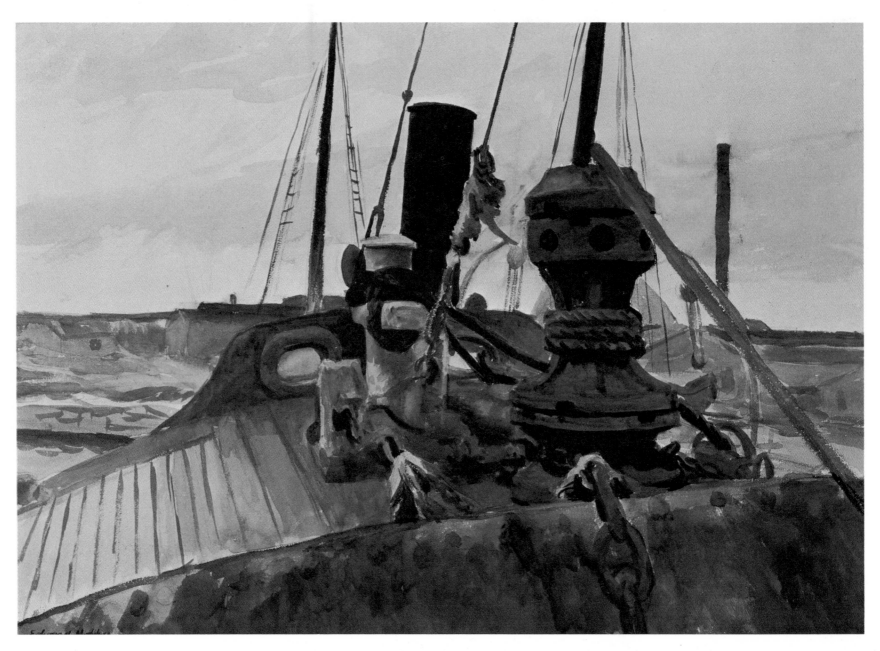

DECK OF BEAM TRAWLER WIDGEON. *1926. Watercolor, 14 × 20". Private collection, New York City*

TWO ON THE AISLE. *1927* ▶
Oil, 40 1/4 × 48 1/4"
The Toledo Museum of Art, Toledo, Ohio
Gift of Edward Drummond Libbey

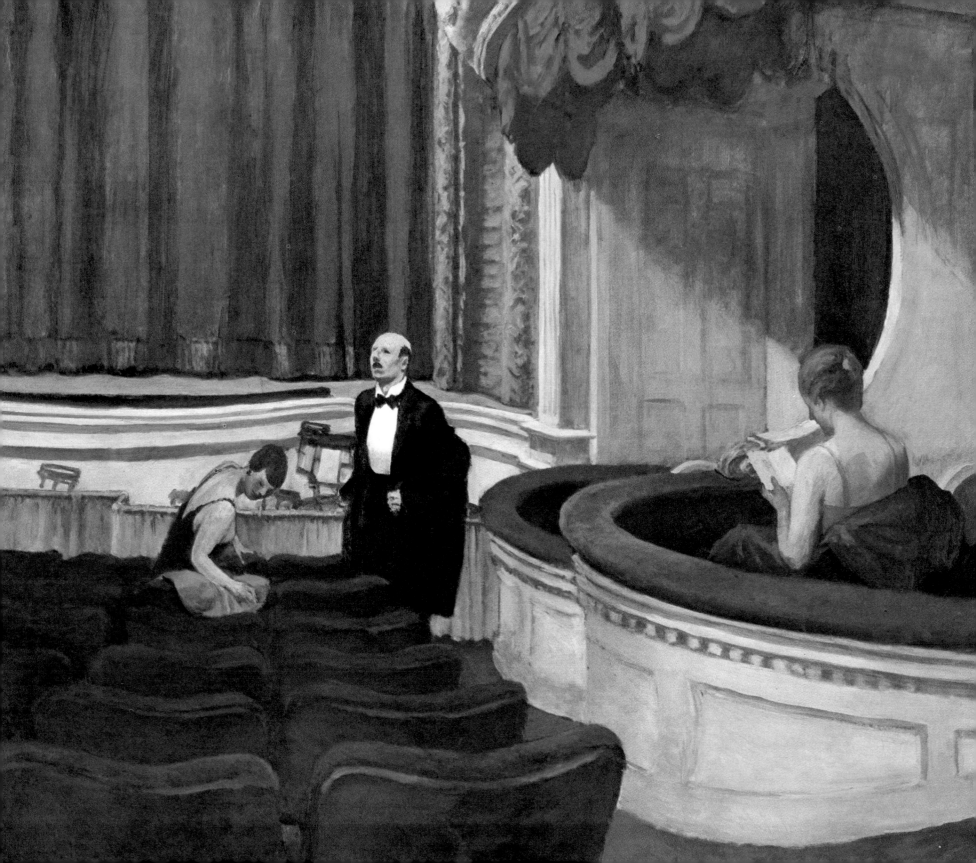

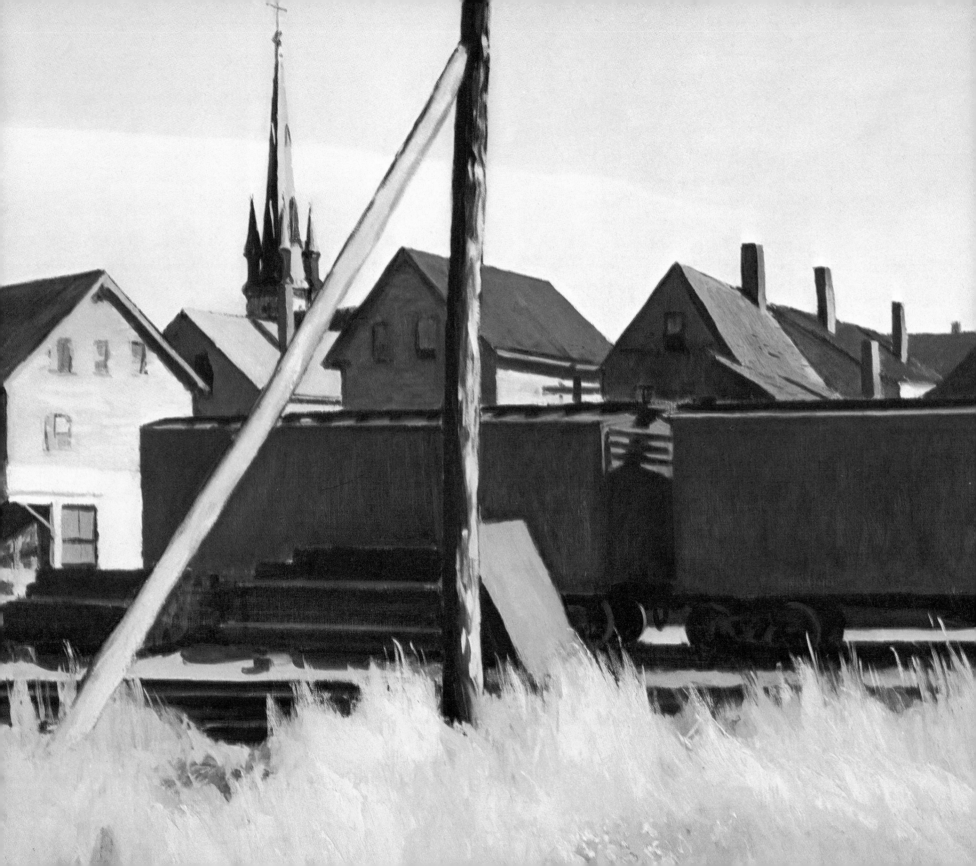

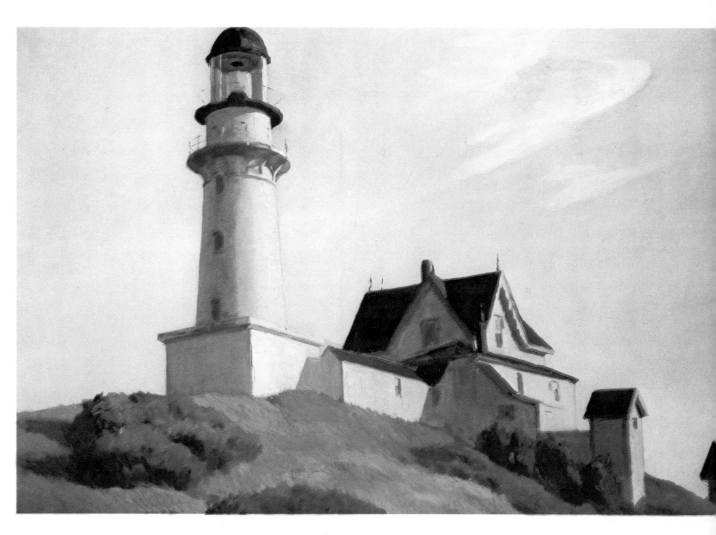

LIGHTHOUSE AT TWO LIGHTS *1929. Oil, 29 1/2 × 43 1/4″ The Metropolitan Museum of Art, New York City Hugo Kastor Fund, 1962*

FREIGHT CARS, GLOUCESTER. *1928. Oil, 29 × 40″ The Addison Gallery of American Art, Phillips Academy, Andover, Mass.*

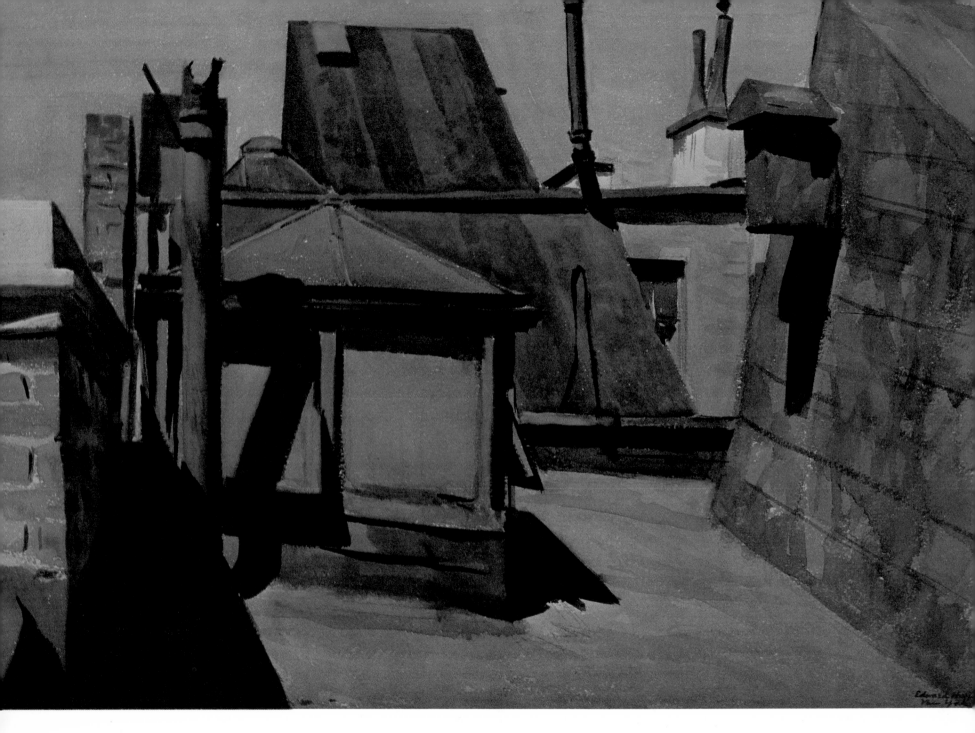

MY ROOF. *1928. Watercolor, 14 × 20″. Collection Mr. and Mrs. Leo J. Goldshlag, New Rochelle, N.Y.*

DRAWINGS FROM THE NUDE

These drawings were made in the evening sketch class of the Whitney Studio Club in the early and middle 1920's. Two are in black conté crayon, four in sanguine. All are owned by the Whitney Museum of American Art, New York City. Bequest of Mrs. Edward Hopper.

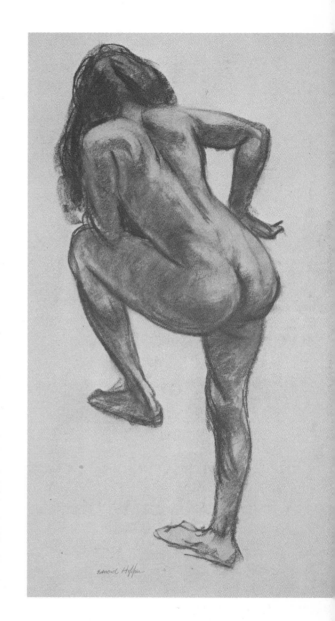

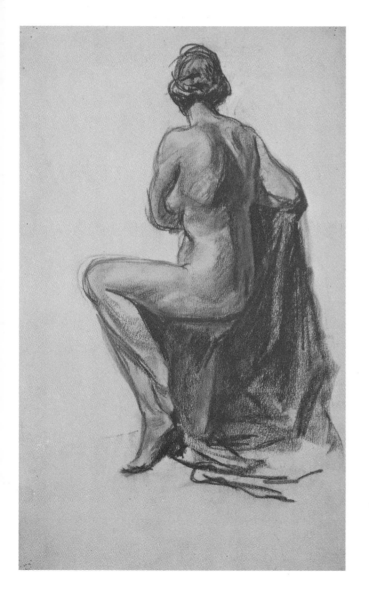

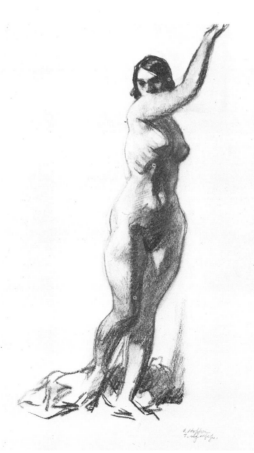

51

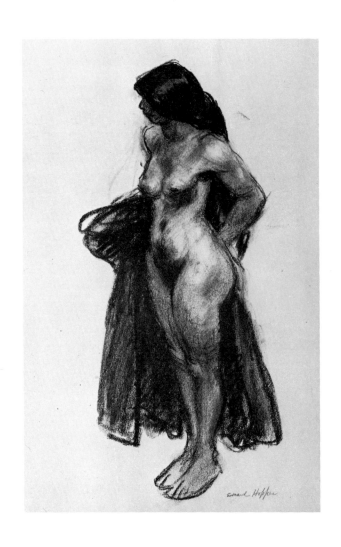

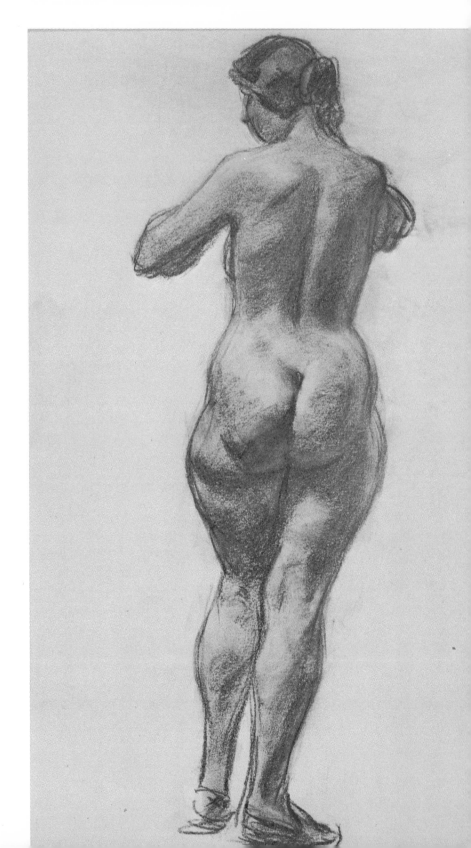

52

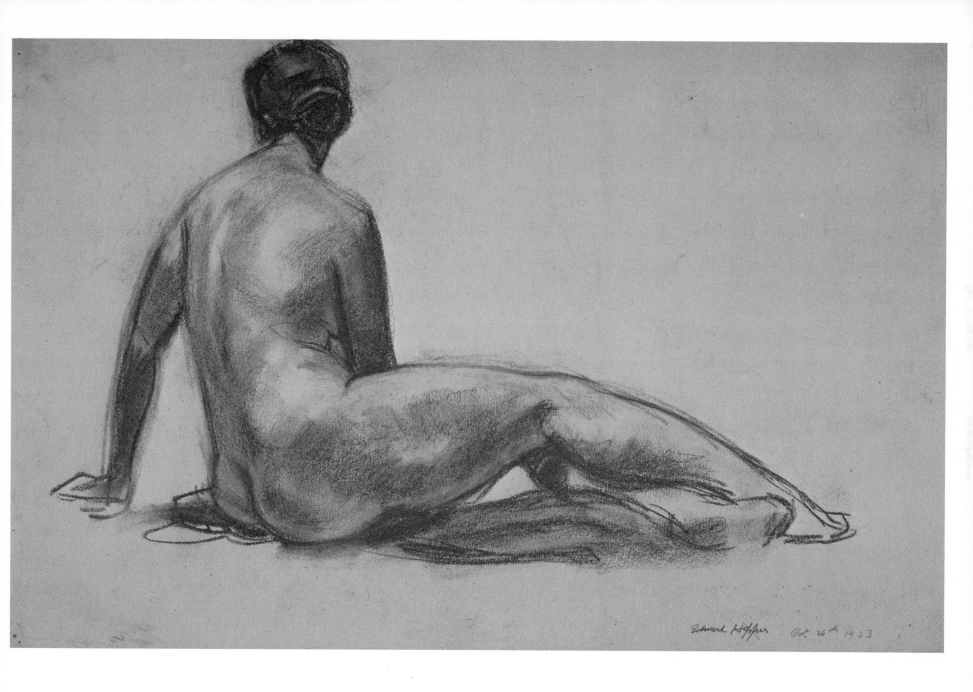

Edward Hopper Oct. 26th 1923

53

MARRIAGE AND PERSONAL LIFE

IN HIS PRIVATE LIFE THESE YEARS brought great changes. In July 1924 he married the painter Josephine Verstille Nivison, who thereafter signed herself Jo N. Hopper. She also had been a Henri student, after his time, and they had met when he came back to visit the school. On one such occasion he helped her stretch a canvas—since when, she once said, "he has had a lifetime of stretching canvases for me." Sharing fully in his interests and beliefs, through the years she was his inseparable companion. (She posed for almost every woman's figure he painted.) Their viewpoints and tastes were identical, not only about art but about the kind of life they liked. They had no children, and they preferred a life of the utmost simplicity and frugality, devoted to painting and to country living for half the year.

Since 1913 Hopper had lived at 3 Washington Square North, on the top floor of an old red brick house inhabited mostly by artists—one of a row of similar fine, solid houses that give this side of the Square its character, almost unique in New York. After their marriage he and Jo continued to live there, he using the south half of the floor as his studio, she the north. For years heat was supplied by a big old-fashioned potbellied stove, and Hopper would carry coal scuttles up four flights of stairs, and later haul them up in a dumbwaiter.

After his first success in 1924 he was able to give up commercial work and illustration. They could now spend whole summers in New England. Both of them liked to see new places (in moderation), and in the 1920's they made several automobile trips, the longest in 1925 to Santa Fé, where they spent the summer. At first Hopper was miserable in New Mexico; everything was too beautiful and from his standpoint unpaintable. But one day Jo Hopper saw him pack his watercolor kit and go out; looking for him later she found him in a railroad yard painting a locomotive.

In 1930 they bought land in South Truro on Cape Cod, on the shore of Massachusetts Bay —a country of rolling sandy hills green with pine and scrub oak. Here they built a plain shingled house (the first in the area) on top of a hill overlooking the bay. Approaching it along their road, no more than two sandy ruts through the underbrush, and climbing a flight of steep wooden steps, one found oneself looking down on a white beach alive with gulls, and across miles of water. The house, planned by him, was as unadorned as one of

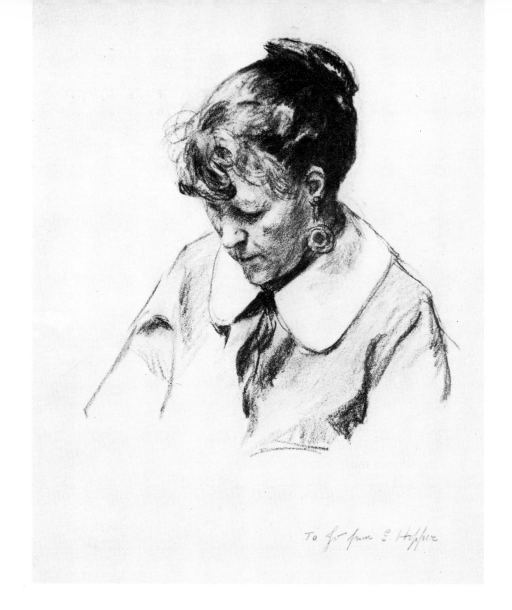

To Jo from E. Hopper

JO HOPPER. *Black conté crayon, 18 × 15 1/2"*
Whitney Museum of American Art, New York City
Bequest of Mrs. Edward Hopper

his paintings; indeed, its austere interior was the starting point for several pictures.

Thenceforth the Cape, with its high dunes on the ocean side, its spare wooden farmhouses and churches, its white-painted villages, and its sense of salt water all around, was the right place to work and to live. From 1930 the Hoppers spent almost half the year there, returning to Washington Square in late October or November. "I chose to live here," Hopper told Katharine Kuh, "because it has a longer summer season. I like Maine very much, but it gets so cold in the fall. There's something soft about Cape Cod that doesn't

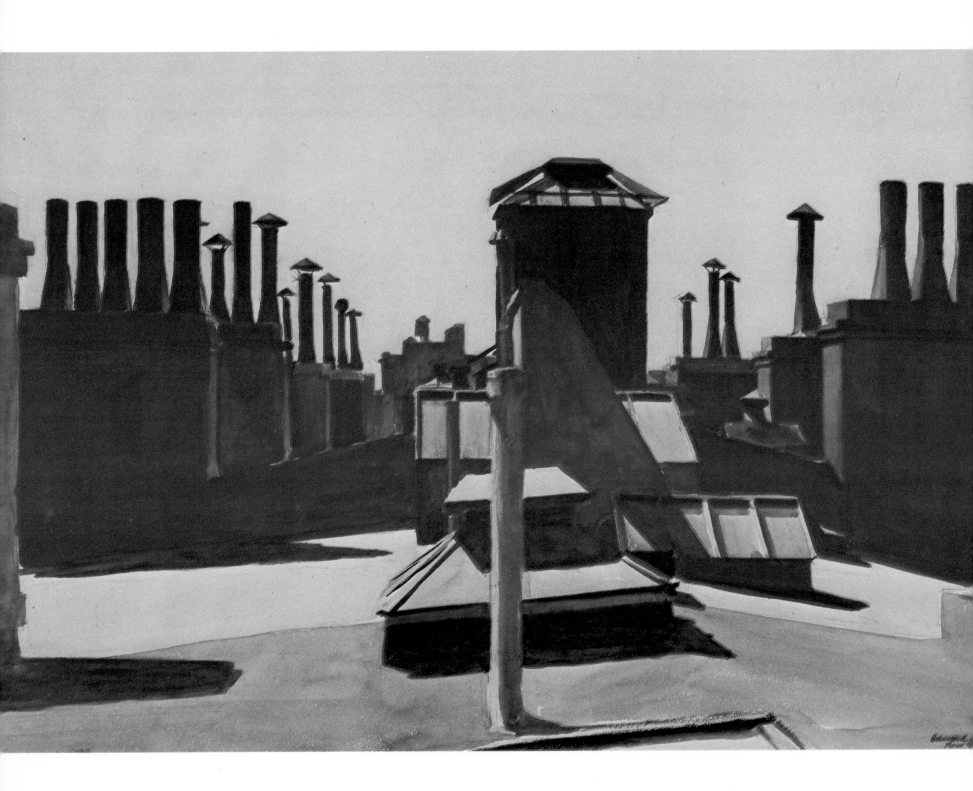

appeal to me too much. But there's a beautiful light there—very luminous—perhaps because it's so far out to sea; an island almost." Most of his landscapes and small-town subjects after 1930 were of the Cape, and many of his best watercolors were painted there.

The austere way of life the Hoppers had chosen seemed to suit both of them completely. They were not unsociable, and they had plenty of friends, old and new; but neither were they gregarious. Hopper had no small talk; he was famous for his monumental silences; but like the spaces in his pictures, they were not empty. When he did speak, his words were the product of long meditation. About the things that interested him, especially art (his own and others'), he had perceptive things to say, expressed tersely but with weight and exactness, and uttered in a slow reluctant monotone. "If you could say it in words, there'd be no reason to paint," he said. The bare honesty of his statements (including those about himself) could be devastating. From what he said, one would class him as a complete pessimist—an impression belied by his work and his whole life. There was an undertone of humor, wry but not unkind. A positive statement was usually followed by a partial withdrawal, a qualification, since it was only his opinion.

Jo Hopper, on the other hand, was as articulate as he was laconic, with a lively sense of humor. (She once remarked that "sometimes talking with Eddie is just like dropping a stone in a well, except that it doesn't thump when it hits bottom.") They could be appallingly frank with each other; to hear them sometimes, one was convinced that they were at the breaking point. But with all their verbal clashes, there was no mistaking their deep mutual attachment and dependence.

Both of them did a good deal of reading, in French as well as English; and moreover they retained what they read. Brian O'Doherty tells of Hopper showing him a quotation from Goethe that he carried in his wallet: "The beginning and end of all literary activity is the reproduction of the world that surrounds me by means of the world that is in me." ("To me," Hopper said, "that applies to painting from memory.") Among Hopper's most-read Americans were Emerson, Thoreau, Robert Frost, and E. B. White. He quoted Emerson in writing of Burchfield's use of common things as material for art: "In every work of genius we recognize our own rejected thoughts; they come back to us with a certain alienated majesty. Great works of art have no more affecting lesson for us than this. They teach us to abide by our spontaneous impression with good-humored inflexibility, then most when the cry of voices is on the other side."

57

ROOFS OF WASHINGTON SQUARE *1926. Watercolor, 14 × 20" Collection Mr. and Mrs. James H. Beal, Pittsburgh, Pa.*

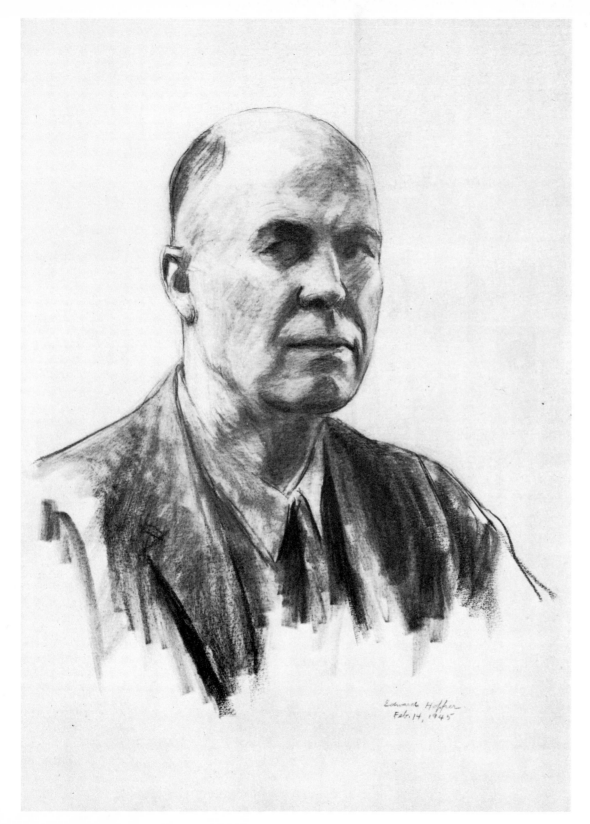

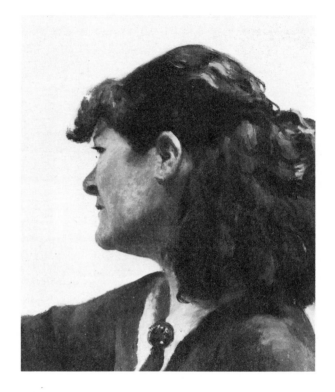

JO PAINTING. *1936. Oil, 18 × 16″*
Whitney Museum of American Art, New York City
Bequest of Mrs. Edward Hopper

SELF-PORTRAIT. *1945. Black conté crayon, 22 × 15″*
Whitney Museum of American Art, New York City
Bequest of Mrs. Edward Hopper

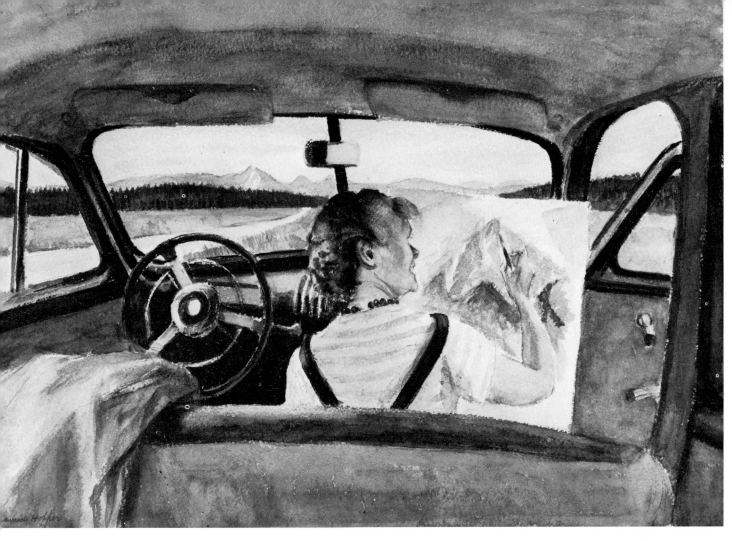

JO IN WYOMING. *1946. Watercolor, 13 3/4 × 20". Whitney Museum of American Art, New York City. Bequest of Mrs. Edward Hopper*

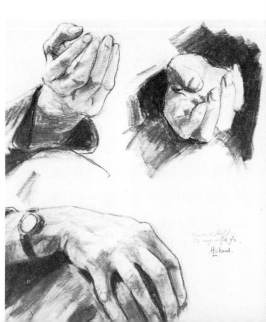

THE ARTIST'S HAND (THREE VIEWS)
Undated. Black conté crayon, 22 × 15"
Whitney Museum of American Art, New York City
Bequest of Mrs. Edward Hopper

Edward Hopper, about 1930. Photo: Soichi Sunami
Courtesy Archives of American Art, New York City

Edward Hopper, October 1933. Photo: Peter A. Juley & Son

◄ *Edward Hopper in his*
Washington Square apartment, 1966.
Photo: Peter Pollack

Edward Hopper in front of his house
in South Truro, Mass.; Josephine Hopper
in the distance, August 1960
Photo: Arnold Newman

THE AMERICAN SCENE

NATIONAL CHARACTER IN ART

WHEN HOPPER ACHIEVED RECOGNITION in the early 1920's the American art world was quite different from that of his youth. The years of his obscurity had seen the development of the modern movements in this country. In the same year that he had begun to paint native subjects, 1908, modernism had crossed the Atlantic with the first of the young radicals returning from Paris and the first of Alfred Stieglitz's modern exhibitions. From 1908 to the early 1920's, while Hopper was striving to develop his individual expression, modernism fought and at least partially won its battle. The decade of the 1920's saw an unparalleled internationalism in the American art world, and specifically the strong influence of the School of Paris.

Hopper's art from the first had been opposite to the general trends of modernism: instead of subjectivity, a new kind of objectivity; instead of abstraction, a purely representational art; instead of international influences, an art based on American life. He had been the first to picture the United States with a new realism. But he was not to remain alone in this. From about 1920 a number of younger men—Thomas H. Benton, Grant Wood, Charles Burchfield, Reginald Marsh, John Steuart Curry—began to paint the native scene in more or less naturalistic styles. In the 1920's and early 1930's, the American scene school shared dominance of the art world with the social content school, and the trend toward abstraction was in temporary eclipse. The nativist movement had its literary counterpart in realistic writing about American society—Theodore Dreiser and Sherwood Anderson (like Hopper, forerunners of the movement), Sinclair Lewis, John Dos Passos, Thomas Wolfe, William Faulkner. And it had parallels in nationalistic and naturalistic tendencies in Europe.

Hopper had strong convictions about national character in art. He wrote in 1933, in the catalogue of his retrospective exhibition at the Museum of Modern Art: "The question of the value of nationality in art is perhaps unsolvable. In general it can be said that a nation's art is greatest when it most reflects the character of its people. French art seems to prove this. . . .

62

"The domination of France in the plastic arts has been almost complete for the last thirty years or more in this country.

"If an apprenticeship to a master has been necessary, I think we have served it. Any further relation of such a character can only mean humiliation to us. After all we are not French and never can be and any attempt to be so, is to deny our inheritance and to try to impose upon ourselves a character that can be nothing but a veneer upon the surface."

But he never indulged in the chauvinism, the self-conscious nativism, or the baiting of foreign art that some of the Midwestern regionalists did. Writing of Burchfield, who had also kept clear of such tactics, he said: "After all, the main thing is the natural development of a personality; racial character takes care of itself to a great extent, if there is honesty behind it"—words that applied equally to himself.

PORTRAIT OF AMERICA

PRACTICALLY ALL OF HOPPER'S MATURE WORK was based on the contemporary United States—the physical face of America. His attitude toward the native scene was complex. In talking of his early years, he said to me that after France the United States seemed "a chaos of ugliness." "It seemed awfully crude and raw here when I got back," he told Brian O'Doherty in the 1960's. "It took me ten years to get over Europe." In his article on Burchfield in 1928 he wrote: "Our native architecture with its hideous beauty, its fantastic roofs, pseudo-Gothic, French Mansard, Colonial, mongrel or what not, with eye-searing color or delicate harmonies of faded paint, shouldering one another along interminable streets that taper off into swamps or dump heaps—these appear again and again, as they should in any honest delineation of the American scene. The great realists of European painting have never been too fastidious to depict the architecture of their native lands."

Despite this diatribe, his own work showed nothing as broad as the satire of Burchfield's early pictures of the Midwest. Hopper's viewpoint was more objective. For that very reason, his portrayals carried conviction, and were equally devastating. He had an unerring eye for the character of places: the monotonous regularity of most city streets; the outskirts of the city, where the apartment houses that the city has not grown up to stand solitary among empty lots; or by contrast, those sections where the suburbs have been engulfed by the spreading town, as in *East Wind over Weehawken*, with its sad, discordant houses—a portrait of much of the United States, where each man builds without regard to his neighbors. He captured accurately the peculiar melancholy of architectural pretension that is no longer fashionable: the massive apartment houses of the 1890's with their overpowering cornices and columns; the grotesque suburban mansions of the President Garfield period; the gawky rococo of seaside boarding houses. Seldom has an inanimate object expressed such penetrating melancholy as *House by the Railroad*.

Nevertheless, Hopper's art was based on a deep emotional attachment to his native environment. Like any emotional relation, it was compounded of love and the reverse. No painter was more aware of the ugliness of certain aspects of our country. But it was his world, to which he was bound by strong ties. He accepted it completely, and in a deeply affirmative spirit, built his art out of it. What he wrote of Burchfield was true also of himself: "His work is most decidedly founded, not on art, but on life, and the life that he knows and loves best. From what is to the mediocre artist and unseeing layman the

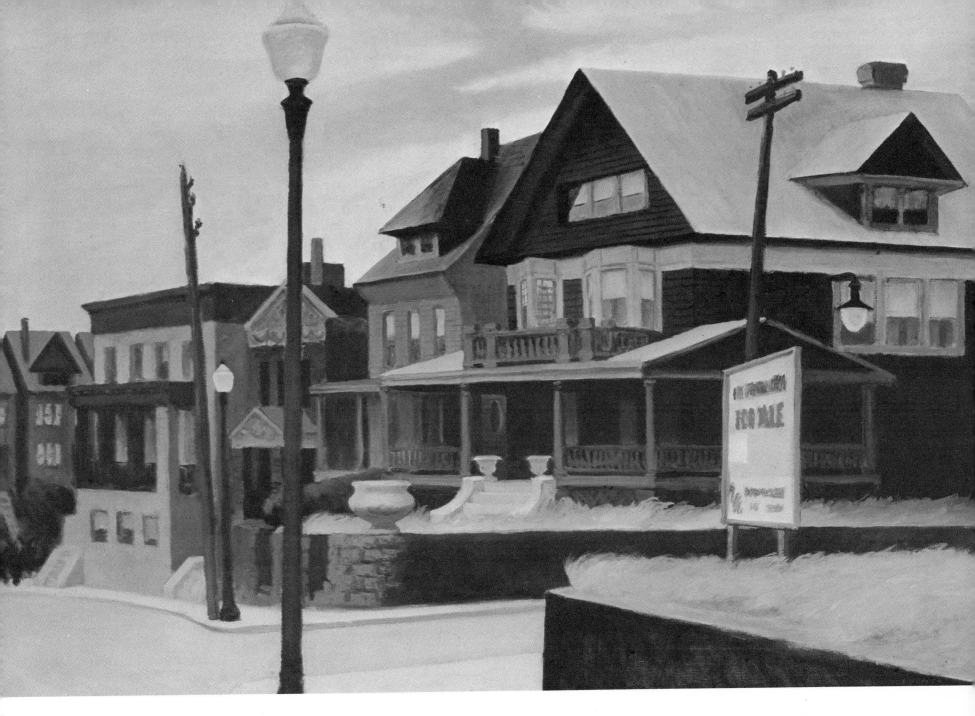

EAST WIND OVER WEEHAWKEN *1934. Oil, 34 1/2 × 50 1/2″ Pennsylvania Academy of the Fine Arts, Philadelphia, Pa.*

boredom of everyday existence in a provincial community, he has extracted a quality that we may call poetic, romantic, lyric, or what you will. By sympathy with the particular he has made it epic and universal. No mood has been so mean as to seem unworthy of interpretation; the look of an asphalt road as it lies in the broiling sun at noon, cars and locomotives lying in God-forsaken railway yards, the steaming summer rain that can fill us with such hopeless boredom, the blank concrete walls and steel constructions of modern industry, mid-summer streets with the acid green of closecut lawns, the dusty Fords and gilded movies—all the sweltering, tawdry life of the American small town, and behind all, the sad desolation of our suburban landscape. He derives daily stimulus from these, that others flee from or pass with indifference."

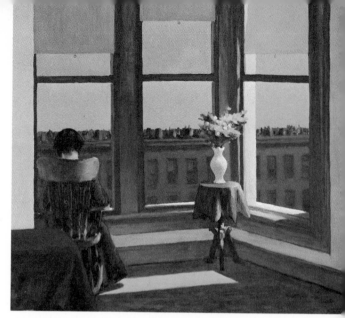

ROOM IN BROOKLYN. *1932. Oil, 29 × 34".*
Museum of Fine Arts, Boston, Mass.

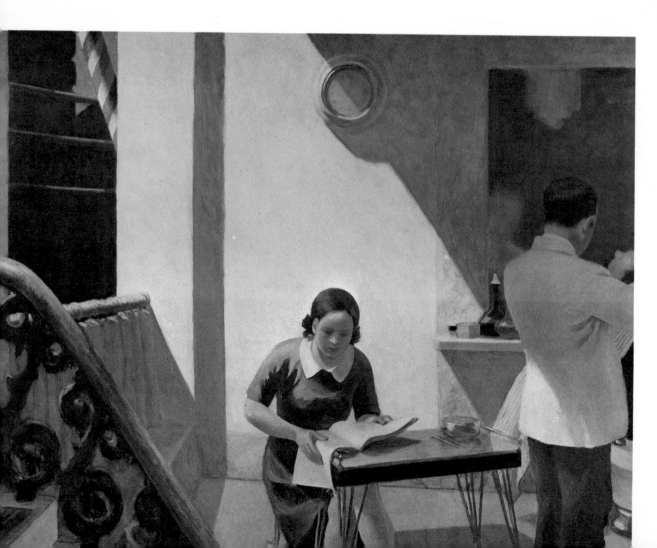

THE CITY. *1927. Oil, 28 × 36"* ▶
University Art Gallery, University of Arizona,
Tucson, Ariz. C. Leonard Pfeiffer Collection

THE BARBER SHOP
1931. Oil, 60 × 78"
Collection Mr. and Mrs. Roy R. Neuberger,
New York City

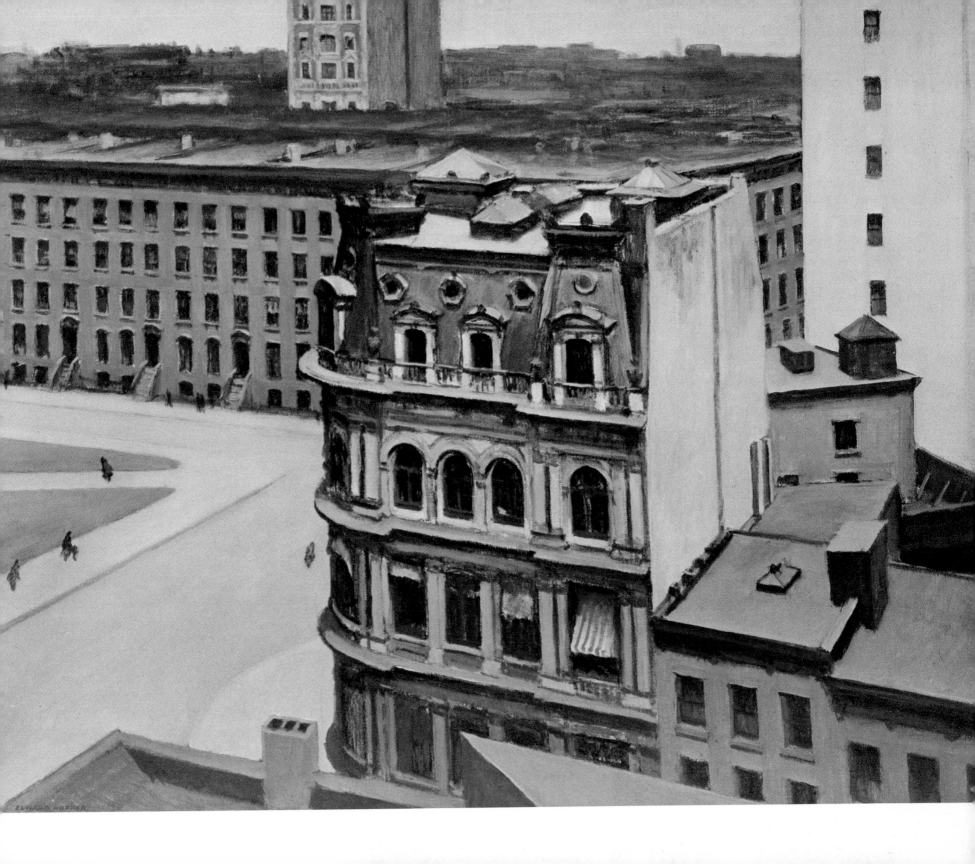

THE CITY

THE CONTEMPORARY AMERICAN CITY was the center of much of Hopper's work. Whereas the Henri group had used the city as a background for human activity, Hopper concentrated on the city itself, that huge complex of steel, stone, concrete, brick, asphalt, and glass. He was one of our first representational painters to realize the pictorial possibilities of the modern city (in his case, New York) and the many kinds of visual material it presents: its heavy masses of masonry and concrete; the individual forms of buildings, their surfaces and ornamentation, the effect of light on them; the omnipresence of glass, and the phenomena of life seen through windows; night in the city with its multitude of lights and its ominous shadows.

On the other hand, he was never interested in the spectacular aspects of New York—its skyscrapers and its famous skyline. The dynamism of the city, its towering buildings and rushing traffic, which inspired pioneer modernists such as Stella, Marin, Weber, and Walkowitz, played no part in his work. His city was monumental and immobile. And his viewpoint was more intimate, concerned with the immediate surroundings of everyday life. When he painted watercolors on the roof of 3 Washington Square North, they were not of the Woolworth Building in the distance, but the skylights and chimneypots of his own roof. Once a fellow painter walking with him in the street pointed out a group of skyscrapers: "Look! What a wonderful composition those skyscrapers make, what light, what massing, look at them, Hopper!" But Hopper wasn't interested. "Anything will make a good composition," he said—a remark that in his case should be taken with a large grain of salt.

There are never any crowds in his pictures, never the hurrying tide of humanity that fascinated a painter such as Marsh. Often he chose the hours when few or no people were abroad. *Early Sunday Morning* is an empty street before anyone is up, with a row of identical houses. The monotony and loneliness of the city have seldom been so intensely conveyed. Yet the final emotion is affirmative: clear morning sunlight, stillness, and a sense of solitude that is poignant yet serene. Like many of his works this gives the sensation that the scene does not stop at the edges of the picture, that these buildings continue for blocks on either side. The strong horizontal lines and the repetition of windows, storefronts, and cornice ornaments carry the eye and mind out of the composition, convincing us that this

slice of life is part of a larger whole—the vastness of a great city. This sensation was consciously aimed at in several paintings; as he wrote of *Manhattan Bridge Loop*: "The very long horizontal shape of this picture is an effort to give a sensation of great lateral extent. Carrying the main horizontal lines of the design with little interruption to the edges of the picture, is to enforce this idea and to make one conscious of the spaces and elements beyond the limits of the scene itself." As he wrote of Burchfield, "he seems always to envisage a wider field than the mere limits of the picture can surround."

In many of his urban subjects, individual men and women do appear, but as parts of the whole scene rather than in leading roles. The woman undressing for bed, the diners in a restaurant, the bored couple seen through their apartment window, the solitary passerby in the street at night, are integral elements in his version of the city; but their environment is as important as they are. Usually they are alone; seldom are more than two or three gathered together. Often they seem isolated in the wide impersonality of the city; they seem to epitomize the lonely lives of so many city dwellers, the solitude that can be experienced most intensely among millions. On the other hand, they are portrayed with little feeling for them as individuals, and without much attempt at characterization. Indeed, in his less successful works his people incline to be inanimate and wooden, like lay figures, with expressionless, masklike faces. Only rarely are they shown in motion, and then the results are not always happy. It is not in these directions that Hopper's strength lay.

The closest human intimacy is attained in his scenes of women in city interiors, nude or half-dressed—a favorite theme since the etching *Evening Wind*, later developed in a series of paintings up to his last years: *Moonlight Interior, Eleven A.M., Night Windows, Hotel Room, Morning in a City*, and *Morning Sun*. Always she appears in entirely realistic circumstances, dressing or undressing; and often she is before a window, looking out—the intimacy of her nakedness contrasting with the impersonal city outside. There is never any academic idealizing, nor on the other hand any obvious eroticism. She is painted with complete honesty, but also with devoted attention to her solid physical existence, her statuesque roundness. These recurring images reveal, beneath Hopper's objectivity, a deep-rooted sensualism. He was often called a puritan (first by his old friend Guy du Bois, who was far from one), and the word does apply to his avoidance of subjective emotion, his detached attitude toward humanity, and the austerity of his artistic language. But puritanism is not incompatible with sexuality. Underlying Hopper's naturalism was that deep sensualism which is fundamental to all vital art, and which contributed to the masculine strength of his art.

69

Many of his city interiors are seen through windows, from the viewpoint of a spectator looking in at the unconscious actors and their setting—a life separate and silent, yet crystal-clear. "The sensation for which so few try," as he wrote of Burchfield, "of the interior and exterior of a building seen simultaneously. A common visual sensation." Usually it is night, with the lighted room and its occupants framed by dark walls. This use of interior light and enframing darkness is the motif of paintings as different in their subjects as *Night Windows*, *Drug Store*, *Room in New York*, and *Nighthawks*. Even when no window is physically present, the impression is sometimes conveyed of a remote observer, as if a wall had been removed. Looking down into *Office at Night* one has the sensation of being outside the room rather than in it. That this sensation is not merely subjective is proved by a preliminary drawing for the painting, which indicates the frame of a window through which we are looking.

Often the artist's viewpoint seems that of a traveler, out of things yet drawn to them. It is noteworthy how many of his pictures actually have to do with travel: with railroads, highways, gas stations, hotels, and motels. (He told me that he frequently got his subjects while driving.) This absorption in the traveler's sensations and feelings was quite conscious; of *Approaching a City*, for example, he said that he was trying to express the emotions one has on a train coming into a strange city—"interest, curiosity, fear." You realize the quality of a place most fully, he added, on coming to it or on leaving it.

All these subjective factors enter into the penetrating sense of loneliness so often felt in his pictures—in those that include human beings as well as those that do not. It is a quality much commented on by critics. He himself admitted that it might be present, but denied that it was intended. Indeed, the emphasis on it annoyed him: "The loneliness thing is overdone," he said. But it undeniably exists. The emotion with which Hopper's art is charged is concentrated not on humanity but on its setting, on the cities and the structures that man has built and among which his life is spent, and on nature with its evidences of man's occupation. His detached attitude toward the human being, and the compensating intensity of his feeling for the human environment, inevitably produce an undertone of loneliness. For all his realism, Hopper was essentially a poet, and his art is an expression of that poetry of places that has been a theme for certain artists throughout the centuries— Guardi and Canaletto, Piranesi and Hubert Robert, Corot and Méryon, Utrillo and Chirico.

ELEVEN A.M. *1926. Oil, 28×36"* ▶
Joseph H. Hirshhorn Foundation

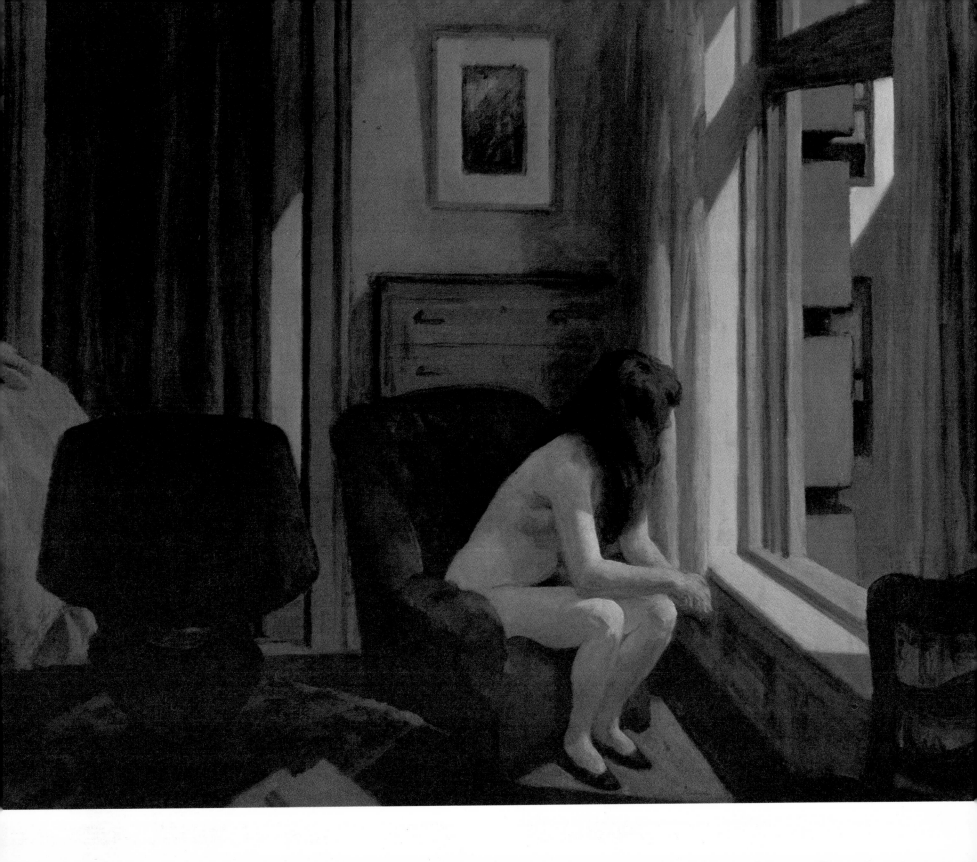

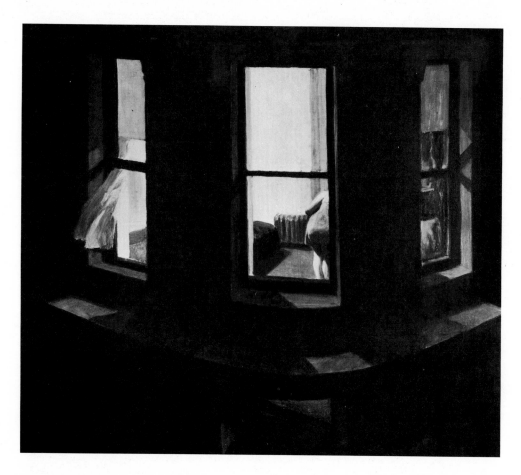

NIGHT WINDOWS. *1928. Oil, 29 × 34″*
The Museum of Modern Art, New York City
Gift of John Hay Whitney

CHOP SUEY. *1929. Oil, 32 × 38″. Collection Mr. and Mrs. Louis D. Cohen, Great Neck, N.Y.* ▶

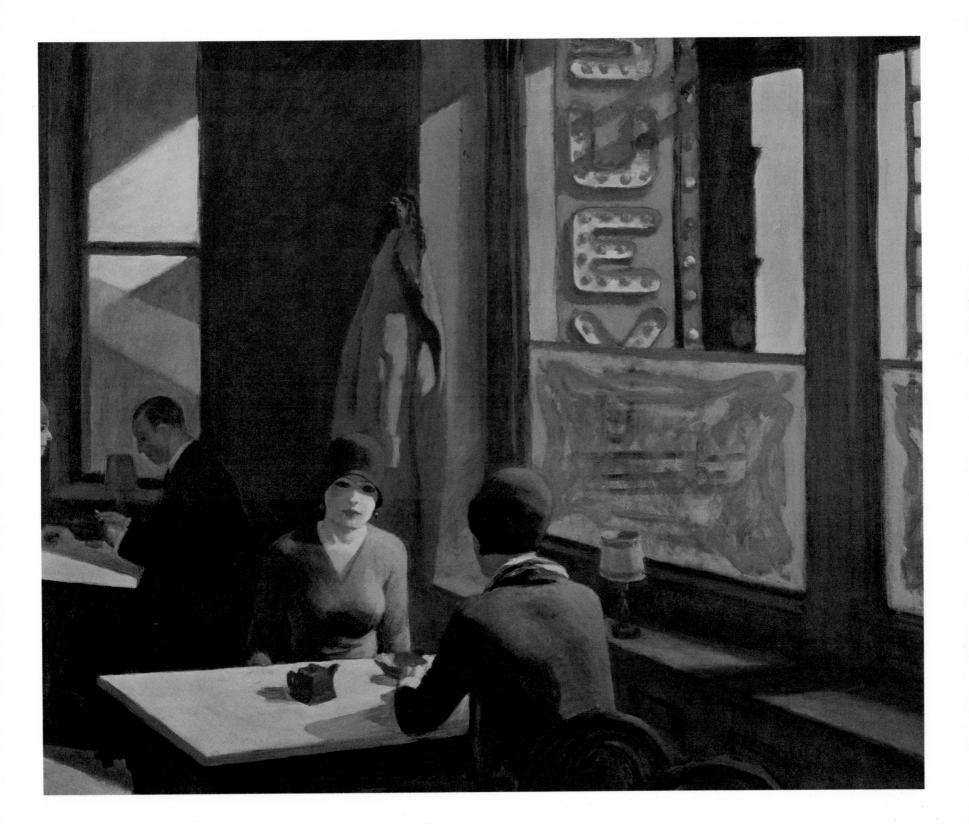

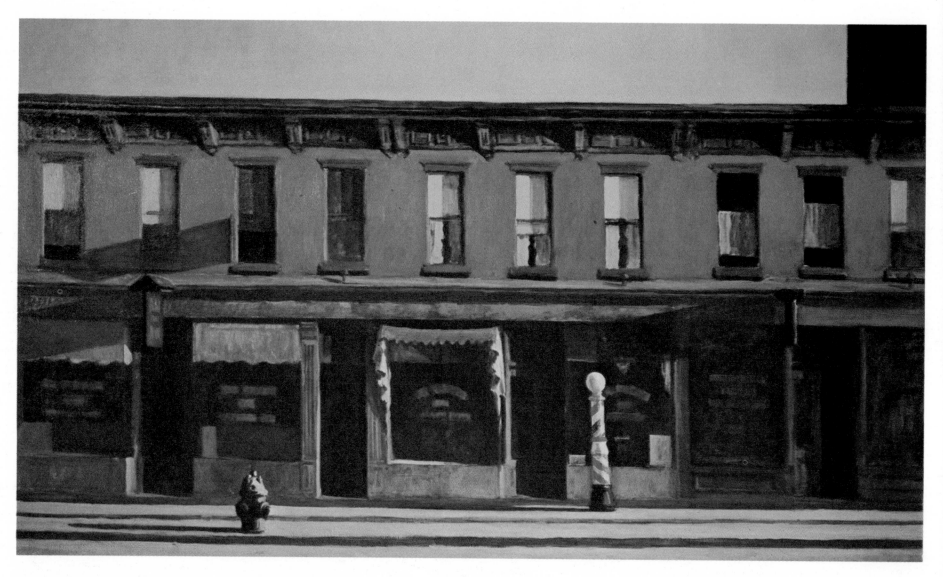

EARLY SUNDAY MORNING. *1930. Oil, 35 × 60" Whitney Museum of American Art, New York City*

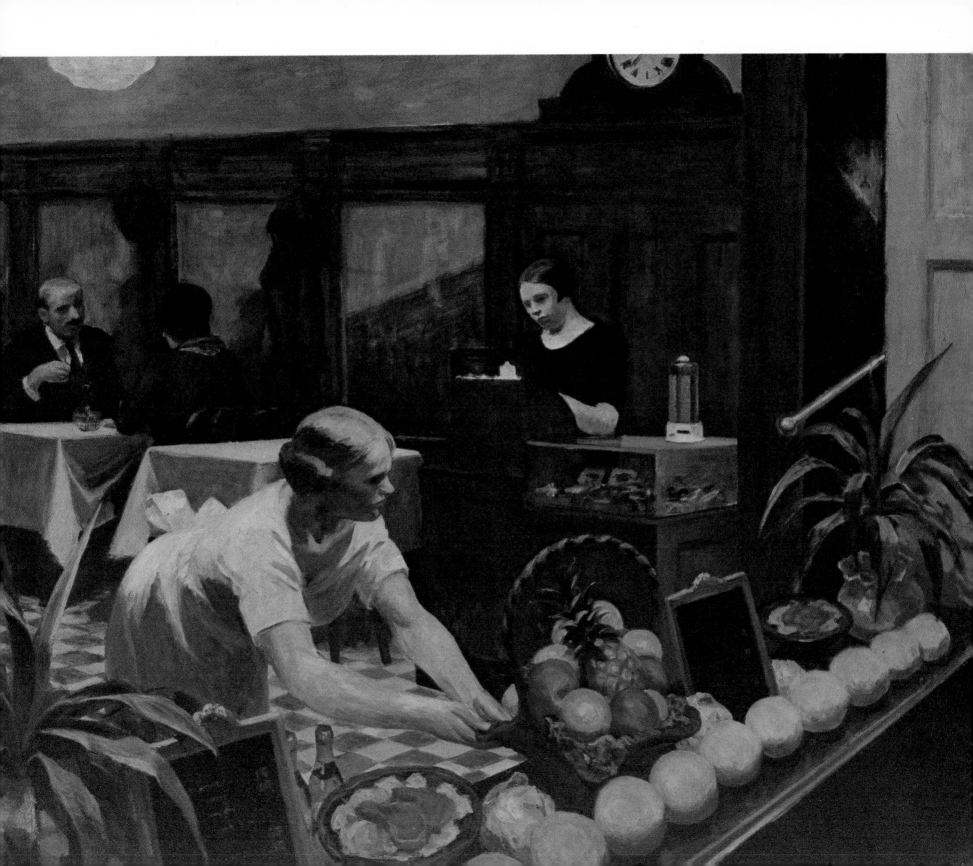

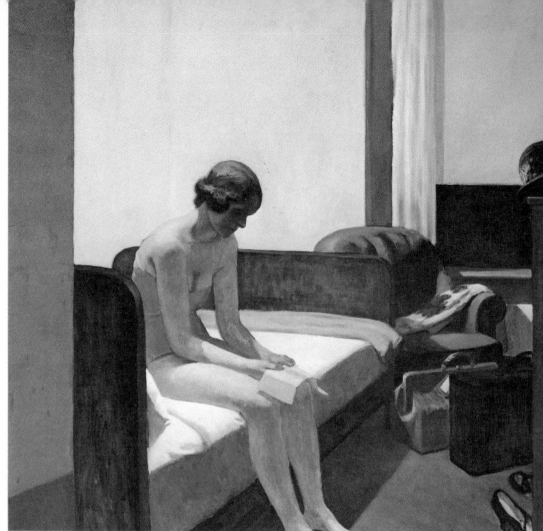

HOTEL ROOM *1931. Oil, 60 × 65″ Nate B. and Frances Spingold Collection*

AUGUST IN THE CITY. *1945. Oil, 23 × 30″.* ▶
Norton Gallery and School of Art, West Palm Beach, Fla.

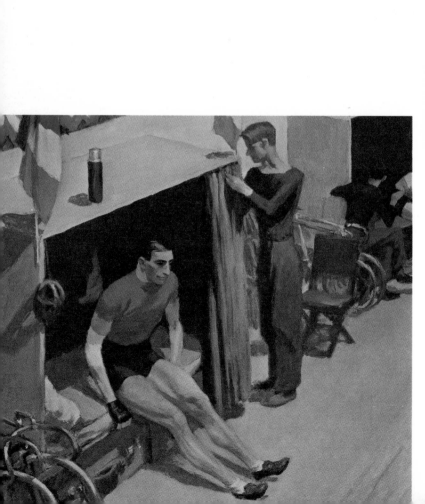

FRENCH SIX-DAY BICYCLE RIDER
1937. Oil, 17 × 19″
Collection Mr. and Mrs. Albert Hackett,
New York City

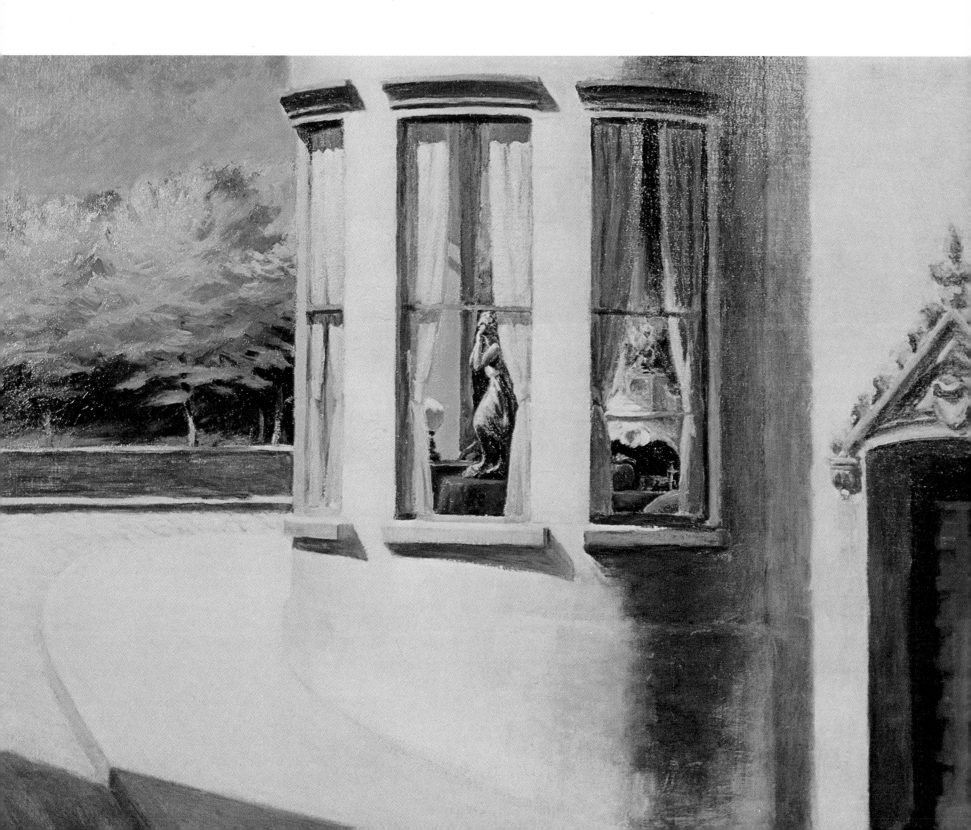

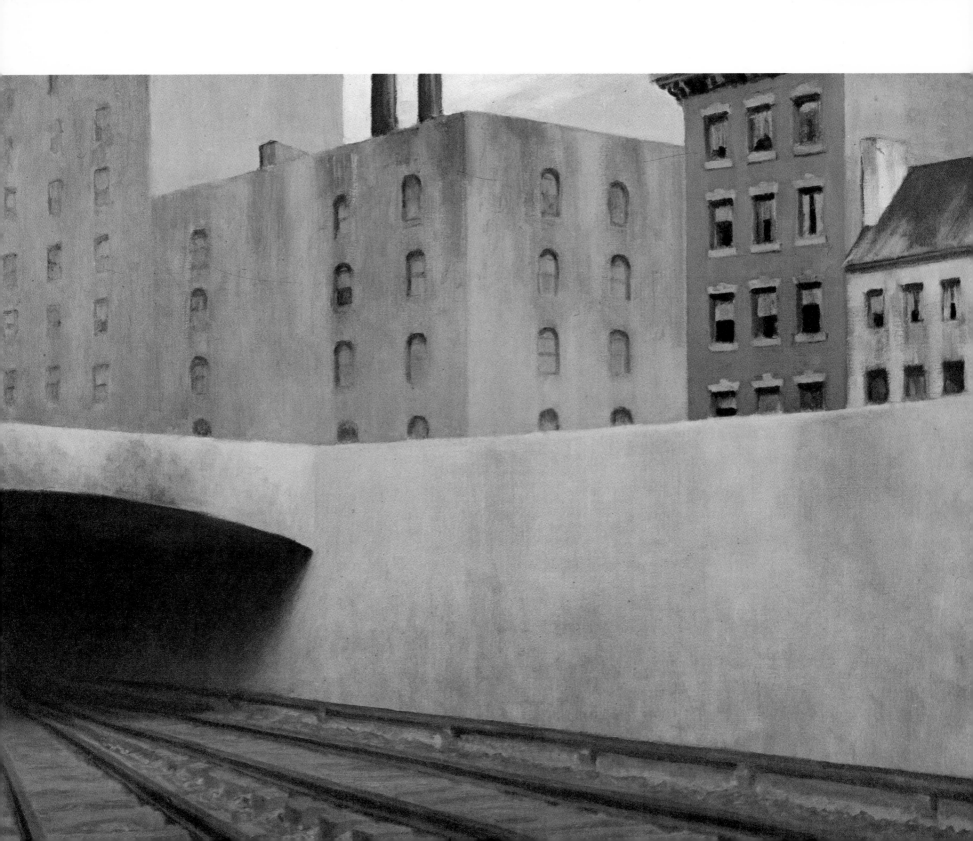

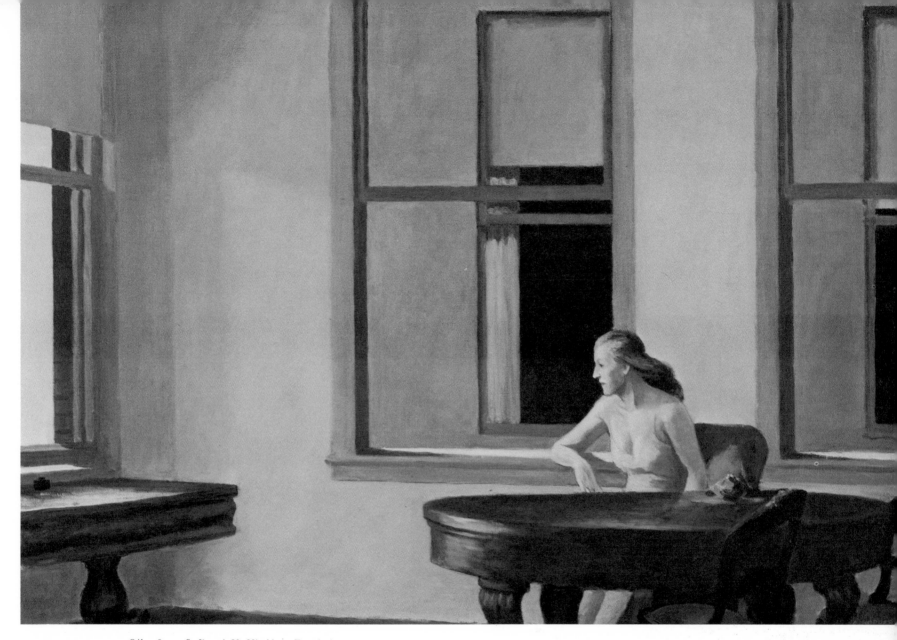

CITY SUNLIGHT. *1954. Oil, 28 × 40″. Joseph H. Hirshhorn Foundation*

◄ APPROACHING A CITY. *1946. Oil, 27 × 36″. The Phillips Collection, Washington, D.C.*

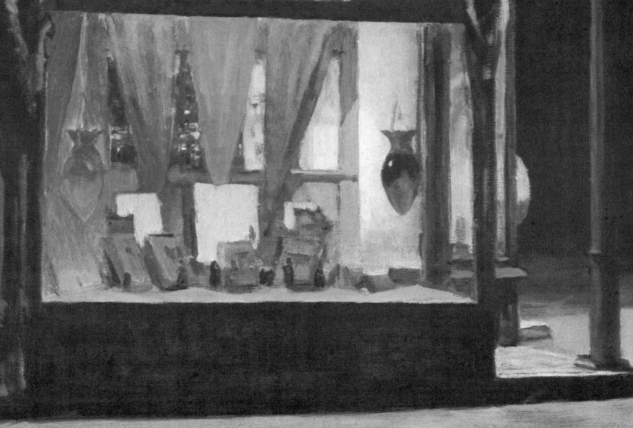

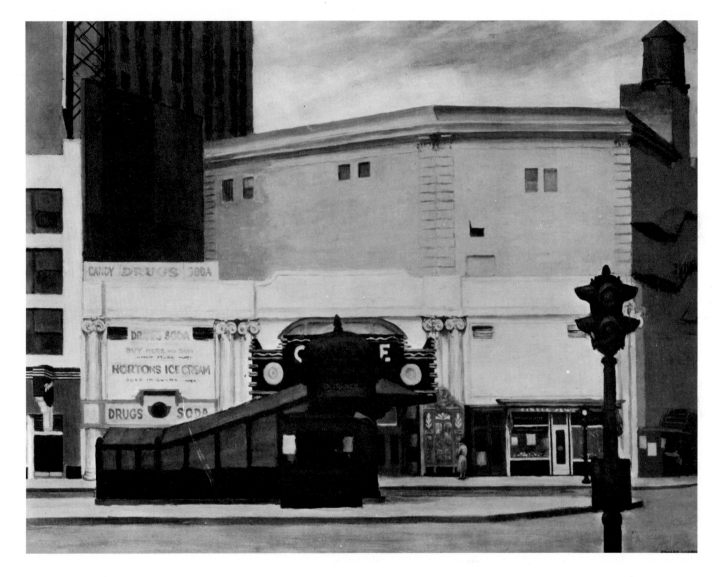

THE CIRCLE THEATRE. *1936. Oil, 27 × 36″ Collection Mr. and Mrs. Charles F. Stein, Jr., Baltimore, Md.*

DRUG STORE. *1927. Oil, 29 × 40″. Museum of Fine Arts, Boston, Mass. John T. Spaulding Collection*

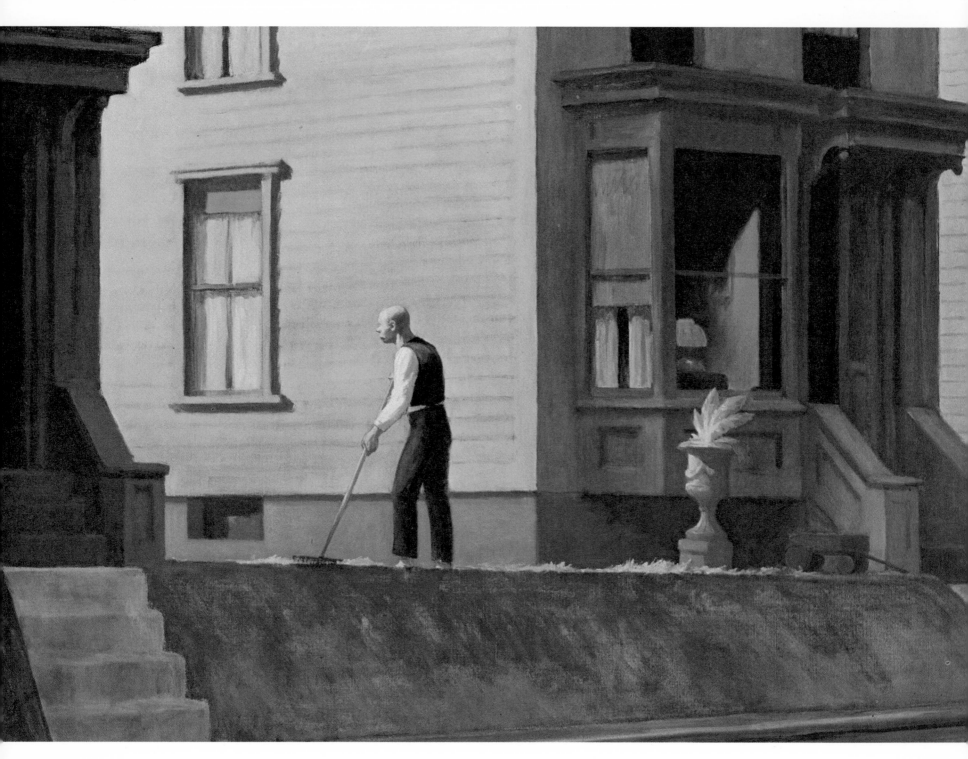

PENNSYLVANIA COAL TOWN. *1947. Oil, 28×40" The Butler Institute of American Art, Youngstown, Ohio*

LIGHT

Light plays an essential role in Hopper's paintings. Whether outdoor or indoor, natural or artificial, its exact nature, its source, direction, and color are as fully realized as the objects on which it falls. It is an active element in the pictorial concept. It reveals the character of buildings, their color and surfaces. Sunlight on the city's stone and concrete structures simplifies them, turns them into massive monoliths, casts heavy shadows that have a somber, brooding effect. By creating definite patterns of light and shade, it acts as an integral element of design. In *Pennsylvania Coal Town* the alternation of lighted and shadowed planes produces a powerful repeated pattern, and is a dominating motif. But light is never allowed to break up forms, as with the impressionists; rather, it defines and models them. Falling on his figures, it reveals and at the same time isolates them. In *Morning in a City* the clear, cool light from outdoors on the naked girl intensifies her isolation.

In his night scenes light becomes a principal actor. In *Drug Store* he has taken one of the city's commonest sights, a lighted store window, and by realizing the pictorial effectiveness of varicolored lights seen against darkness, has produced a feeling of romantic excitement, almost of glamor. In *Nighthawks* the lunch counter is an oasis of light in the midnight city; strong light falls on the interior and its four occupants, separating them from the outside world; out there, the subdued light of an unseen street lamp shows dark, empty stores. In the play of these two lights against surrounding darkness lies much of the painting's impact. In *Office at Night* the situation is reversed; a cool overhead light pervades the room, while a warm secondary light comes through the window from a street lamp; as in *Nighthawks*, the actors are alone in a darkened city. In all these night scenes it is the interplay of lights from various sources and in varied colors and intensities that creates pictorial drama.

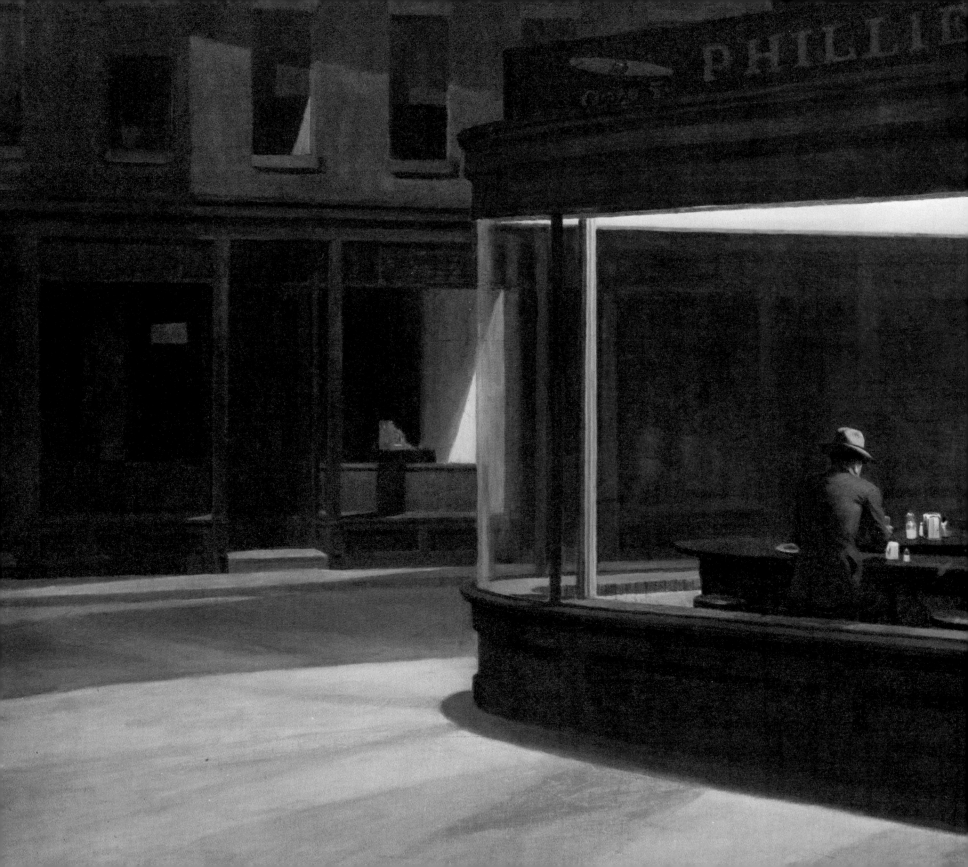

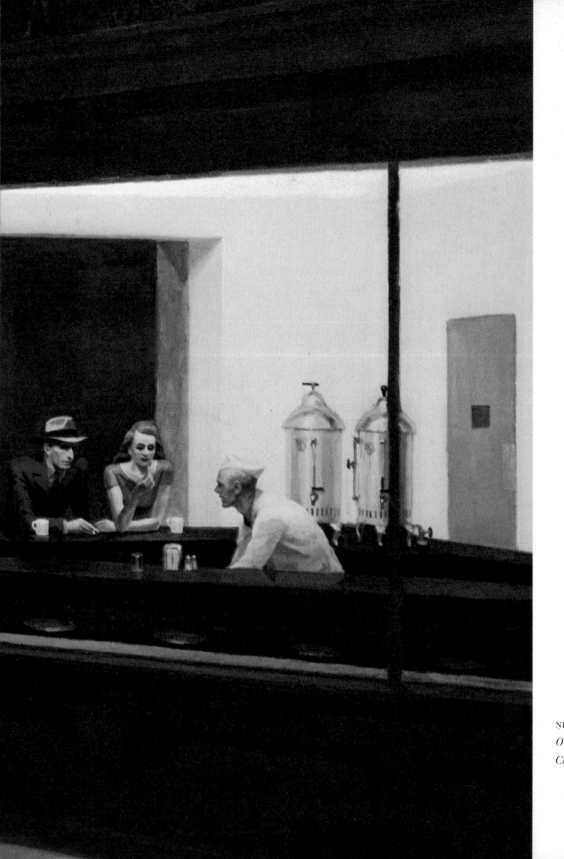

NIGHTHAWKS. *1942*
Oil, 33 1/4 × 60 1/8". The Art Institute of Chicago,
Chicago, Ill. Friends of American Art Collection

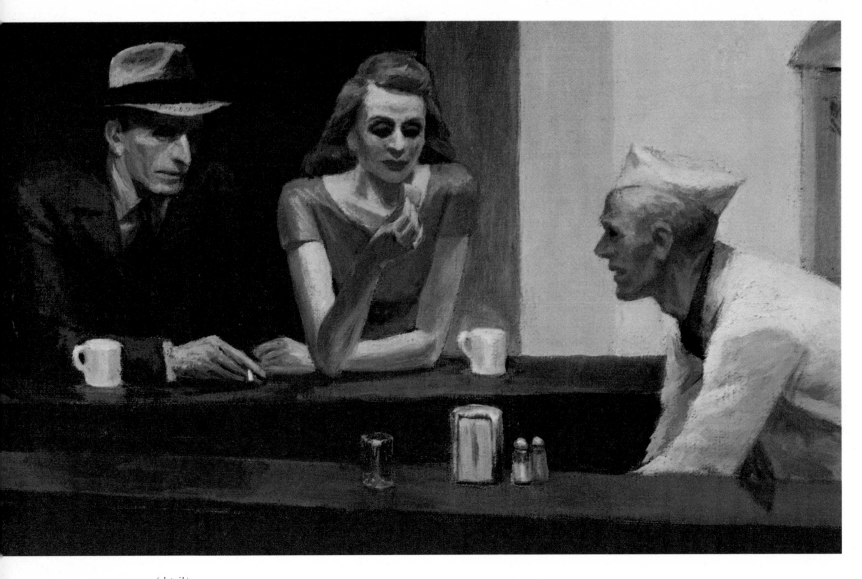

NIGHTHAWKS *(detail)*

MORNING IN A CITY. *1944. Oil, 44 × 60″. Collection Mr. and Mrs. Lawrence H. Bloedel, Williamstown, Mass.* ▶

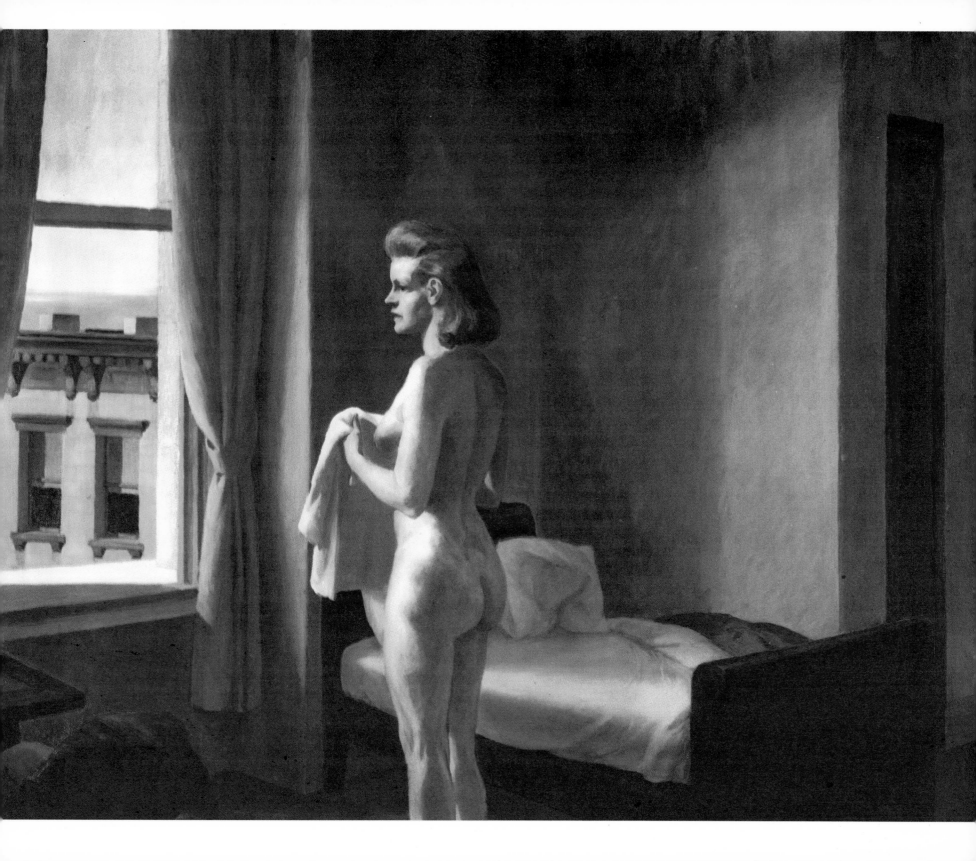

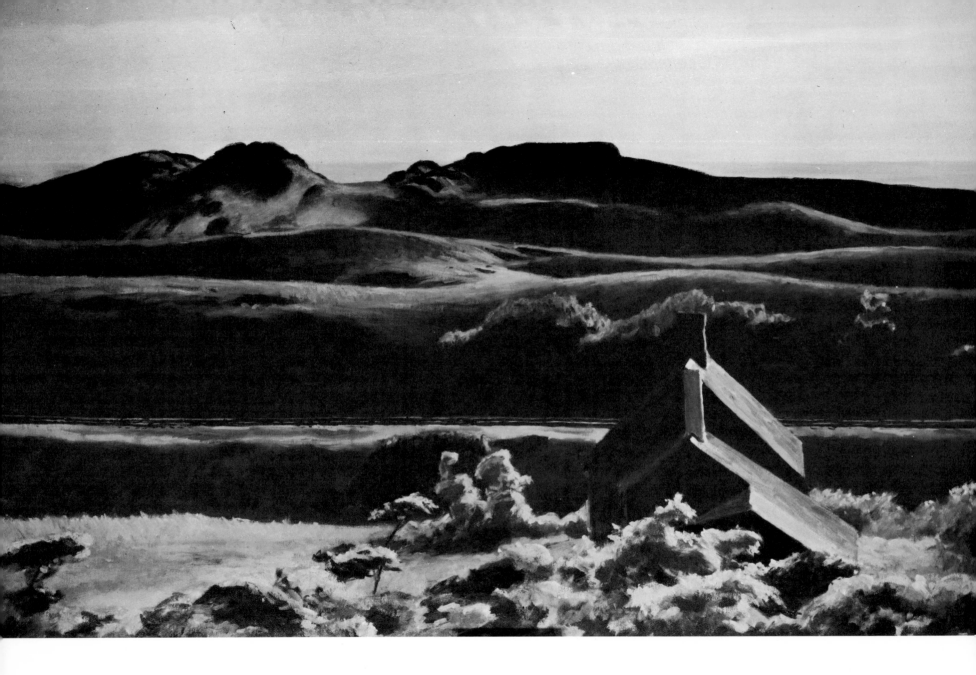

HILLS, SOUTH TRURO. *1930. Oil, 27 3/8 × 43 1/8". The Cleveland Museum of Art, Cleveland, Ohio. Hinman B. Hurlbut Collection*

THE COUNTRY

HOPPER PAINTED THE DEEP COUNTRY as much as the city and town. From the first his landscapes broke with the American tradition of picturing idyllic nature and avoiding the works of man. Those prominent features of our land, the railroad and the automobile highway, with their accompanying bridges, freight yards, depots, telephone poles, and gas stations, were essential elements in his work. To him they did not detract from the pictorial value of the country, but enhanced it. He liked the relationship between nature and the functional forms of man-made things—the straight lines of railway tracks, the sweeping curves of highways, the sharp angles of buildings, the immaculate forms of lighthouses. In two Cape Cod landscapes, *New York, New Haven and Hartford* and *Hills, South Truro*, the long rolling moors, like great waves, are given added value by the line of tracks cutting across them. In his three paintings of Two Lights in Maine the clean-cut white buildings, rising to a climax in the powerful upright of the lighthouse, seem to grow out of the long folds of the earth like natural features of this rugged landscape. His acceptance of these man-built actualities that give the American land its character, and his creative use of them, were solid contributions to our landscape painting. Here was a masculine landscape art instead of the feminine one of his immediate predecessors.

No one before had painted that most familiar of American phenomena, the automobile highway, with such accuracy and feeling. The simplest of everyday subjects, an empty Cape Cod road running flatly past a grove of pines, its surface dusted with windblown sand, becomes a poignant expression of what its title indicates, *Solitude*. In *Gas* a filling station on a country road with darkness coming on, its illuminated red pumps bright against dark woods and cold evening sky, embodies all the loneliness of the traveler at nightfall.

In pure landscape he preferred country where the structure of the earth was visible—the granite-strewn pastures of Cape Ann, the fantastic formations of the Cape Cod dunes, the abrupt green hills of Vermont. The strength and inexhaustible richness of nature's forms meant more to him than her evanescent appearances. In these qualities his landscapes recall another realist, older than impressionism—Gustave Courbet.

Light is again a major factor in Hopper's landscapes. Whereas the American impressionists had imported the soft air and light of France, he liked the strong sunlight, clear air, and high, cool skies of the American Northeast. ("He told me the other day," wrote Guy du Bois in 1931, "that it had taken him years to bring himself into the painting of a cloud in the sky.") Where the impressionists had dissolved objects in luminous haze, with him everything was seen with complete clarity. He liked the blazing sun of summer noon, projecting sharp patterns of light and shadow; or again, the clear raking sunlight of early morning or late afternoon, striking one side of objects and leaving the other in deep shadow—a light that models forms roundly and produces a dramatic play of light and shade. In his landscapes movement is created by light more than by the forms themselves. Light streams into the picture, falls on its motionless forms, becomes a dynamic element in the whole pictorial concept.

The exact visual sensations of materials under specific lights and weathers absorbed him. His pictures sometimes seem to convey a sense of actual heat—the burning force of midsummer sunlight on white-painted wood or macadam roads, or on broiling city pavements.

Hopper wrote in 1933: "My aim in painting has always been the most exact transcription possible of my most intimate impressions of nature." From the very first his relation to visual reality was unusually direct. He painted by eye more than by secondhand precepts. The outworn recipes of impressionism were discarded in favor of the direct visual impact of nature. This visual naturalism led him to paint aspects of the real world that a more conventional artist would consider non-artistic. Sometimes he painted things as if no one had ever painted them before. His firsthand observation produced effects that were startling at first. In *Ground Swell* the prevailing cold pale blues are a tonality that the average marine specialist would avoid, but that are very true to the color of the open sea; and the long regular rollers, as weighty as if cast in concrete, the unbroken horizon and cold wide sky, give an immediate sense of the immensity and solitude of the ocean. Such a work has the innocent vision of a primitive painter; and Hopper did have an element of primitivism, as any artist must who was so much on his own.

His color sense was highly personal. Color as decoration or sensuous language or emotional expression did not interest him. He himself said he was "no colorist"—a characteristic piece of self-depreciation. Actually, color is fundamental in his work. Everything is seen in chromatic terms. Based on the direct sensation of the eye, his color has a pristine force. Instead of the delicate pinks, violets, and mauves of impressionism, it is strong and full-bodied, ranging down to deep tones that had been banished from the impressionist palette.

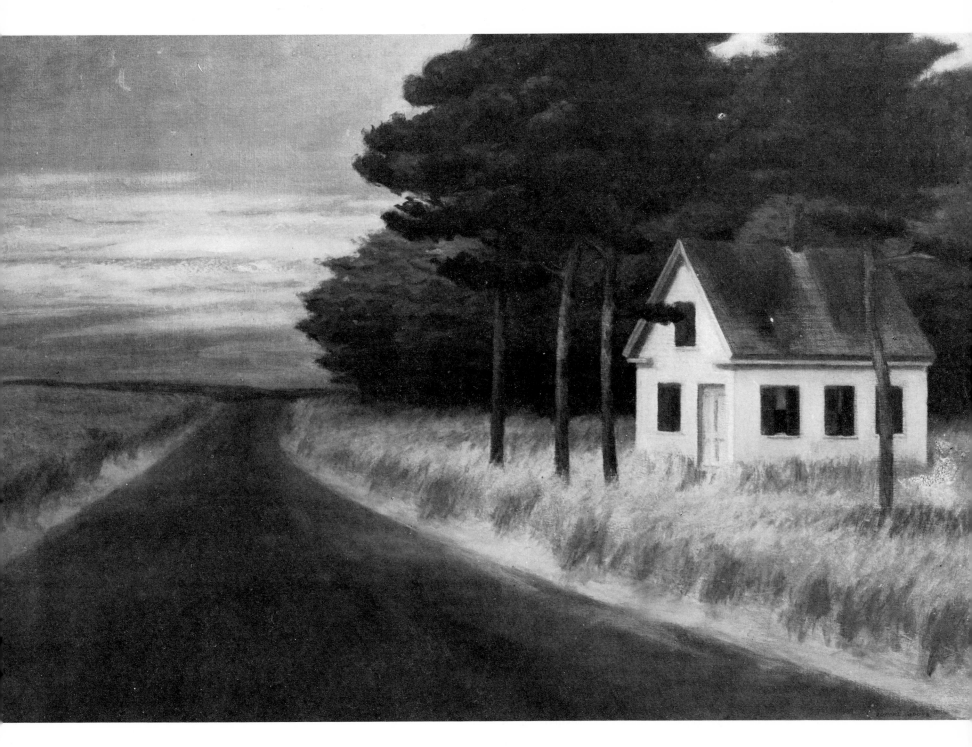

SOLITUDE. *1944. Oil, 32×50″ Collection Mr. and Mrs. Louis D. Cohen, Great Neck, N.Y.*

Especially noticeable in his outdoor scenes is the use of cool colors in a wide range of vivid greens and blues and blue-greens. There are acid notes that may set a conventional observer's teeth on edge, but the total effect is rich and alive. In some pictures, color contrasts are pushed to a maximum; in *Nighthawks* the garish colors of the interior are juxtaposed to the equally strong dark notes of the exterior; there are hardly any grays; almost all the colors are positive. The result is arresting—a spectrum-like range that could be gaudy, but is both vital and balanced. One feels that here is a painting that will mellow with age.

The scale of values, unlike that of impressionism, ranges from white to the near-blacks of shadows, even in his landscapes. In this Hopper was reverting to the pre-impressionist tonality of Courbet, Homer, and Eakins. Since his pictures are constructed in values as much as in color, they do not lose their structure in black-and-white reproduction, as much modern painting does.

Beyond these purely visual factors is the sum of them all—the mood of the place and hour. The hills of Cape Cod on an autumn afternoon, when the low sunlight and crystalline air are filled with a sense of silence and waiting. A Yankee couple outside their neat white house in the twilight, when the woods are growing dark and their dog is listening to evening voices. A railroad platform under an arc lamp, grim gray factories against a cold night sky, with the first signs of a cold bleak dawn. A dreary city room which bright sunlight makes drearier, bare uncurtained windows looking out on monotonous brick houses and an empty sky—a haunting conviction that one has been there, that this is not just *a* room in Brooklyn but *the* room. In conveying exactly the special qualities of these places at these times, his art combines uncompromising realism and poetic emotion. His poetry never becomes sentimental; it has too direct a relation to actualities. Where a sentimentalist would make such subjects banal, with him they are fresh and genuine. Banality, indeed, is inherent in much of his subject-matter; but the intensity of his feeling for the everyday and familiar transformed banality into authentic poetry. As he wrote of Burchfield, "he is one of those who, in each generation, naturally and honestly liberate their subjects from the taboos of their time."

NEW YORK, NEW HAVEN AND HARTFORD *1931. Oil, 32×50″ The Indianapolis Museum of Art, Indianapolis, Ind.*

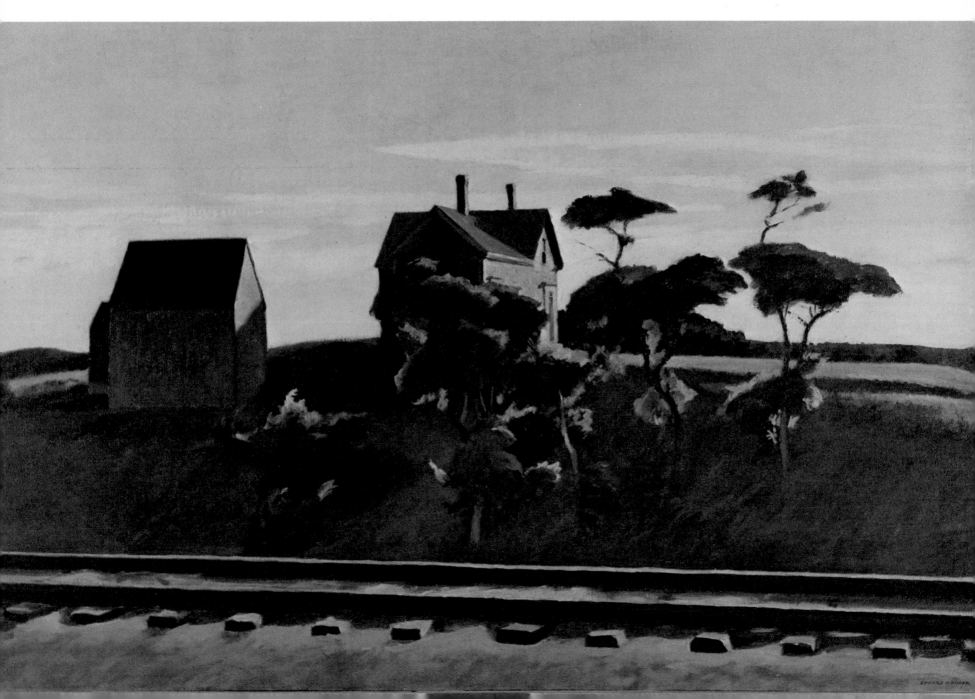

NEW YORK, NEW HAVEN AND HARTFORD *1931. Oil, 32×50″ The Indianapolis Museum of Art, Indianapolis, Ind.*

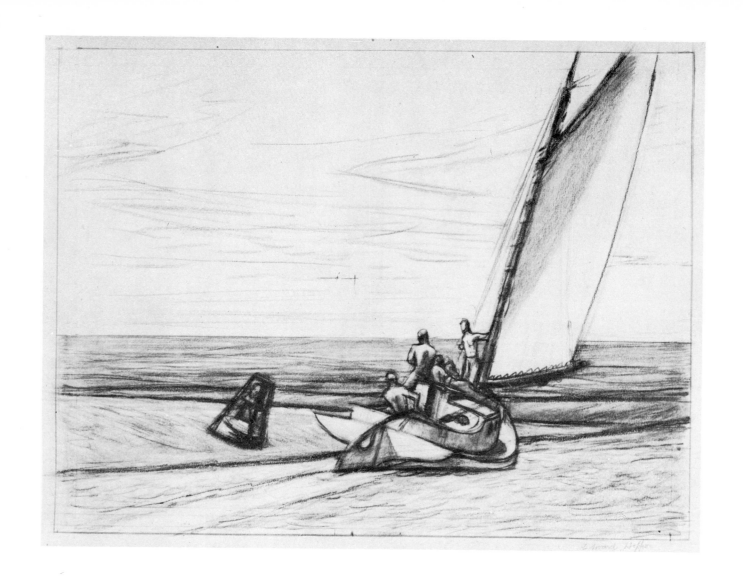

Study for painting "GROUND SWELL" *1939. Black conté crayon, 13 1/2 × 22" Whitney Museum of American Art, New York City Bequest of Mrs. Edward Hopper*

GROUND SWELL *1939. Oil, 36 1/2 × 50 1/4" The Corcoran Gallery of Art, Washington, D.C.* ▶

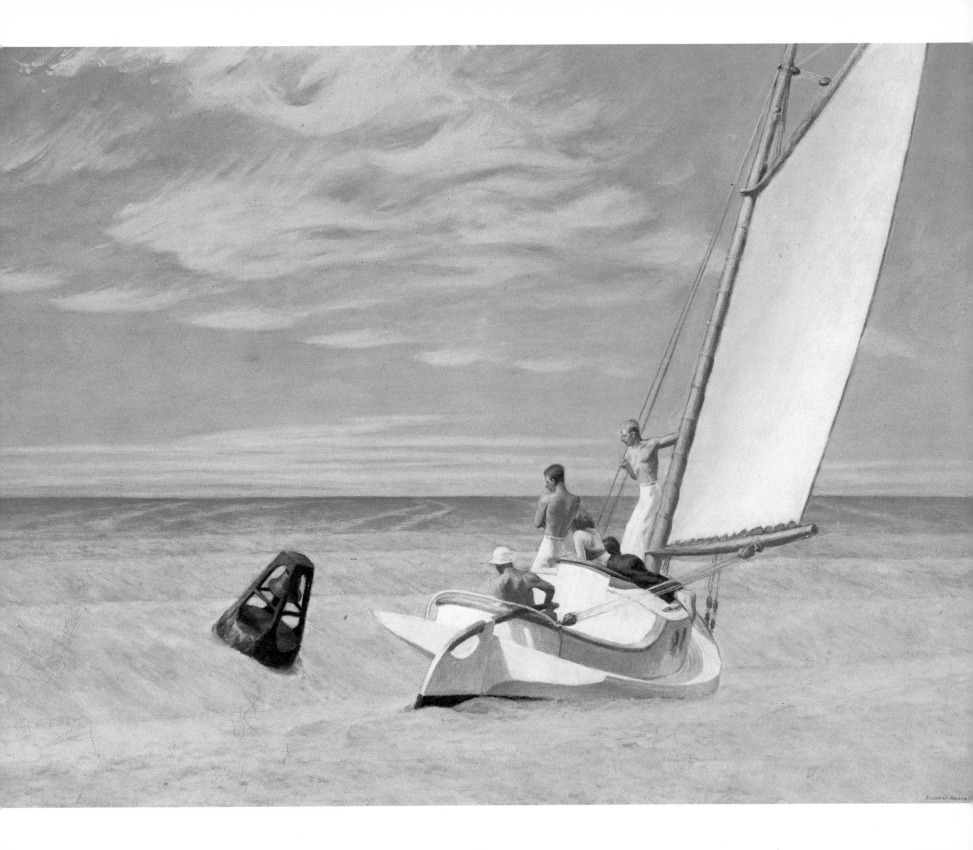

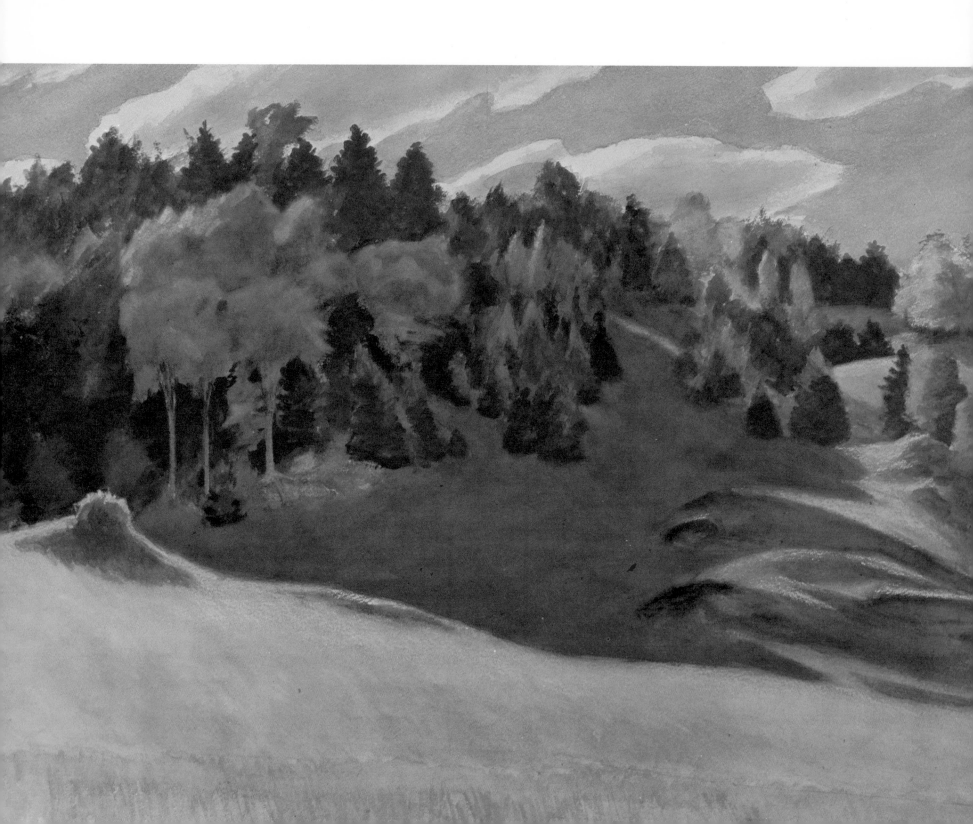

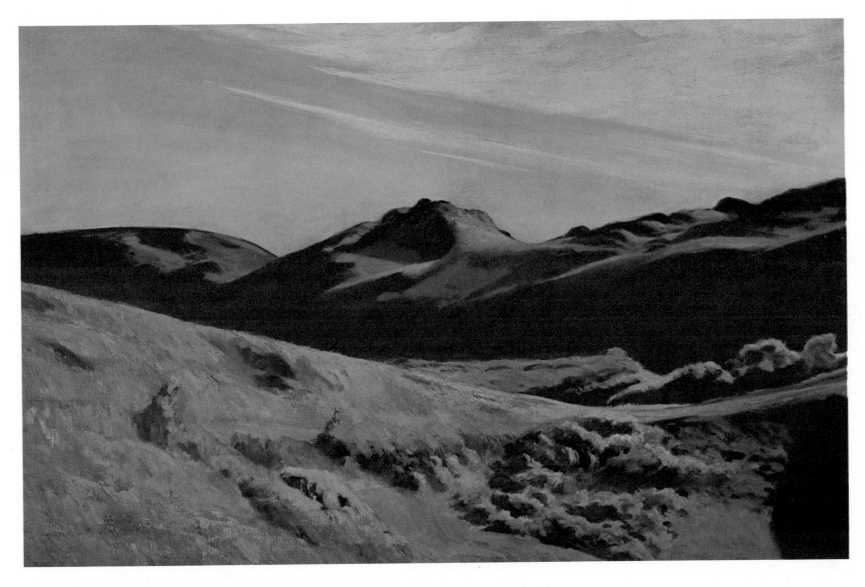

THE CAMEL'S HUMP *1931. Oil, 32 1/4 × 50 1/8″ Munson-Williams-Proctor Institute, Utica, N.Y. Edward W. Root Bequest*

◄ VERMONT HILLSIDE. *1936. Watercolor, 20 1/8 × 27 7/8″. Collection Mr. and Mrs. Lloyd Goodrich, New York City*

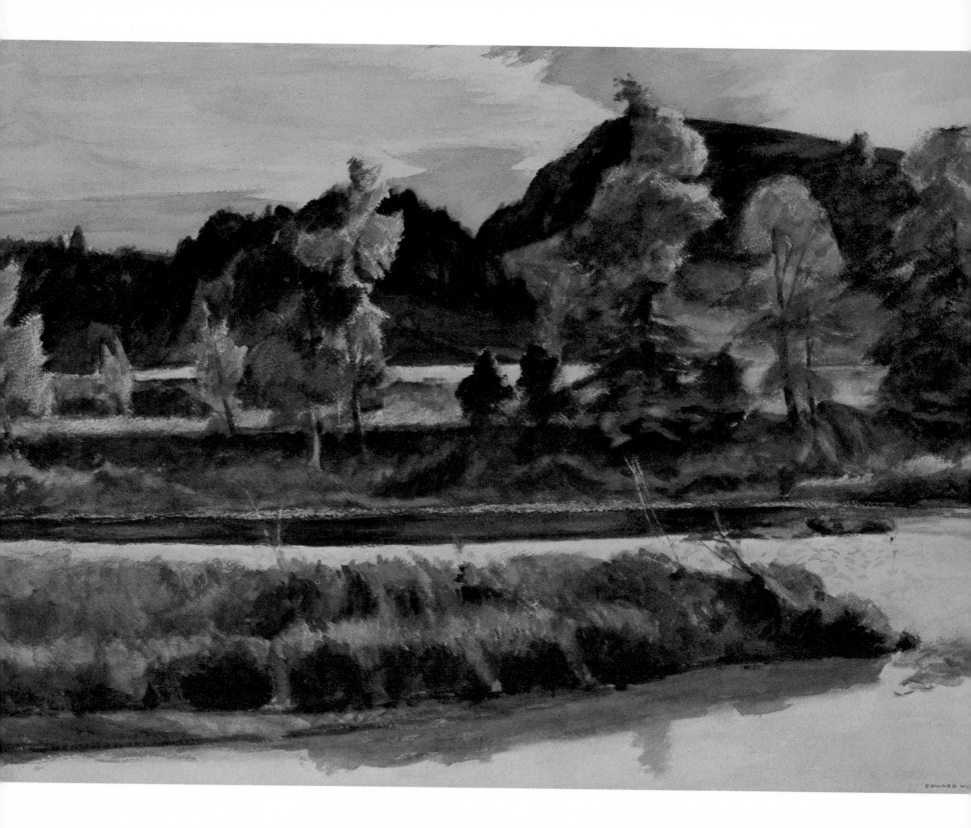

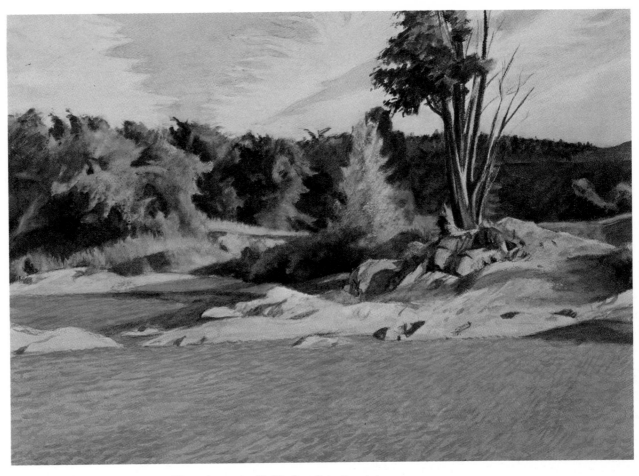

WHITE RIVER AT SHARON. *1937. Watercolor, 20 × 28″. The Sara Roby Foundation*

◀ WHITE RIVER AT ROYALTON. *1937. Watercolor, 20 × 28″. Collection Dr. Allister M. McLellan, Pelham, N.Y.*

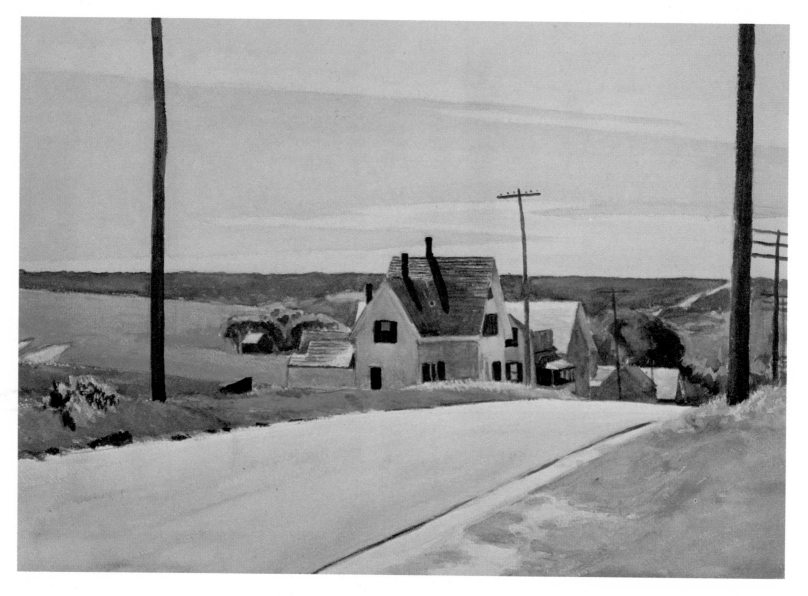

ROAD AND HOUSES, CAPE COD. *Probably about 1940. Watercolor, 20 × 27 7/8". Whitney Museum of American Art, New York City. Bequest of Mrs. Edward Hopper*

SHOSHONE CLIFFS. *1941. Watercolor, 20 × 25". The Butler Institute of American Art, Youngstown, Ohio* ▶

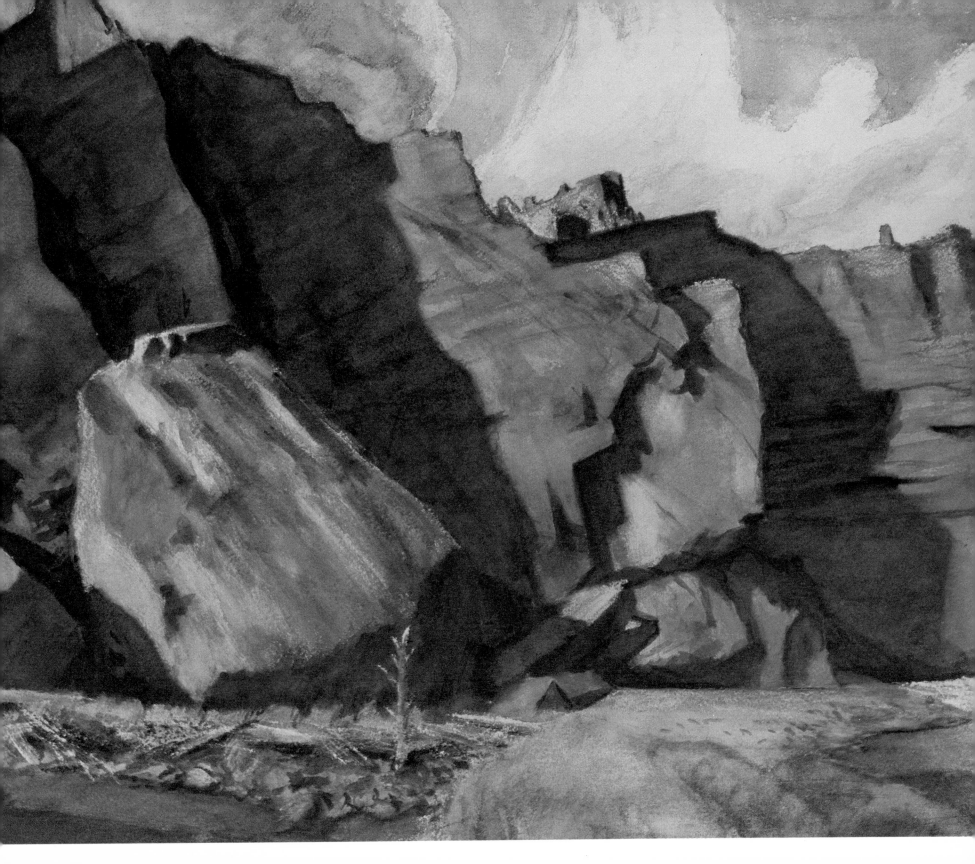

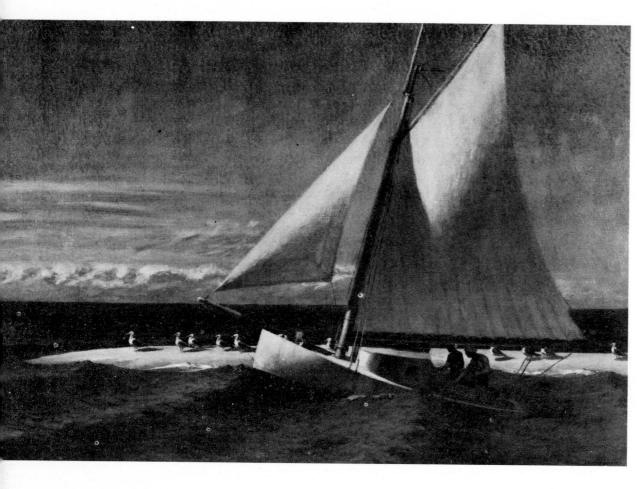

THE MARTHA MCKEAN OF WELLFLEET. *1944. Oil, 32×50″. Collection Mr. and Mrs. Harold Harris, Ellenville, N.Y.*

THE LEE SHORE. *1941. Oil, 28 1/4×43″ The Sara Roby Foundation*

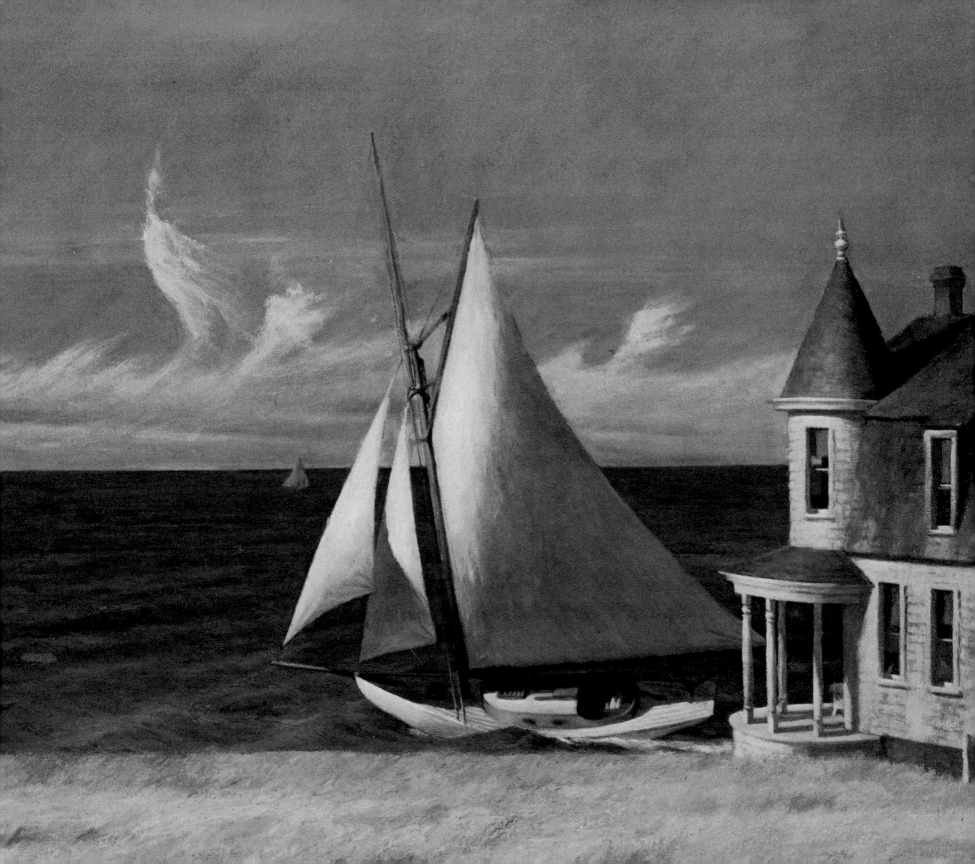

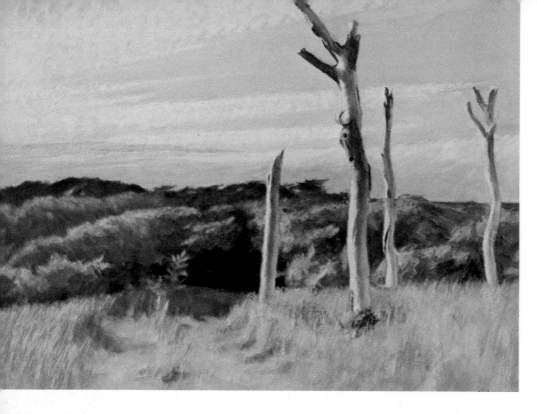

FOUR DEAD TREES.
1942. Watercolor, 20 × 28".
Private collection, Andover, Mass.

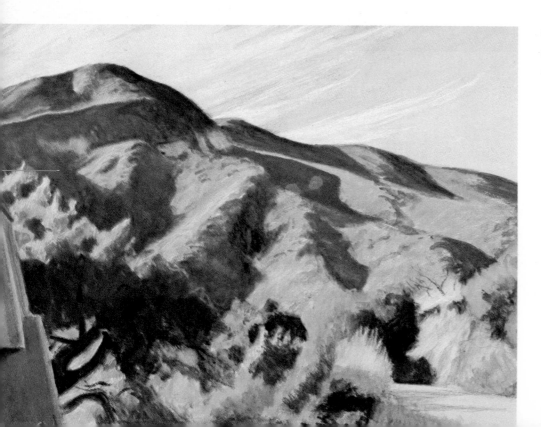

CALIFORNIA HILLS.
1957. Watercolor, 21 1/2 × 29 1/4".
Hallmark Cards Collection, Kansas City, Mo.

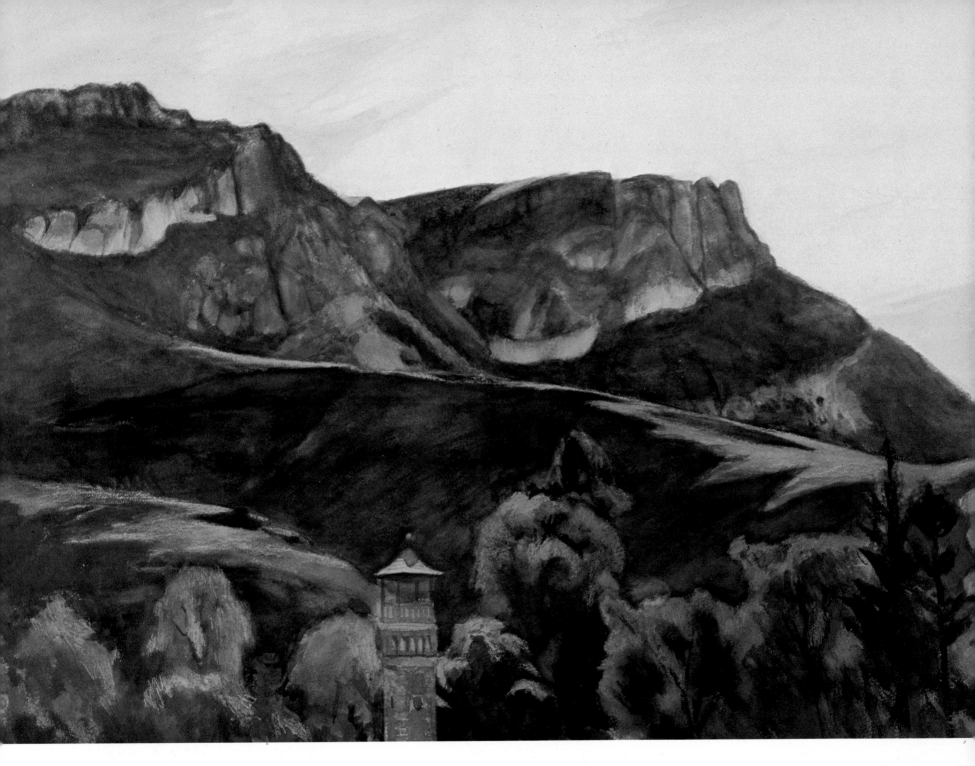

MOUNTAINS AT GUANAJUATO. *1953/4. Watercolor, 21 × 29″. Yale University Art Gallery, New Haven, Conn. Bequest of Stephen Carlton Clark*

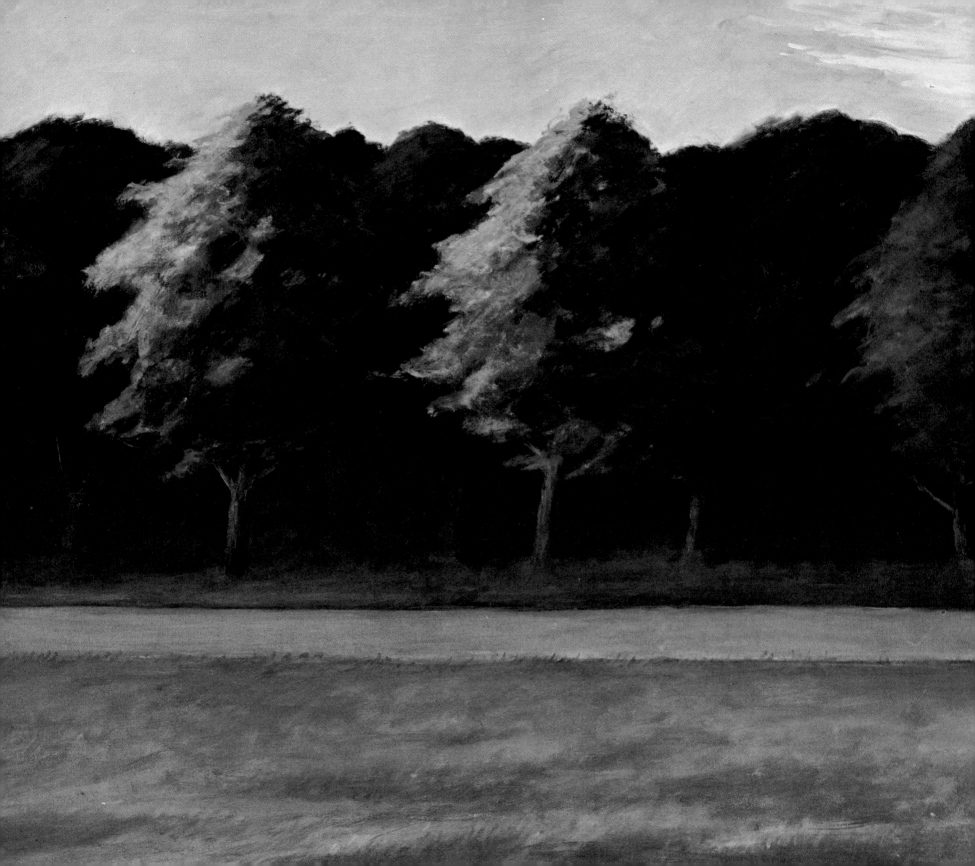

ROAD AND TREES. *1962. Oil, 34×60" Collection Mr. and Mrs. Daniel Dietrich, Villanova, Pa.*

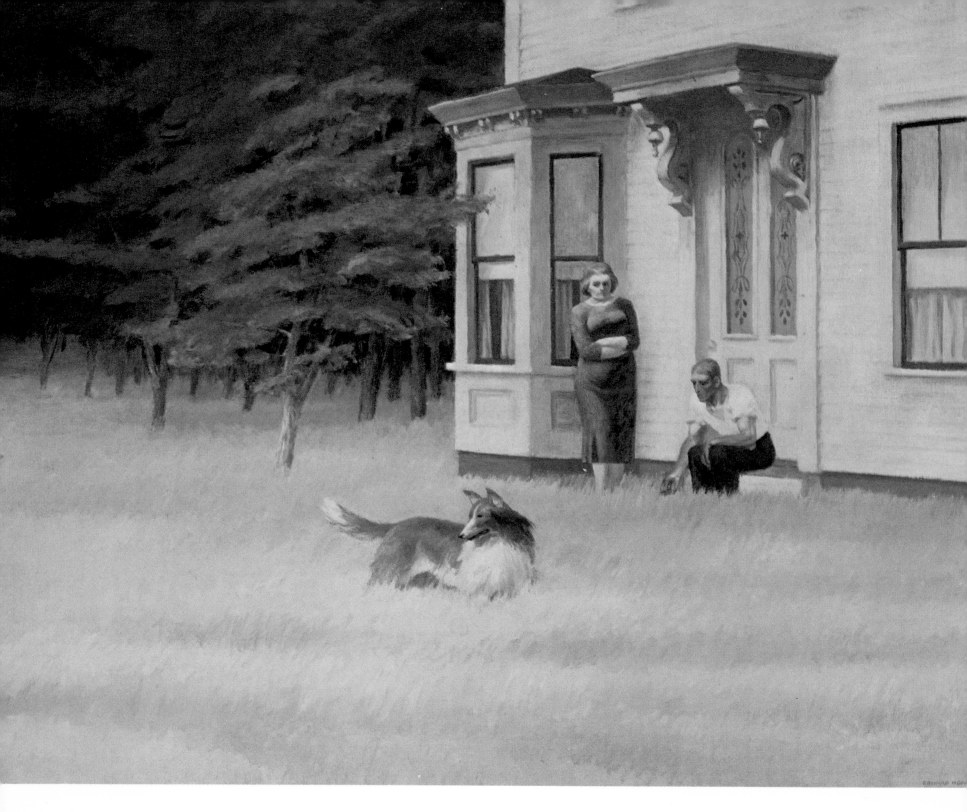

CAPE COD EVENING *1939. Oil, 30×40″ Collection Mr. and Mrs. John Hay Whitney, New York City*

THE PROCESS OF CREATION

HOPPER'S PAINTING METHODS were far from the literal copying of reality. Some of his early oils and almost all his watercolors were painted "from the fact," as he put it. But after his early years his oils were composed by a process of imaginative reconstruction in which both observation and memory played parts. He selected the subject with extreme care, spending a long time looking at actual motifs and pondering them. From these various sources, elements were taken, combined, and transformed into the image that was to be realized on canvas. Of *Cape Cod Evening*, for example, he wrote: "It is no exact transcription of a place, but pieced together from sketches and mental impressions of things in the vicinity. The grove of locust trees was done from sketches of trees nearby. The doorway of the house comes from Orleans about twenty miles from here. The figures were done almost entirely without models, and the dry, blowing grass can be seen from my studio window in the late summer or autumn. In the woman I attempted to get the broad, strong-jawed face and blond hair of a Finnish type of which there are many on the Cape. The man is a dark-haired Yankee. The dog is listening to something, probably a whippoorwill or some evening sound."

To an inquiry about the origin of *Room in New York* he replied: "I'm always at a loss when asked for facts about any of my pictures or to describe how any one of them came to be made. It is so often a very complicated mental process that would not interest people. The idea for 'Room in New York' had been in my mind a long time before I painted it. It was suggested by glimpses of lighted interiors seen as I walked along the city streets at night, probably near the district where I live (Washington Square), although it's no particular street or house, but it is rather a synthesis of many impressions."

In composing *Gas*, he told me, he searched for a filling station like the one he had in mind; not finding it, he made one up out of parts of several—but the pumps were studied from real ones. (In working he frequently referred back to "the fact," he said.) The degree of transformation varied; an occasional picture such as *Rooms for Tourists* was an exact portrait of a real house. (In this case, a house in Provincetown, painted in his studio, with nightly observations from his parked car which aroused the suspicions and fears of the

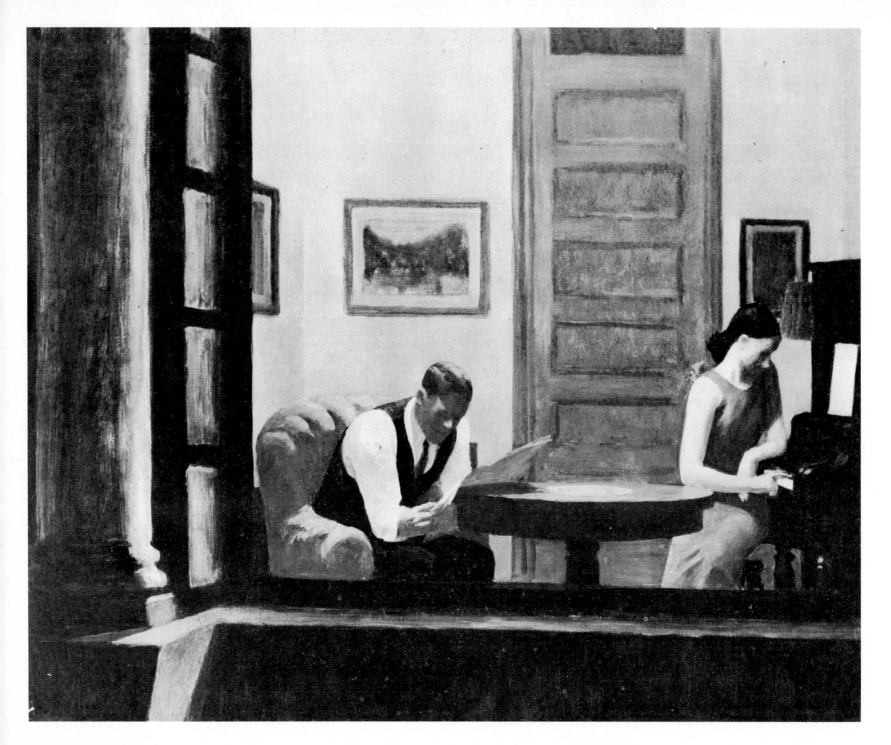

ROOM IN NEW YORK. *1932. Oil, 29 × 36". University of Nebraska Art Galleries, Lincoln, Neb. F. M. Hall Collection*

NEW YORK MOVIE *1939. Oil, 32 1/4 × 40 1/8" The Museum of Modern Art, New York City Anonymous gift* ▶

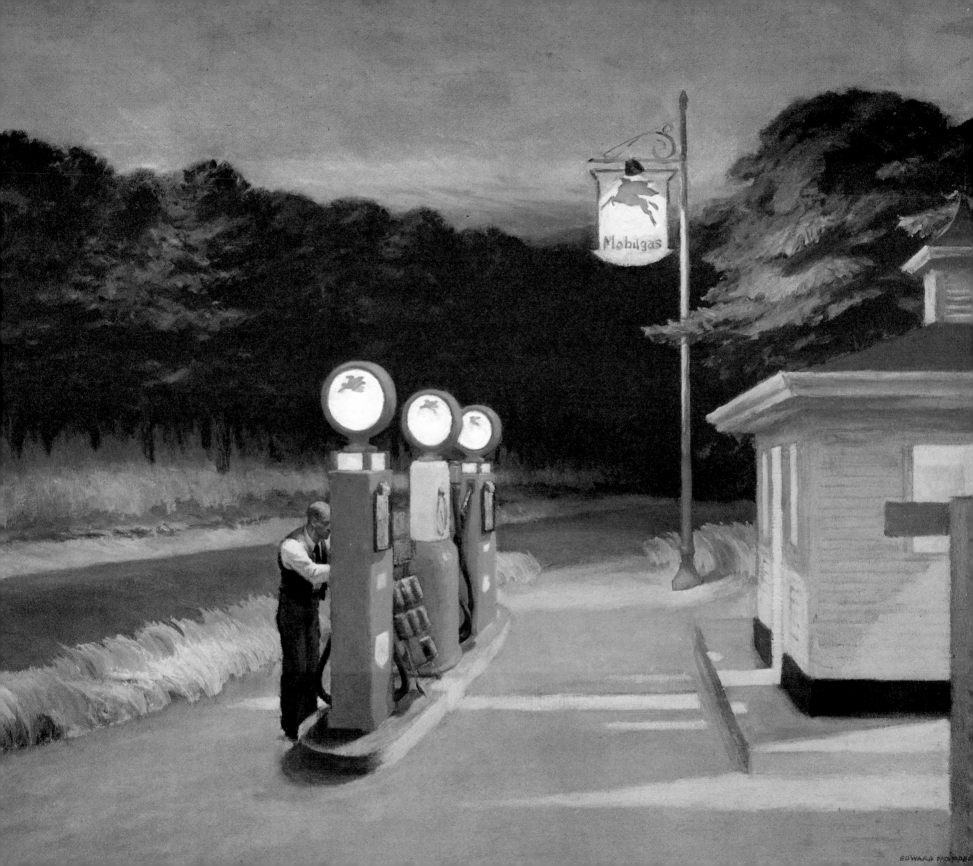

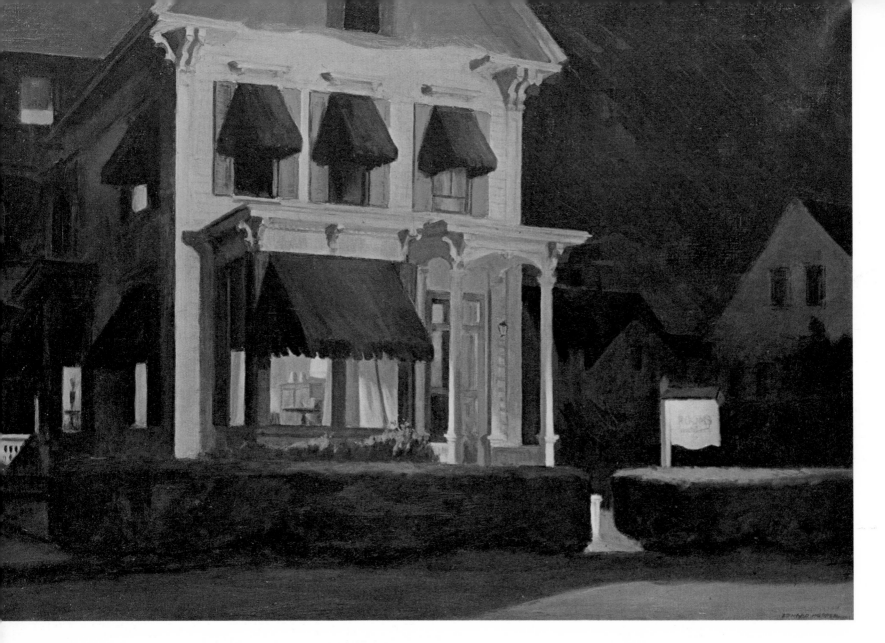

ROOMS FOR TOURISTS. *1945. Oil, 30 × 42″. Yale University Art Gallery, New Haven, Conn. Bequest of Stephen Carlton Clark*

SECOND-STORY SUNLIGHT *1960. Oil, 40 × 50″ Whitney Museum of American Art, New York City Gift of the Friends of the Whitney Museum of American Art, and Purchase* ▶

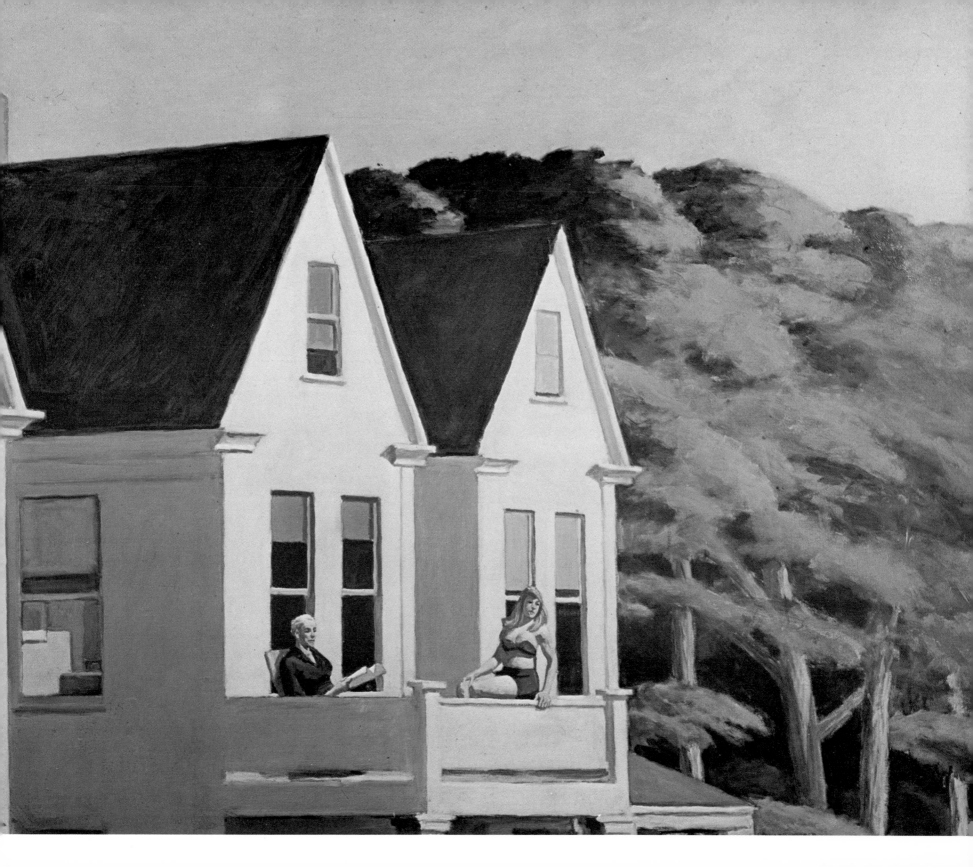

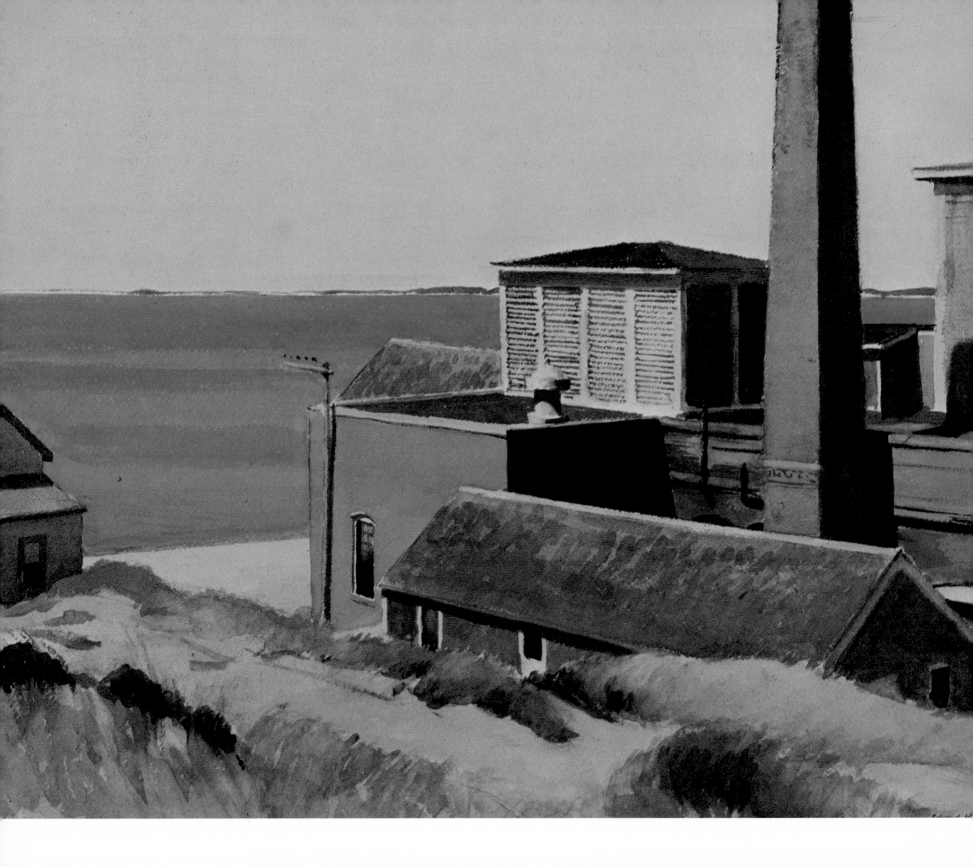

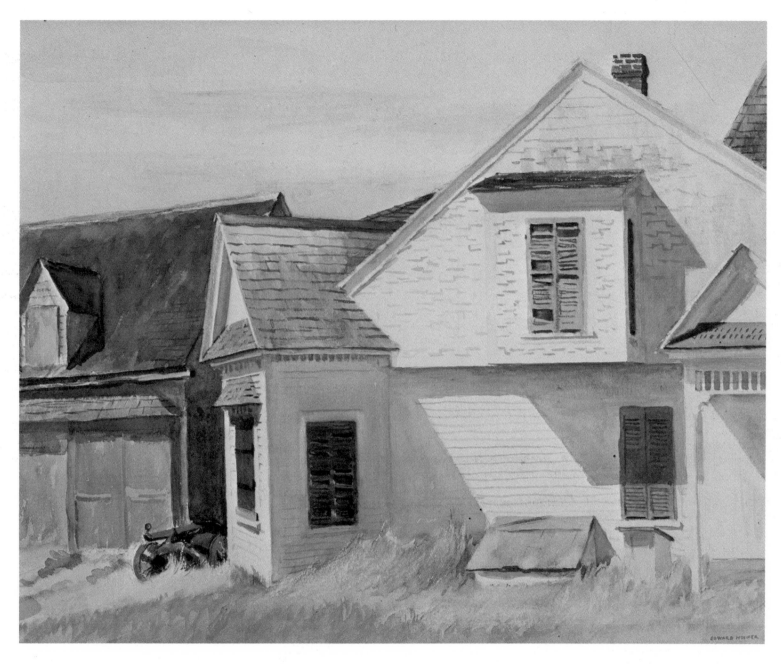

HOUSE ON PAMET RIVER. *1934. Watercolor, 20 × 25″. Whitney Museum of American Art, New York City*

◀ COLD STORAGE PLANT. *1933. Watercolor, 20 × 25″. Fogg Art Museum, Harvard University, Cambridge, Mass. Louise E. Bettens Fund*

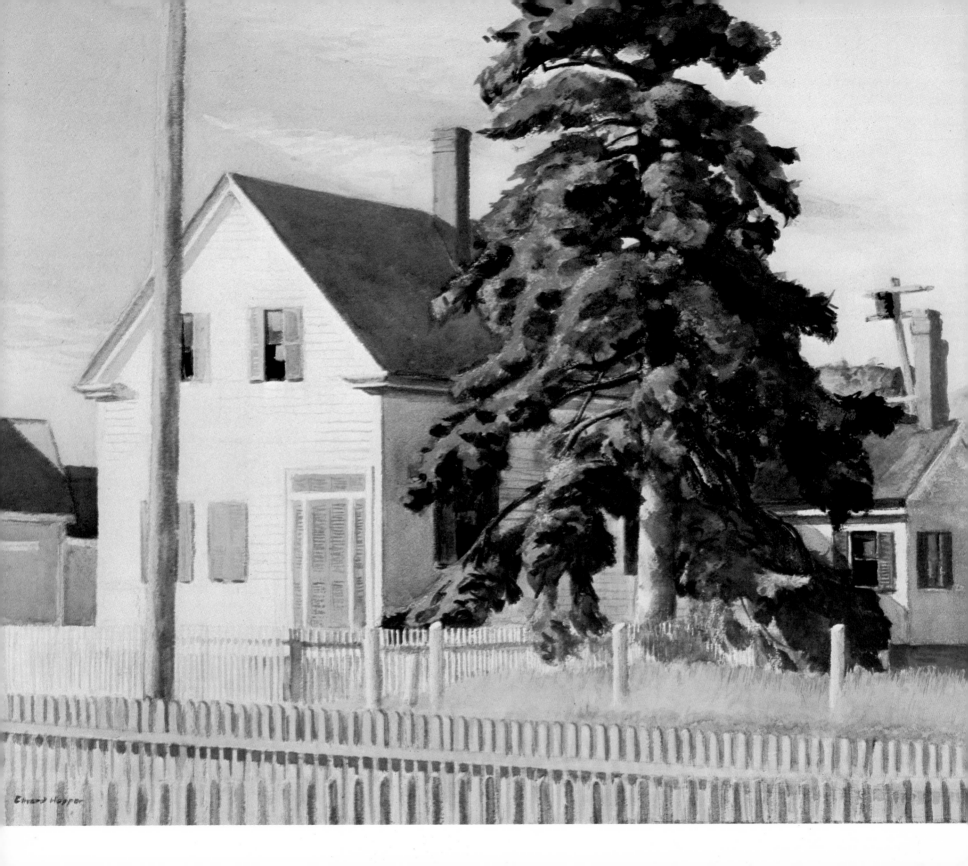

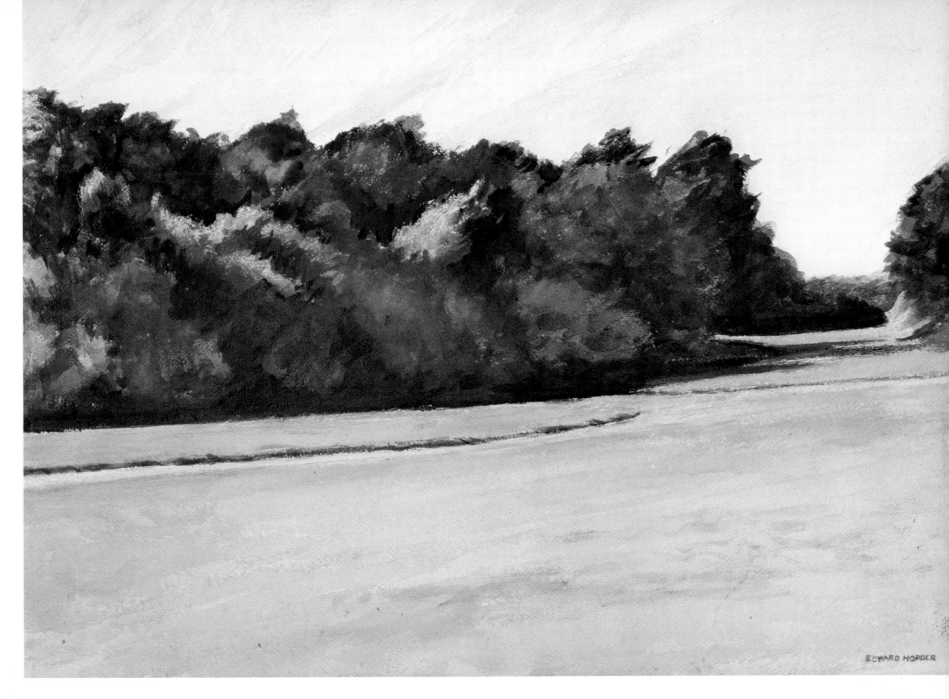

MASS OF TREES AT EASTHAM. *1962. Watercolor, 21 × 29″. Whitney Museum of American Art, New York City. Bequest of Mrs. Edward Hopper*

◄ HOUSE WITH A BIG PINE. *1935. Watercolor, 20 × 25″. Collection Mr. and Mrs. Albert Hackett, New York City*

FORM AND DESIGN

HOPPER HAD A NATURAL GIFT FOR CREATING SOLID FORMS, possessing physical substance and weight—a gift as inborn as a color sense, but less common. His forms are massive, severely simplified, without unnecessary details. The sheer physical power of his paintings is a fact that strikes one immediately on seeing them. They exist, with a natural unforced strength. Their strength is not on the surface, but in all the elements—form, space, color, design—that make up the whole.

He confirmed to me that he designed his paintings consciously and carefully. For him design was not flat pattern but the construction of solid forms in three-dimensional space— the sense in which design has been conceived by the past masters of Western painting. Like other non-academic traditionalists, he knew that the work of art can exist on several levels—those of content and associative values as well as of more abstract elements, and that there need be no conflict between representation and the creation of design. Although he did not talk much about the formal element in painting, it was evident that he gave much thought to it. (Unlike many of his fellow artists, Hopper was not a teacher. He told me that he felt it took too much out of an artist, and that he had once had one pupil and it had exhausted him.) His art is far from mere illusionistic representation; while the vision is naturalistic, the forms are those of art. They are plastic, and they are always contained within the picture plane, the pictorial space beyond which they cannot project or recede without destroying the plastic unity.

His design has certain marked characteristics. It is built largely on straight lines. The over-all shape is almost always a horizontal rectangle; he painted only a few upright compositions. Horizontals provide the foundation of the structure. They are crossed and interrupted by strong verticals. This interaction of horizontals and verticals is an essential element in his design, producing the pronounced angularity so typical of it.

Certain favorite devices are evident. Frequently a strong horizontal across the foreground —a railroad track, highway, street, or sidewalk—acts as a base for the less regular, more complex forms above and beyond. As Alfred Barr has written, these horizontals "are like the edge of a stage beyond which drama unfolds."

An outstanding example of this horizontality is *Early Sunday Morning*. The row of houses is seen from directly in front, so that the chief lines are exactly horizontal. These dominant lines are broken by the upright forms of barber pole and hydrant, and the repeated vertical patterns of doorways and windows. It is a concept of stark simplicity, but the just relations of the elements one to another, and the over-all unity, create a design that is rich and satisfying, giving a feeling of inevitability, as if it could not have been done otherwise.

A more complex kind of design is the horizontal wedge form, constructed in three dimensions, cutting across the picture and receding in depth. An early example is *Manhattan Bridge Loop*, where the mass of the bridge approach creates a wedge running from right to left, crossed by the verticals of steel arches, lamppost, and buildings. It is noticeable that none of these uprights is exactly vertical; all lean somewhat in different directions. Such variations are true of all his compositions; there is nothing mechanically regular about them. In *East Wind over Weehawken* the extreme variation in the forms of the houses, and the irregular uprights of lamppost, billboard, and telephone poles, may at first disguise the finely conceived over-all wedge form.

The clearest example of the wedge design is *Nighthawks*. The strong wedge of the restaurant, thrusting from right to left like the bow of a ship, is countered by the solid row of buildings at right angles to it. Here the moving wedge is met by a static mass. No main planes are parallel to the surface of the painting, as they were in *Early Sunday Morning*, and hence no main lines are parallel to the rectangular frame, and none are purely horizontal. When one contrasts the strict horizontality of the earlier picture (strong as it is) with the thrust and countering mass of *Nighthawks*, a growth in complexity of design is evident. This more dynamic kind of composition, which Hopper developed through the years, was a fundamental evolution in his art.

Another development was in the use of diagonals. As early as *New York Pavements* and *The City* he selected a viewpoint from above the center of interest and at an angle with the central mass to produce a basic diagonal composition. The plan is carried further in *Office at Night*; the viewpoint is again somewhat from above, the main structural lines are all diagonal to the four edges of the picture, and the angles are all oblique or acute instead of right angles. The result is a closely knit diagonal design, still based on straight lines and their interactions, but avoiding obvious rectangularity.

Characteristically, Hopper had doubts about his design being too limited, about his using the same type too often. It is true that his design has definite limitations: it is based largely on straight lines and seldom uses curvilinear elements; it is predominantly horizontal,

though with strong vertical forms; it is relatively static, lacking fluidity, and restricted in movement; and it employs certain devices again and again. But within these limitations Hopper achieved design that is among the strongest, most thoughtfully planned, and most fully realized in modern painting.

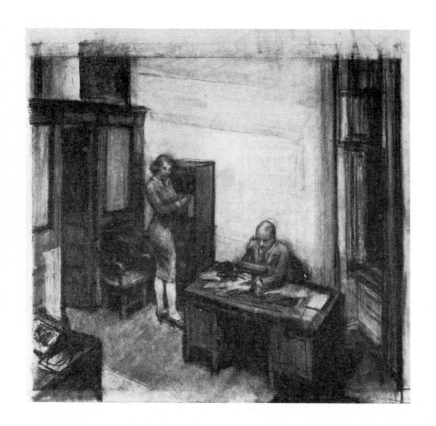 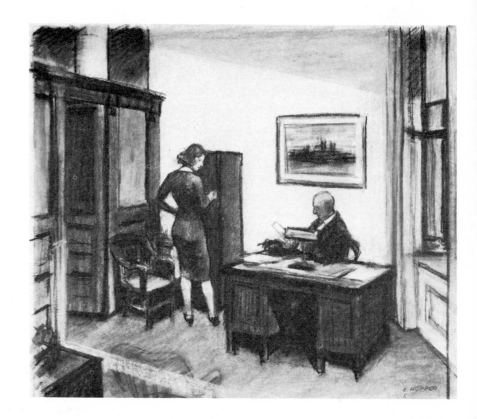

*Study for painting "*OFFICE AT NIGHT,*" Nos. 1. and 2. 1940. Black conté crayon with touches of white, 14 1/4 × 17 1/4" and 13 1/4 × 15" respectively*
Whitney Museum of American Art, New York City. Bequest of Mrs. Edward Hopper

OFFICE AT NIGHT. *1940. Oil, 22 1/8 × 25". Walker Art Center, Minneapolis, Minn.* ▶

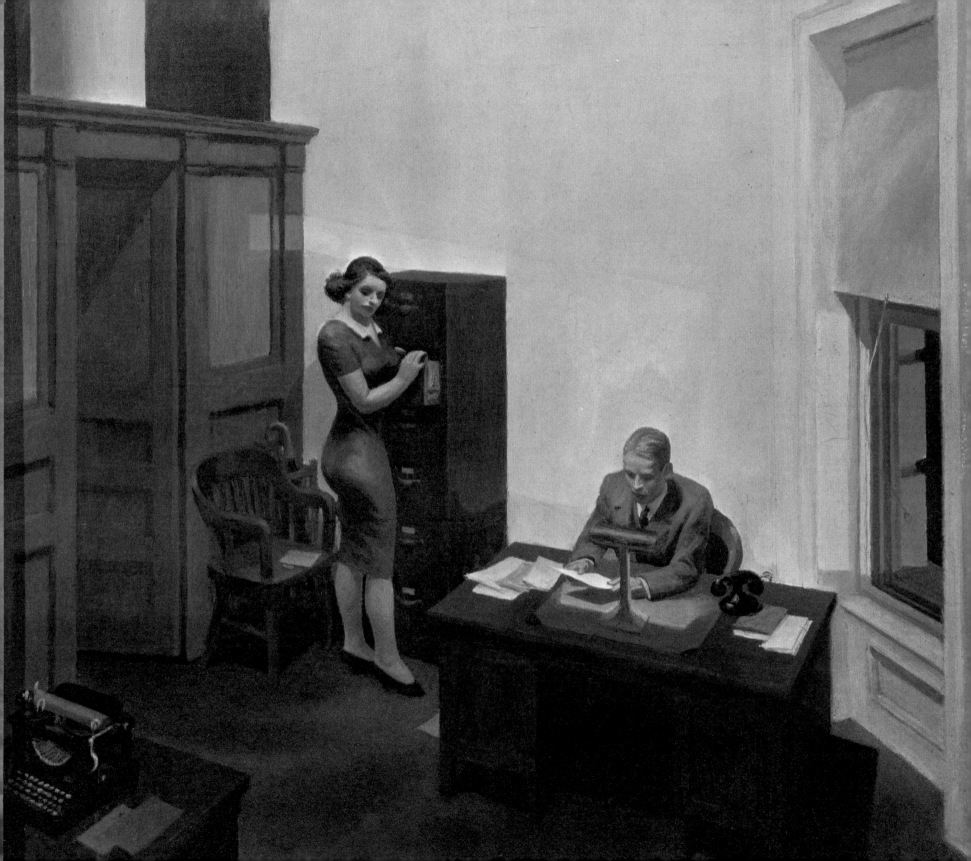

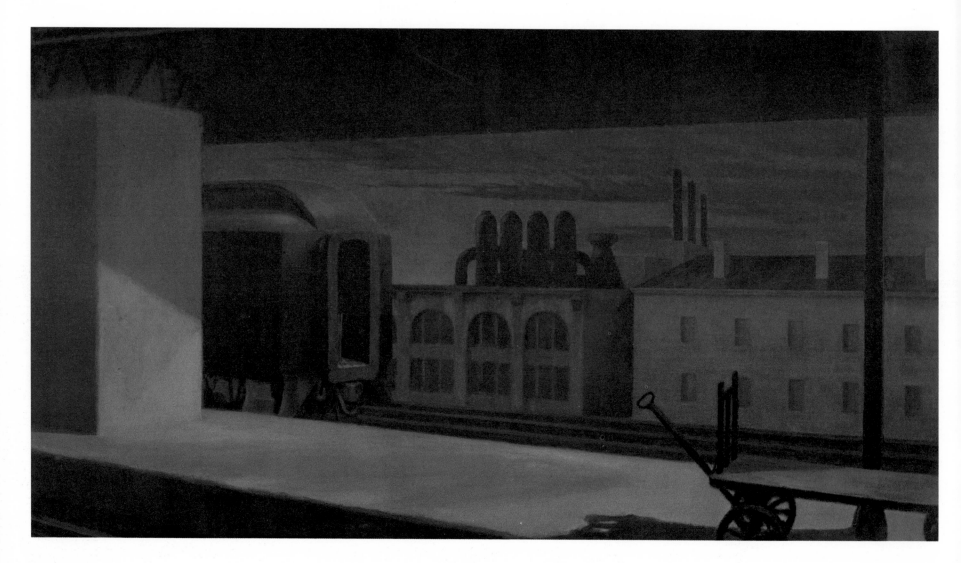

DAWN IN PENNSYLVANIA. *1942. Oil, 24 1/2 × 44 1/2" Collection Dr. and Mrs. James Hustead Semans, Durham, N.C.*

EL PALACIO. *1946. Watercolor, 21 × 29". Whitney Museum of American Art, New York City* ▶

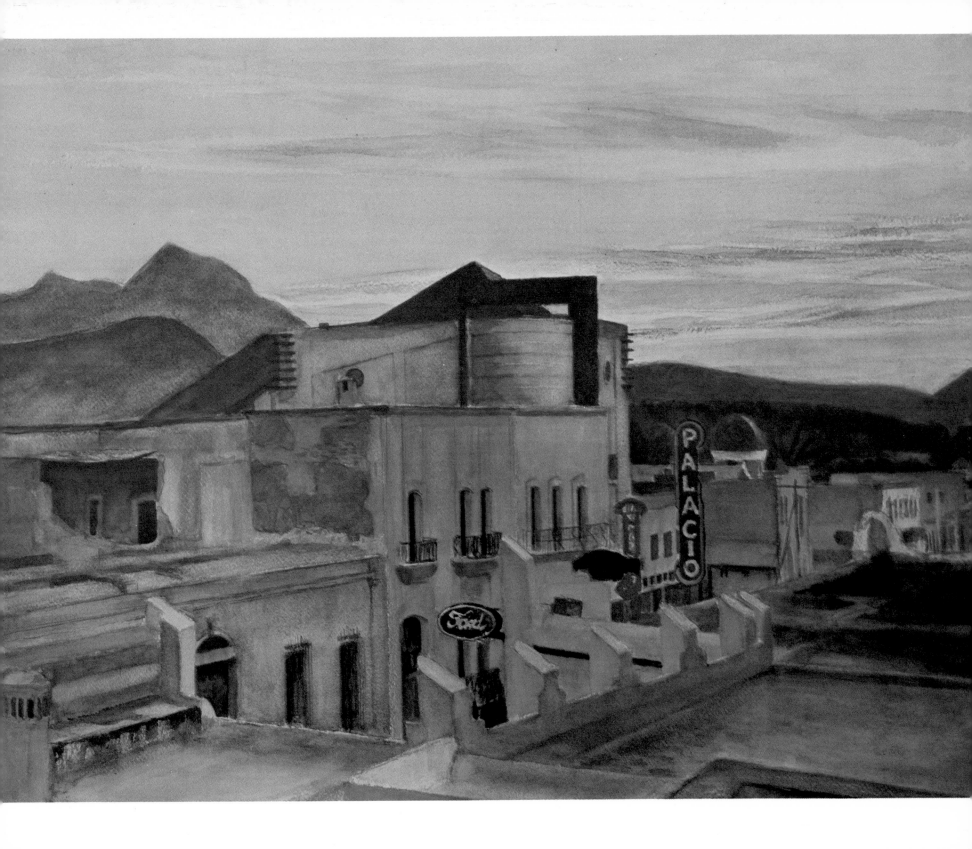

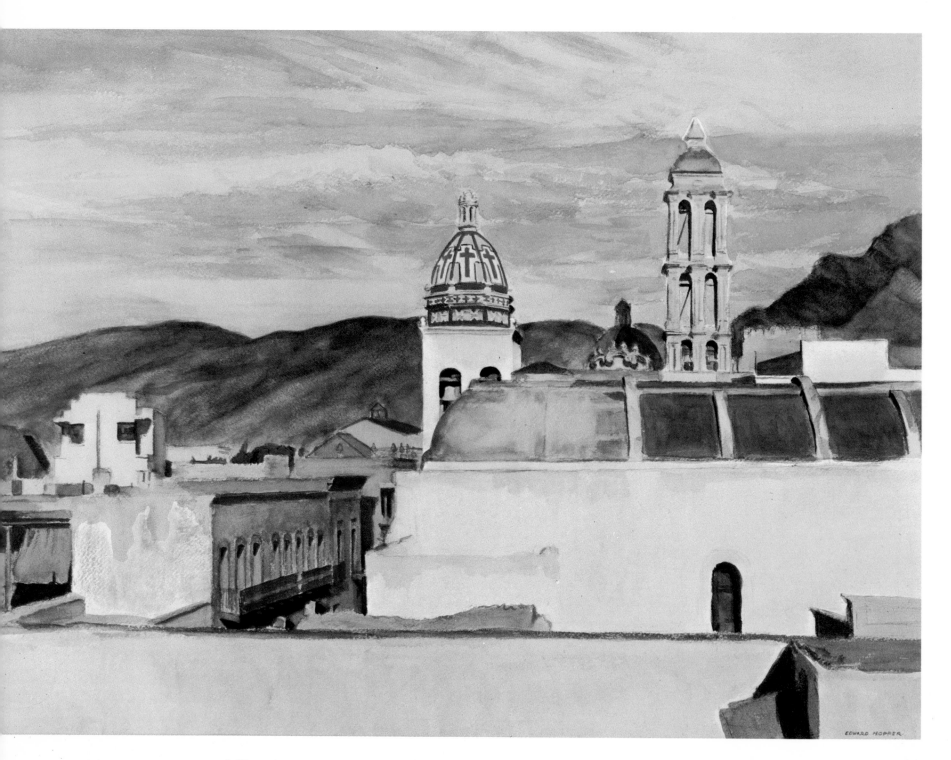

CHURCH OF SAN ESTEBAN. *1946. Watercolor, 22 1/4 × 30 1/2″. The Metropolitan Museum of Art, New York City. George A. Hearn Fund, 1948*

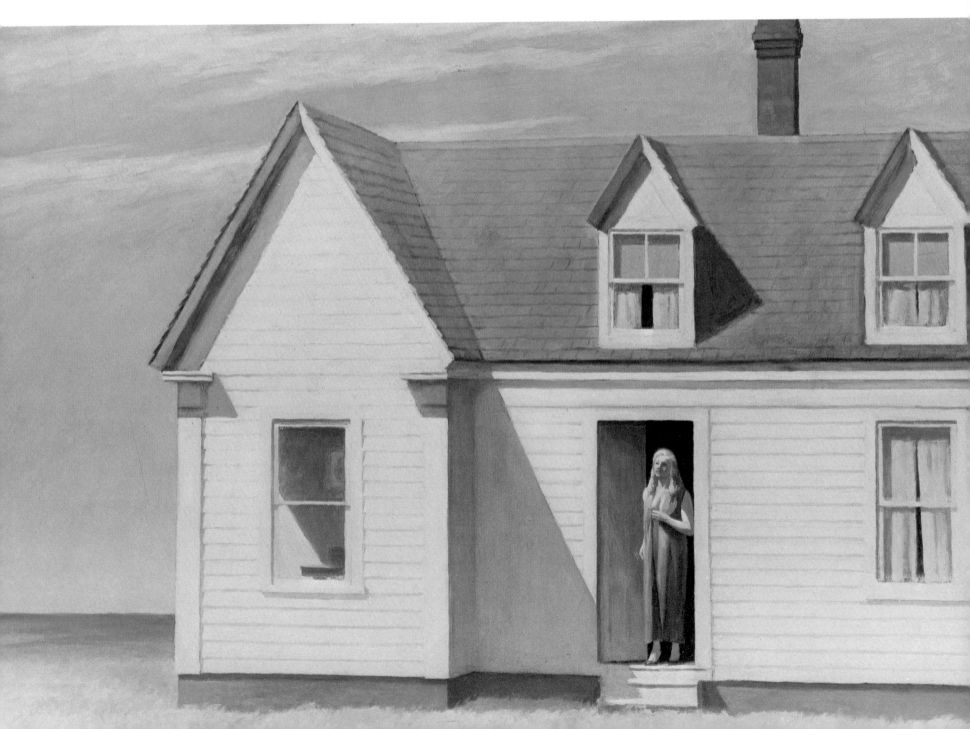

HIGH NOON. *1949. Oil, 28×40". Collection Mr. and Mrs. Anthony Haswell, Dayton, Ohio*

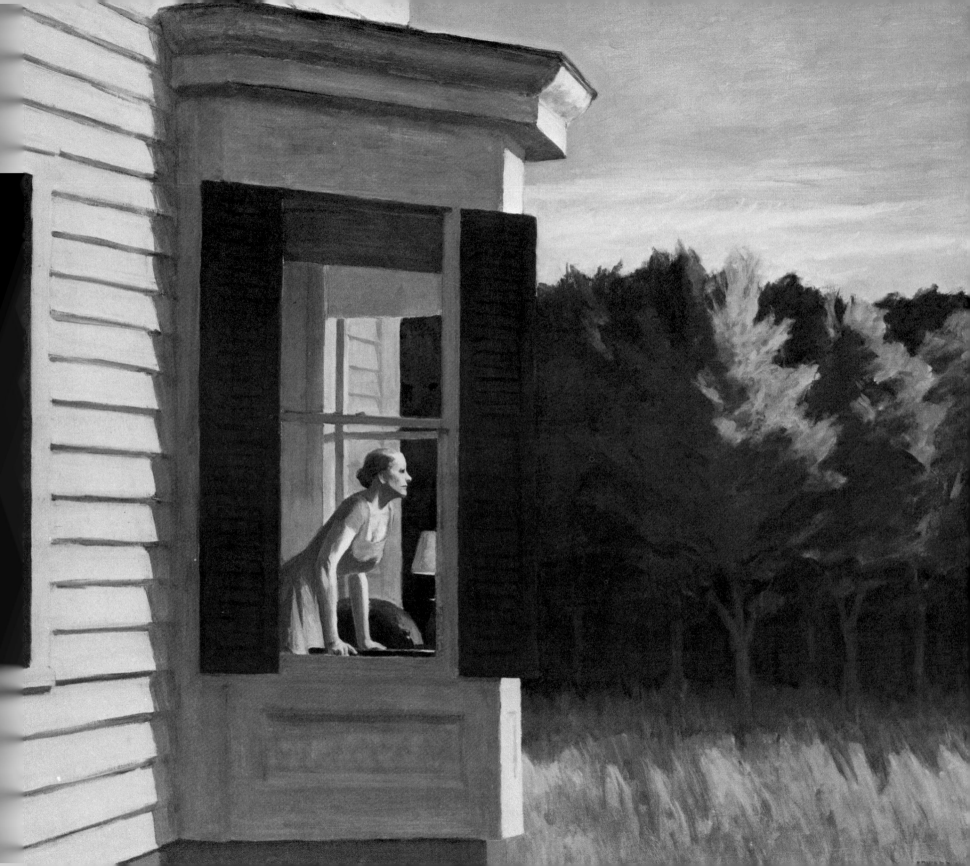

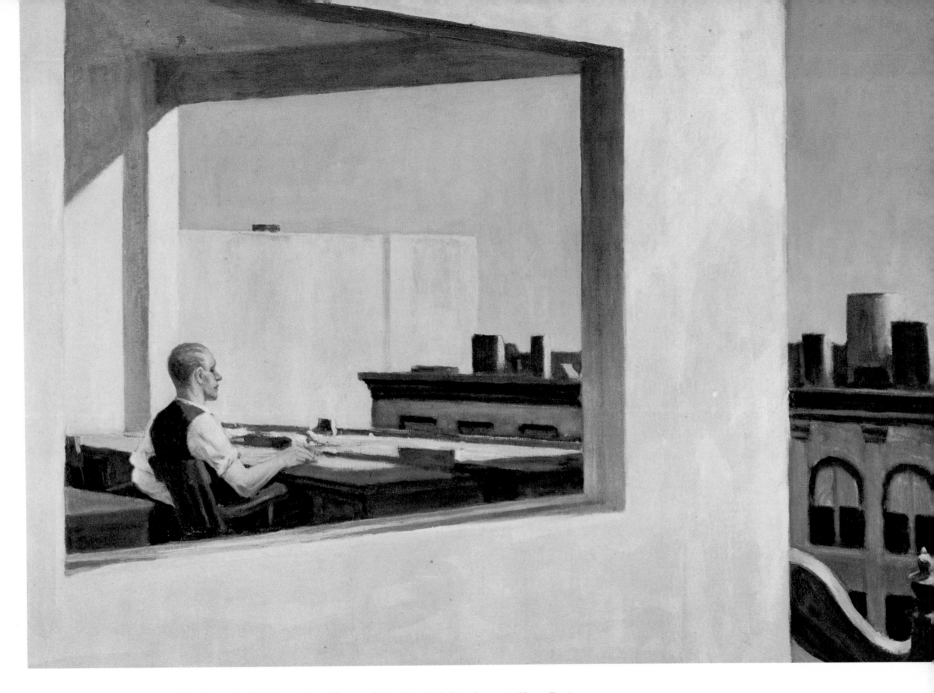

OFFICE IN A SMALL CITY. *1953. Oil, 28 × 40". The Metropolitan Museum of Art, New York City. George A. Hearn Fund, 1953*

◄ CAPE COD MORNING. *1950. Oil, 34 1/4 × 40 1/8". The Sara Roby Foundation*

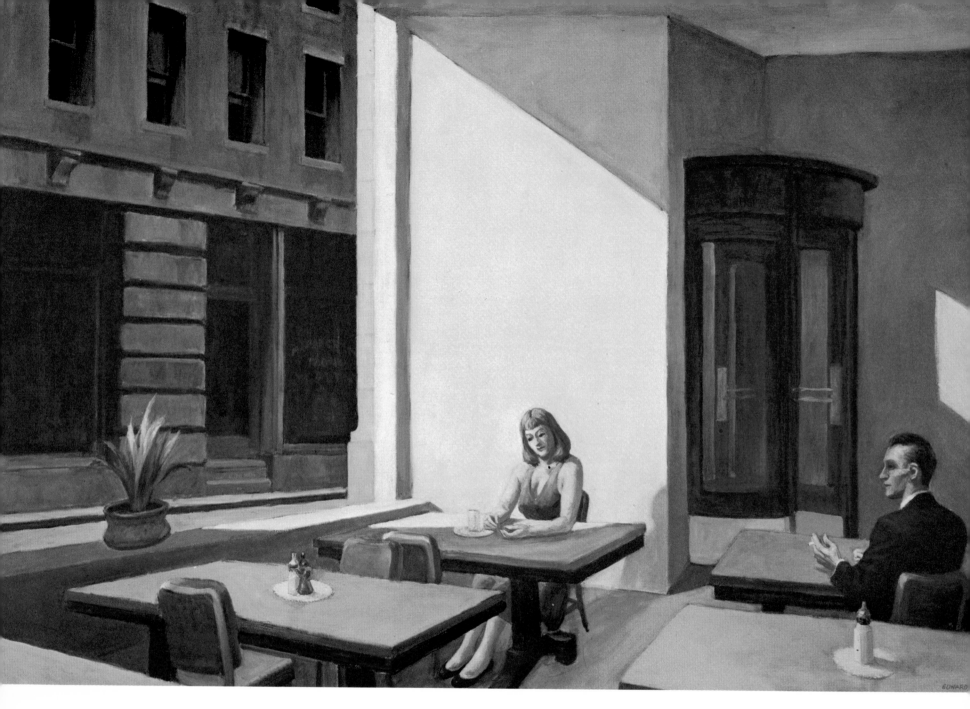

SUNLIGHT IN A CAFETERIA *1958. Oil, 40 1/4 × 60 1/8″ Yale University Art Gallery, New Haven, Conn. Bequest of Stephen Carlton Clark*

LATER WORK

One of the outstanding characteristics of Hopper's artistic evolution was his unwavering consistency. In a period of unceasing revolutions in concepts and styles, when many of his contemporaries changed their viewpoints overnight, he pursued a steady course, never revealing the slightest response to current movements. From first to last, his content, vision, and style remained fundamentally unchanged, and the main development was a constant growth in complexity and power.

His style showed no sign of softening with the years. Particularly in his last fifteen years or so, certain paintings revealed their rectilinear and angular structure even more clearly. *High Noon*, for example, is almost pure geometry; the dominant straight lines and acute angles, the emphatic pattern of sunlight and shadow, the extreme simplification and utter clarity—all create a design that has interesting parallels with geometric abstraction. (This is a comparison, incidentally, that Hopper did not care for; when I told him that in a lecture I had used a slide of *High Noon* together with a Mondrian, his only comment was, "You kill me.") Even more severely geometric is *Rooms by the Sea*: an empty room with an open doorway looking out on blue water, and sunlight falling in a diagonal pattern on the wall and floor—a painting made up only of interrelations of light, space, and a few bare forms. And in 1960, when he was seventy-eight, he produced one of his boldest, most vigorous, and most uncompromisingly angular works, *Second-Story Sunlight*. (In answering a questionnaire from the Whitney Museum when it purchased the painting, his only statement as to its subject was: "This picture is an attempt to paint sunlight as white, with almost or no yellow pigment in the white. Any psychologic idea will have to be supplied by the viewer.")

The paintings of his last ten or fifteen years, compared with earlier ones on the same or similar themes, are generally larger in scale and more complex in their basic elements. If one compares, for example, *Sunlight in a Cafeteria* (1958) with *Automat* (1927) one finds a considerably more complex interplay of geometric forms. The stress on substance and weight has increased. In city scenes like *Hotel by a Railroad* and *New York Office* the heavy masonry with its repeated patterns of cut stone builds a three-dimensional structure of monumental power and largeness. The angular design of strongly contrasted light and shadow is emphasized more than ever.

AUTOMAT. *1927. Oil, 28 × 36".*
Des Moines Art Center, Des Moines, Iowa. Edmundson Collection.

133

Light maintains its central role; indeed, it has become the common denominator of most of his subjects. It is interesting to note how often "Sun" and "Sunlight" appear in his later titles: *Morning Sun, City Sunlight, Sunlight on Brownstones, A Woman in the Sun*. And even when the words are not in the title, the theme is dominant; in *Sea Watchers* the man and woman gazing out to sea have the silent, brooding air of sun worshipers. One of his last paintings is *Sun in an Empty Room*, the same concept as *Rooms by the Sea*, but even more drastically simple: light has become the entire motif, filling the picture with a haunting presence. When Brian O'Doherty asked him, "What are you after in it?" he answered, "I'm after *me*."

His relation to realities was as direct as in the past, and his use of them as candid. To take an extreme example, *Western Motel* with its awful interior in decorator's green, beige, and crimson, its hard-faced blonde, its bright green automobile, and its bare desert landscape under a burning sun, is one of his toughest pictures of any period. It makes no concessions to accepted ideas of what is artistically admissible. Its garish colors are unsoftened by grays. It captures the quintessence of that most American of institutions, the motel. In a purely naturalistic style it is as firsthand an exposé of our mass culture as pop art.

Hopper's other major medium, watercolor, went through developments parallel to those of his oils. After the simple directness of the Gloucester and Maine works of the 1920's, the subjects became more complex, the technique richer, the scale larger. His watercolors were still painted from nature, outdoors (or from his car, since he hated being watched), but he now worked longer on them—instead of a single sitting as before, days and sometimes weeks. *Cliffs near Mitla* took him a month, working for a short time at a certain hour of the day, and interrupted by bad weather. From the late 1930's his watercolors numbered considerably fewer than formerly. With the years he found it more difficult to work outdoors, and after 1953, as far as is known, he painted only three watercolors, in 1957, 1962, and 1965.

His later watercolors were more thoughtfully composed than his earlier ones. The technique was no longer one of direct, spontaneous washes. Hopper said that watercolor painting is "a series of glazes"; and his later works were built up in glaze over glaze. But they remained translucent, without opaque pigment. Asked once whether he used Chinese white, he said emphatically, "Absolutely none"; that to secure whites in an area already painted, he would scrape with a knife down to the paper. Particularly in his watercolors of the 1940's and 1950's the technique is a complex, rich combination of painting, overpainting, and scraping, resulting in a new depth of color and values, and a new roundness of form. In these qualities, and in their more complete design, these mature

HOTEL BY A RAILROAD ▶
1952. Oil, 31 × 40"
Joseph H. Hirshhorn Foundation

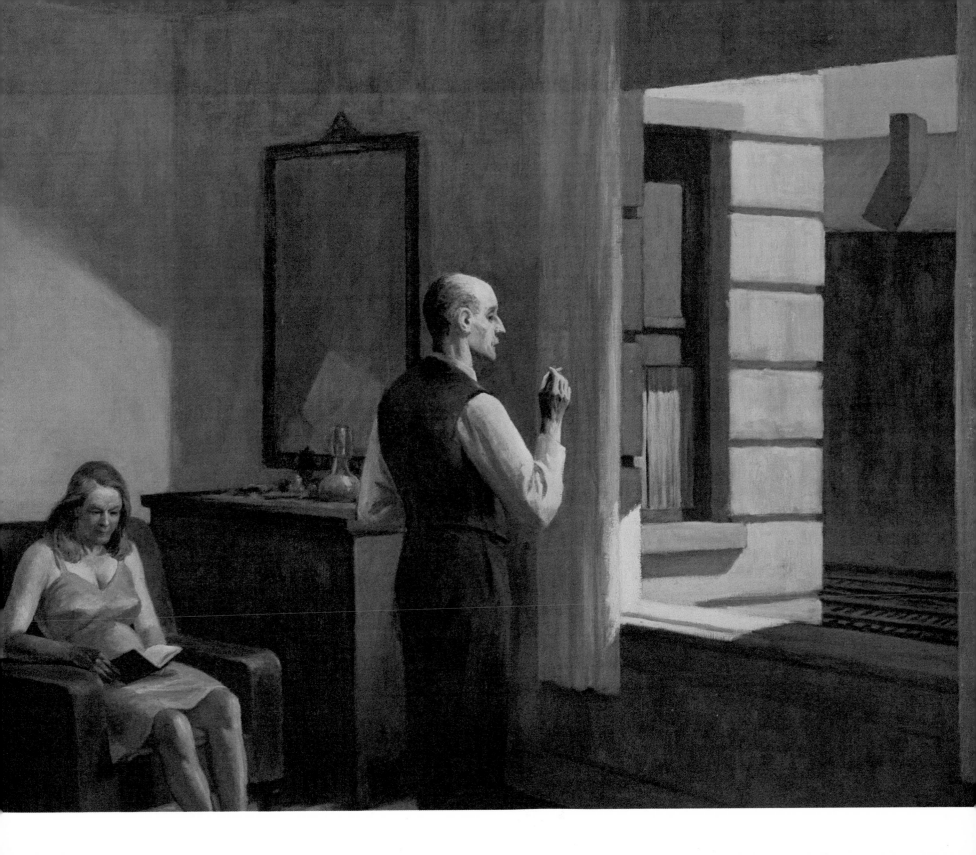

watercolors are close to his oils, while preserving the transparency and freshness that are among the special qualities of the medium. In some ways their color is the most alive and vivid he ever achieved. They are as fully realized as his works of any period in any medium.

Almost all his watercolors after 1940 were painted during the travels that he and Jo Hopper made to the West and to Mexico (driving all the way): in 1941 to the West Coast, and in 1943, 1946, and 1953 to Mexico, where they settled among the northern mountains at Monterrey and Saltillo. In the West and in Mexico, Hopper found the kind of spectacular subject-matter he had avoided on their first Western trip in 1925. That he now sought and painted it showed a continuing capacity to enlarge his horizons. It was subject-matter that only a strong artist could use without reverting to illustrative banality. By realizing to the fullest the power of these great natural forms, the richness of their color, and the beauty of light on them, Hopper added a unique and impressive chapter to his long creative record.

From his breakthrough in the 1920's, Hopper's career was one of steadily increasing honors. Practically all the oils and watercolors he put out for sale were sold, many to museums. He received numerous prizes, several honorary degrees, and the *Art in America* award "for an outstanding contribution to American art." He was on the cover of *Time*. He was interviewed again and again, appeared on television, and was the subject of many articles. In 1945 he was elected a member of the National Institute of Arts and Letters, and ten years later of the American Academy of Arts and Letters, the most distinguished body of creative men and women in the nation. In 1955 the Institute, by vote of its membership, awarded him its Gold Medal, probably the highest cultural honor in America. The annual ceremonies of these two societies are impressive affairs, and the recipient customarily delivers a major acceptance speech. Hopper was in Mexico, and the presentation was made *in absentia* by Henry Varnum Poor, who said: "From the safe distance of Monterrey, Mexico, Edward Hopper has sent his acceptance speech. . . . It is two paragraphs long. If he were here to make it by spoken word it would have been: 'Thanks,' or if he felt really expansive: 'Thanks a lot.'"

In 1964, when he was eighty-two, the Whitney Museum, which had given a large retrospective exhibition in 1950, held a second, filling the entire museum and including most of his works since the previous show. The response from the public, critics, and fellow artists was an extraordinary tribute, not only from traditionalists but from many of the avant-garde. One of the unusual features of Hopper's reputation in later years was the respect he commanded, by and large, from all factions of the art world. This was

SALTILLO ROOFTOPS. *1943. Watercolor, 19 3/4 × 27 1/2″.*
Museum of Art, Carnegie Institute, Pittsburgh, Pa.
Gift of Mr. and Mrs. James H. Beal

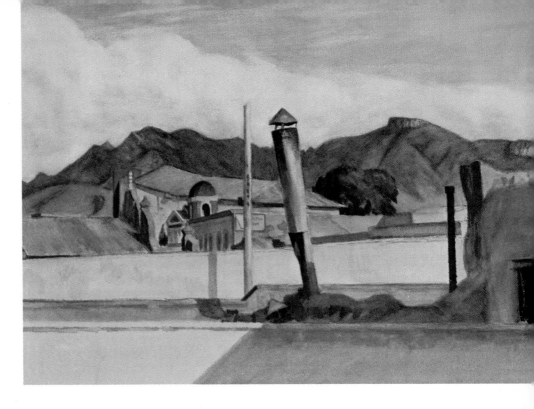

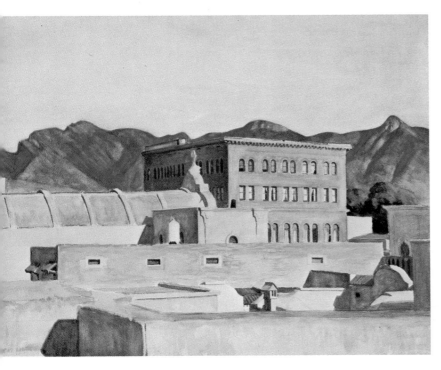

ROOFS, SALTILLO. *Probably 1943.*
Watercolor, 21 × 28 7/8″. Whitney Museum
of American Art, New York City.
Bequest of Mrs. Edward Hopper

PALMS AT SALTILLO. *1943. Watercolor, 20 × 25″.*
Collection Mr. and Mrs. Robert M. Bernstein, New Rochelle, N.Y.

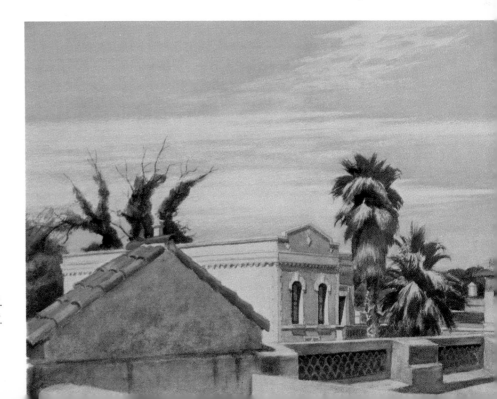

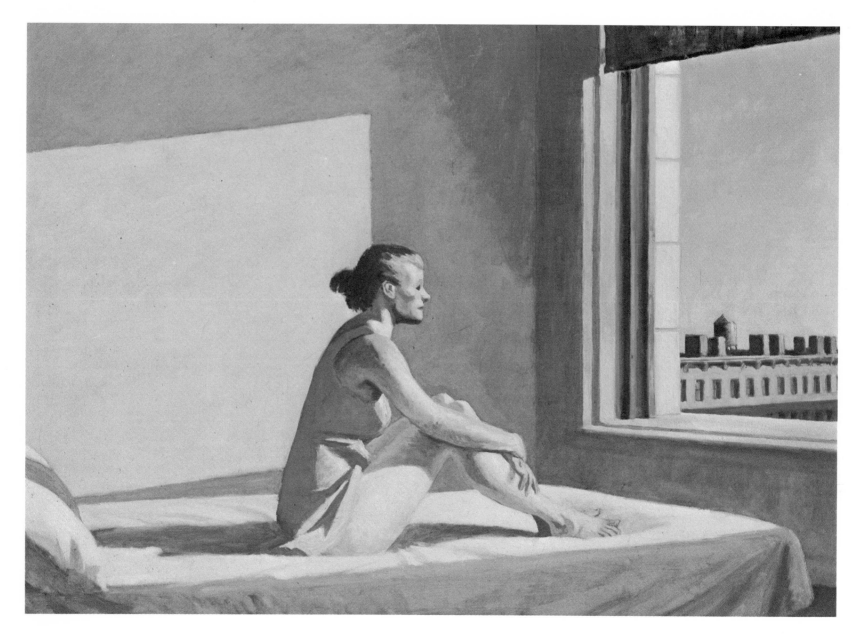

MORNING SUN. *1952. Oil, 28 1/8 × 40 1/8". Columbus Gallery of Fine Arts, Columbus, Ohio. Howald Fund*

manifested by the choice of him, for the São Paulo Bienal exposition of 1967, as the central figure around which the organizer, William C. Seitz, assembled a show of advanced artists depicting the American environment, including a large proportion of pop artists.

All these honors made no perceptible difference in the quantity or quality of Hopper's works. Nor did they have any marked effect on his and Jo Hopper's personal lives. There were more demands on them, more public appearances, and more parties, which they always attended if they could. But they still lived as simply as they had when this was a necessity. They continued to occupy the top floor of 3 Washington Square North, up four flights and seventy-four steps. Until 1966 they still spent summers in the house they had built in South Truro in 1930. The year he turned eighty, 1962, he painted two of his strongest pictures, and two more the next year. Illness in 1964 kept him from work; but in 1965 came *Chair Car*, which showed no sign of failing powers. That year he did his last painting, *Two Comedians*. It is a personal testament; the tall male comedian and the small female comedian whom he is presenting to the public are obviously himself and Jo Hopper —a fact which she herself confirmed to me.

In the spring of 1967 recurring illness forced Hopper to spend weeks in a hospital. But when he was able to leave, he insisted on going home to the studio in which he had lived for over fifty years. It was here that he died peacefully on May 15, 1967, in his eighty-fifth year. And a little less than a year later Jo Hopper followed him.

Only posterity can determine the ultimate stature of an artist. But even to us today it seems clear that Edward Hopper belongs in the company of those American creative realists, such as Copley, Mount, Bingham, Homer, and Eakins, who by expressing with strength and integrity their individual visions of the world they lived in, transformed the personal into the universal, and made enduring contributions to the art of their country and of the world.

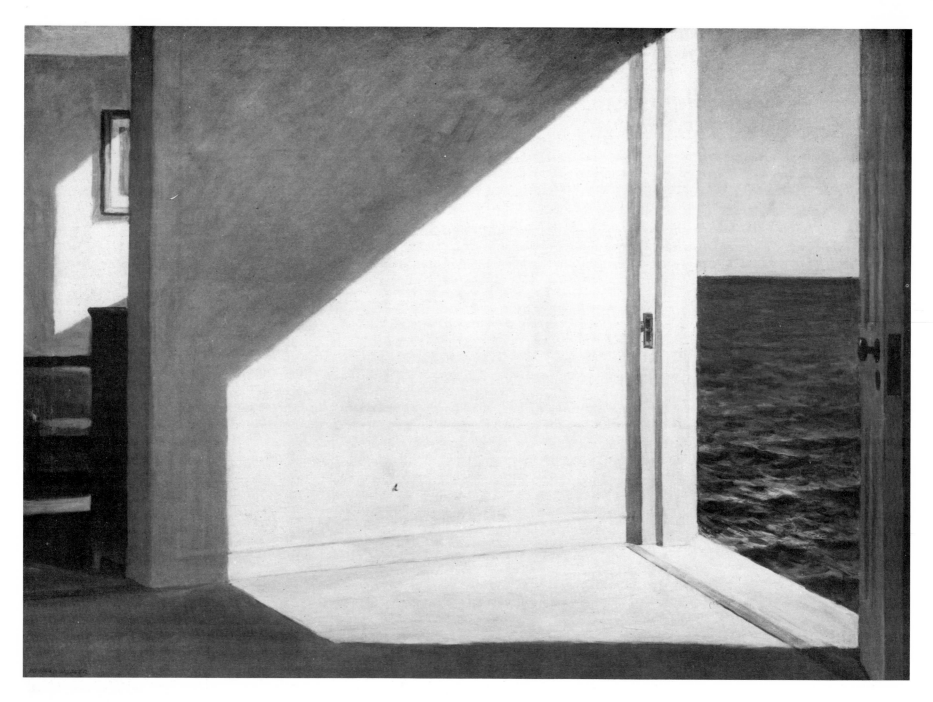

ROOMS BY THE SEA. *1951. Oil, 29×40″. Yale University Art Gallery, New Haven, Conn. Bequest of Stephen Carlton Clark*

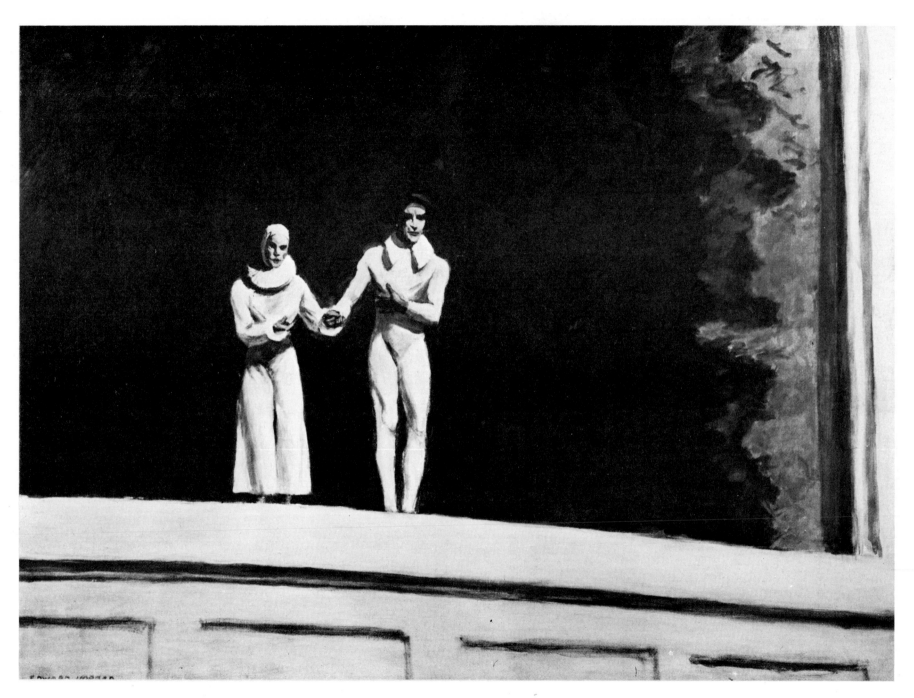

TWO COMEDIANS. *1965. Oil, 29×40". Collection Mr. and Mrs. Irving Mitchell Felt, New York City*

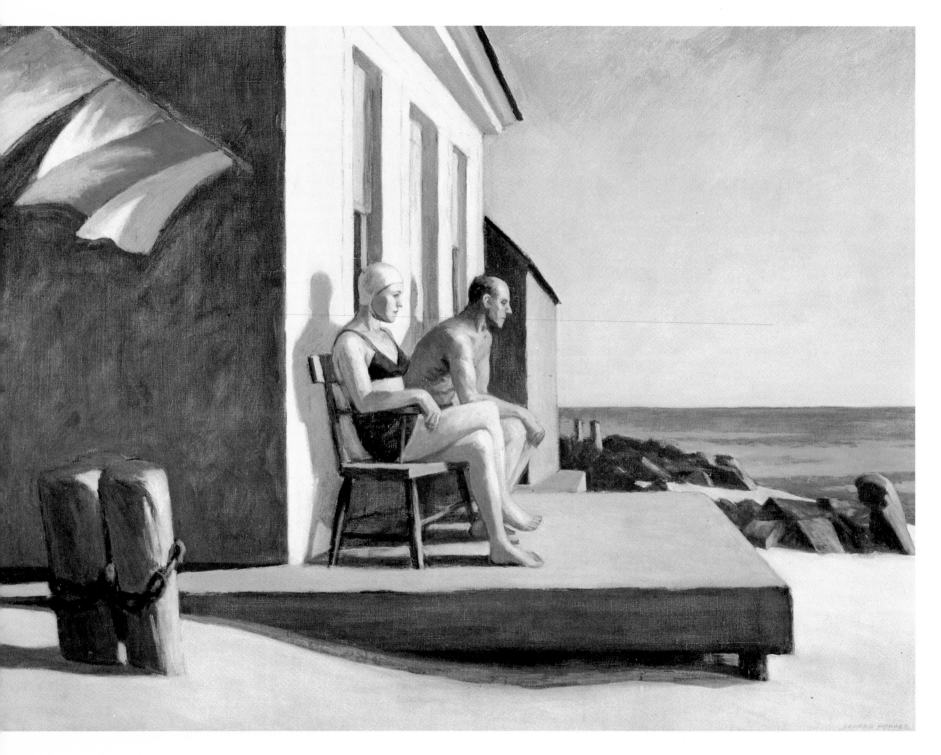

SEA WATCHERS. *1952. Oil, 30 × 40″. Collection Mr. and Mrs. Ralph L. Ritter, Kansas City, Mo.*

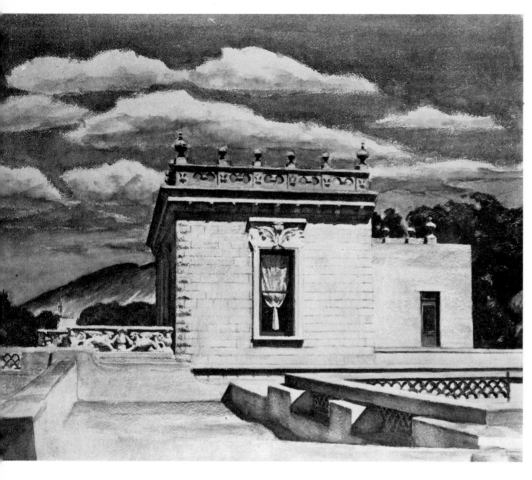

SALTILLO MANSION. *1943. Watercolor, 21 1/4 × 27 1/8".*
The Metropolitan Museum of Art, New York City. George A. Hearn Fund, 1948

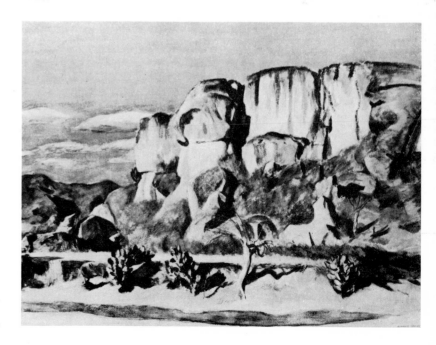

CLIFFS NEAR MITLA. *1953. Watercolor, 21 × 29". Collection Mr. and Mrs. Charles F. Stein, Jr., Baltimore, Md.*

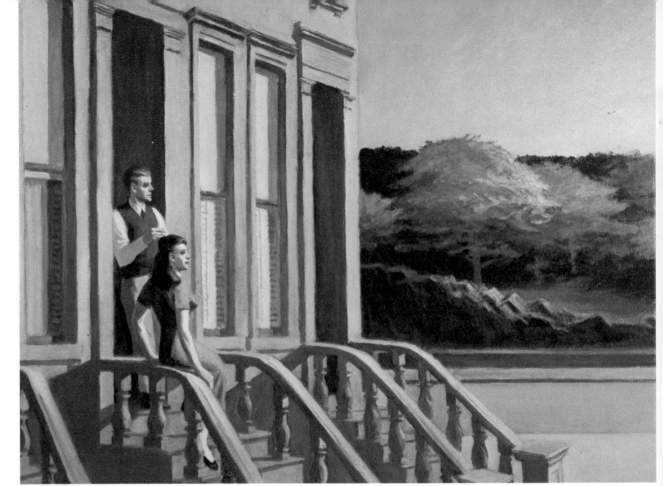

SUNLIGHT ON BROWNSTONES. *1956.*
Oil, 30 × 40″. Wichita Art Museum, Wichita, Kan.
Roland P. Murdock Collection

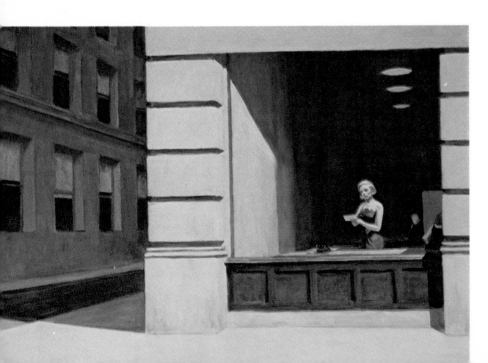

NEW YORK OFFICE. *1962. Oil, 40 × 55″. Private collection*

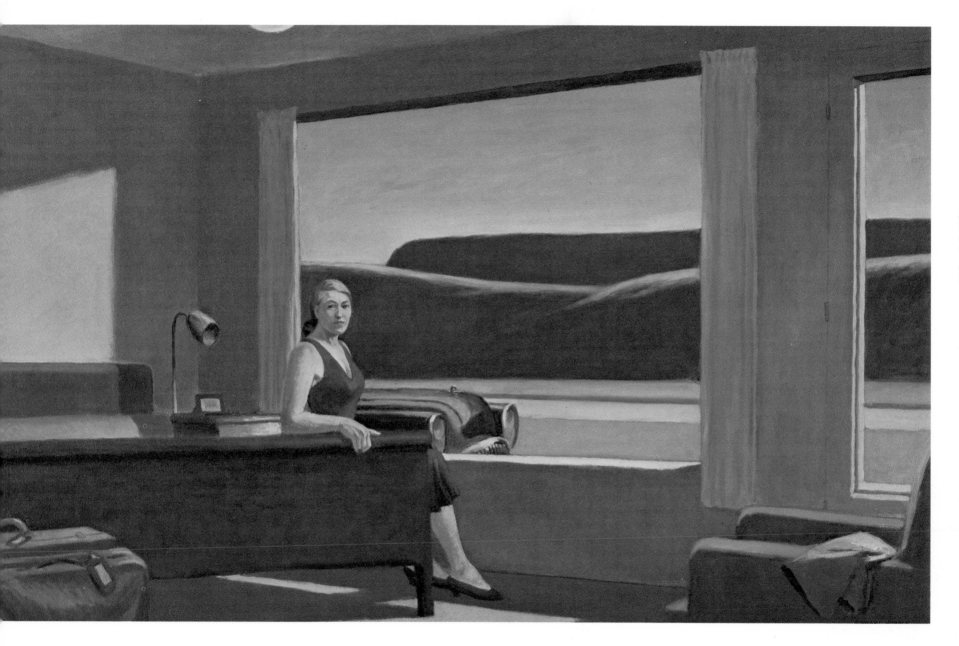

WESTERN MOTEL. *1957. Oil, 30 1/4 × 50 1/8" Yale University Art Gallery, New Haven, Conn. Bequest of Stephen Carlton Clark*

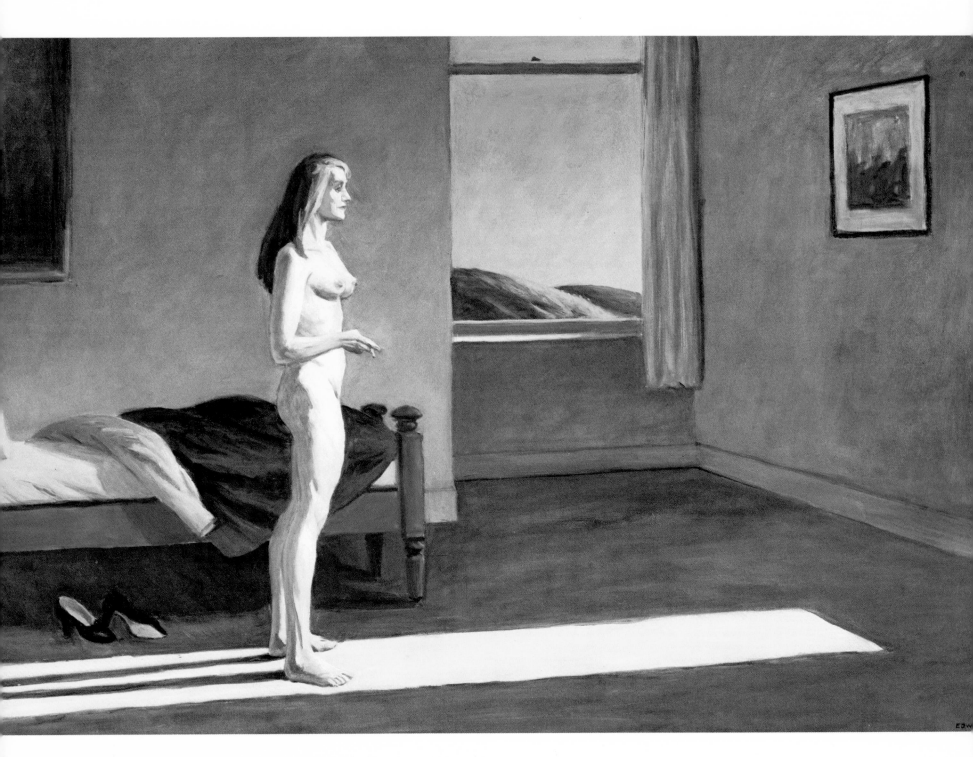

A WOMAN IN THE SUN *1961. Oil, 40 × 60" Collection Mr. and Mrs. Albert Hackett, New York City*

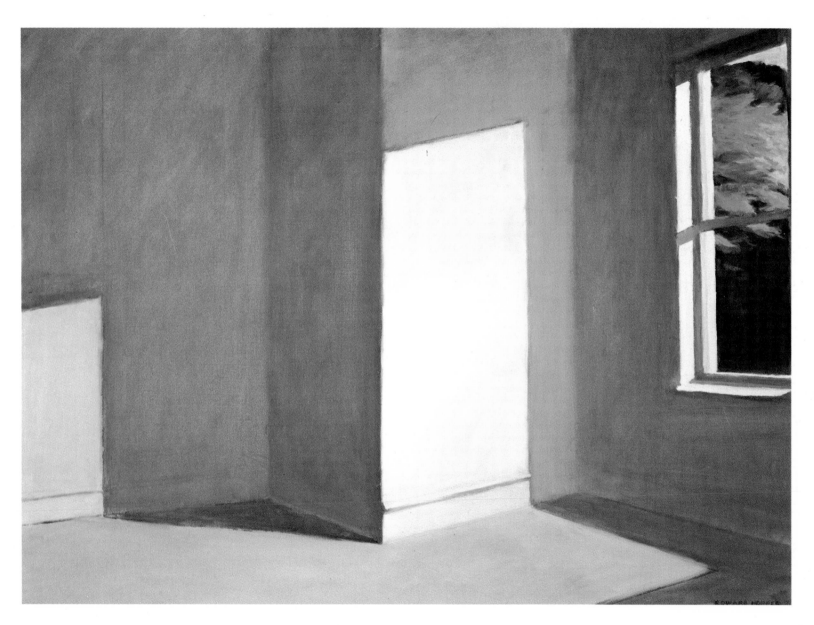

SUN IN AN EMPTY ROOM. *1963. Oil, 29 × 40″. Collection Mr. and Mrs. David Workman, New York City*

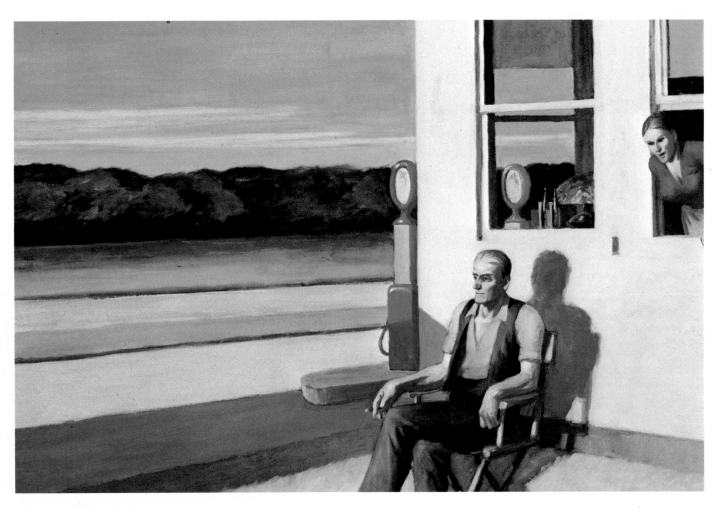

FOUR LANE ROAD. *1956. Oil, 27 1/2 × 41 1/2". Collection Mr. and Mrs. Malcolm G. Chace, Jr., Providence, R.I.*

MANHATTAN BRIDGE LOOP. *1928. Oil, 35 × 60" The Addison Gallery of American Art, Phillips Academy, Andover, Mass.*

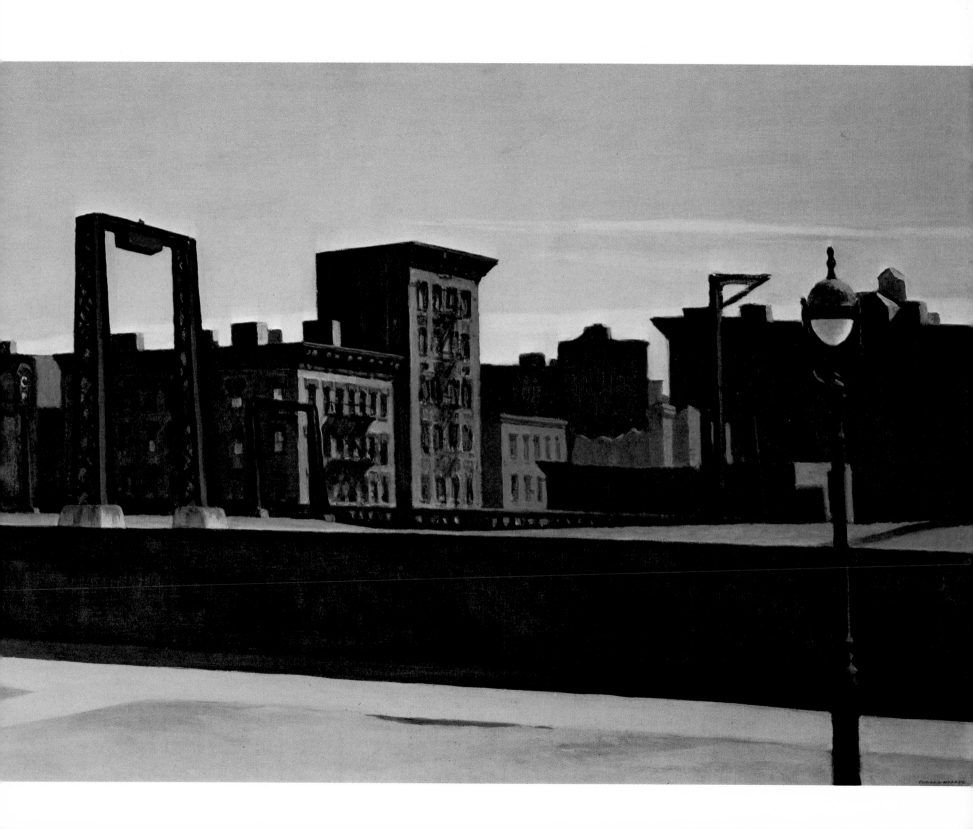

THREE STATEMENTS
BY EDWARD HOPPER

THE FOLLOWING STATEMENTS about his aims and ideas in painting are the most complete that Hopper made in writing. The first, "Notes on Painting," was published in the catalogue of his retrospective exhibition at the Museum of Modern Art in 1933. The second, previously unpublished, is a letter of October 29, 1939, to Charles H. Sawyer, then Director of the Addison Gallery of American Art, about the Gallery's painting *Manhattan Bridge Loop*. The third is a statement published in *Reality*, Spring 1953.

STATEMENT ONE

My aim in painting has always been the most exact transcription possible of my most intimate impressions of nature. If this end is unattainable, so, it can be said, is perfection in any other ideal of painting or in any other of man's activities.

The trend in some of the contemporary movements in art, but by no means all, seems to deny this ideal and to me appears to lead to a purely decorative conception of painting. One must perhaps qualify this statement and say that seemingly opposite tendencies each contain some modicum of the other.

I have tried to present my sensations in what is the most congenial and impressive form possible to me. The technical obstacles of painting perhaps dictate this form. It derives also from the limitations of personality. Of such may be the simplifications that I have attempted.

I find, in working, always the disturbing intrusion of elements not a part of my most interested vision, and the inevitable obliteration and replacement of this vision by the work itself as it proceeds. The struggle to prevent this decay is, I think, the common lot of all painters to whom the invention of arbitrary forms has lesser interest.

I believe that the great painters, with their intellect as master, have attempted to force this unwilling medium of paint and canvas into a record of their emotions. I find any digression from this large aim leads me to boredom.

The question of the value of nationality in art is perhaps unsolvable. In general it can be said that a nation's art is greatest when it most reflects the character of its people. French art seems to prove this.

The Romans were not an aesthetically sensitive people, nor did Greece's intellectual domination over them destroy their racial character, but who is to say that they might not have produced a more original and vital art without this domination. One might draw a not too far-fetched parallel between France and our land. The domination of France in the plastic arts has been almost complete for the last thirty years or more in this country.

If an apprenticeship to a master has been necessary, I think we have served it. Any further relation of such a character can only mean humiliation to us. After all we are not French and never can be and any attempt to be so, is to deny our inheritance and to try to impose upon ourselves a character that can be nothing but a veneer upon the surface.

In its most limited sense, modern art would seem to concern itself only with the technical innovations of the period. In its larger and to me irrevocable sense it is the art of all time; of definite personalities that remain forever modern by the fundamental truth that is in them. It makes Molière at his greatest as new as Ibsen, or Giotto as modern as Cézanne.

Just what technical discoveries can do to assist interpretive power is not clear. It is true that the Impressionists perhaps gave a more faithful representation of nature through their discoveries in out-of-door painting, but that they increased their stature as artists by so doing is controversial. It might here be noted that Thomas Eakins in the nineteenth century used the methods of the seventeenth, and is one of the few painters of the last generation to be accepted by contemporary thought in this country.

If the technical innovations of the Impressionists led merely to a more accurate representation of nature, it was perhaps of not much value in enlarging their powers of expression. There may come or perhaps has come a time when no further progress in truthful representation is possible. There are those who say that such a point has been reached and attempt to substitute a more and more simplified and decorative calligraphy. This direction is sterile and without hope to those who wish to give painting a richer and more human meaning and a wider scope.

No one can correctly forecast the direction that painting will take in the next few years, but to me at least there seems to be a revulsion against the invention of arbitrary and stylized design. There will be, I think, an attempt to grasp again the surprise and accidents of nature, and a more intimate and sympathetic study of its moods, together with a renewed wonder and humility on the part of such as are still capable of these basic reactions.

STATEMENT TWO

Dear Mr. Sawyer:

You are asking me to do something which is perhaps as difficult to do as painting is; that is to explain painting with words.

To me, form, color and design are merely a means to an end, the tools I work with, and they do not interest me greatly for their own sake. I am interested primarily in the vast field of experience and sensation which neither literature nor a purely plastic art deals with. One must say guardedly, human experience, for fear of having it confounded with superficial anecdote. I am always repelled by painting that deals narrowly with harmonies or dissonances of color and design.

My aim in painting is always, using nature as the medium, to try to project upon canvas my most intimate reaction to the subject as it appears when I like it most; when the facts are given unity by my interest and prejudices. Why I select certain subjects rather than others, I do not exactly know, unless it is that I believe them to be the best mediums for a synthesis of my inner experience.

I spend many days usually before I find a subject that I like well enough to do, and spend a long time on the proportions of the canvas, so that it will do for the design, as nearly as possible what I wish it to do. The very long horizontal shape of this picture, "Manhattan Bridge Loop," is an effort to give a sensation of great lateral extent. Carrying the main horizontal lines of the design with little interruption to the edges of the picture, is to enforce this idea and to make one conscious of the spaces and elements beyond the limits of the scene itself. The consciousness of these spaces is always carried by the artist to the very limited space of the subject that he intends to paint, though I believe all painters are not aware of this.

The picture was planned very carefully in my mind before starting it, but except for a few small black and white sketches made from the fact, I had no other concrete data, but relied on refreshing my memory by looking often at the subject. The preliminary sketches would do little for you in explaining the making of the picture. The color, design, and form have all been subjected, consciously or otherwise, to considerable simplification.

So much of every art is an expression of the subconscious, that it seems to me most all of the important qualities are put there unconsciously, and little of importance by the conscious intellect. But these are

152 *things for the psychologist to untangle.*

STATEMENT THREE

I hope that what I have written will be of use to you.

Great art is the outward expression of an inner life in the artist, and this inner life will result in his personal vision of the world. No amount of skillful invention can replace the essential element of imagination. One of the weaknesses of much abstract painting is the attempt to substitute the inventions of the intellect for a pristine imaginative conception.

The inner life of a human being is a vast and varied realm and does not concern itself alone with stimulating arrangements of color, form, and design.

The term "life" as used in art is something not to be held in contempt, for it implies all of existence, and the province of art is to react to it and not to shun it.

Painting will have to deal more fully and less obliquely with life and nature's phenomena before it can again become great.

BIOGRAPHICAL NOTE

Edward Hopper was born July 22, 1882, at Nyack, N.Y., son of Garrett Henry Hopper and Elizabeth Griffiths Smith Hopper. He was educated at a local private school, then in the Nyack High School. In the winter of 1899–1900 he studied illustration at a commercial art school in New York; from 1900 to 1906 he studied at the New York School of Art, at first illustration, then painting under Robert Henri and Kenneth Hayes Miller. In the fall of 1906 he went abroad for about nine months, visiting England, Holland, Germany, and Belgium, but spending most of his time in Paris, where he painted and drew city scenes. He went again in the summer of 1909 for about six months, spent entirely in France, chiefly in Paris. His third trip was in the summer of 1910 for about four months, to France and Spain. He never visited Europe again.

From 1908 he lived in New York. After leaving art school he made his living by commercial art and some illustration, painting in his free time and in the summers: at Gloucester, Massachusetts, in 1912; at Ogunquit, Maine, about 1914 and 1915; and at Monhegan, Maine, about 1916. He exhibited, probably for the first time, in March 1908 with other Henri students at the Harmonie Club, New York. Included in the Armory Show, 1913, he sold an oil, *Sailing*. Because of lack of opportunities to exhibit he was less active as a painter from 1915 to 1920.

In 1915 he took up etching, producing about fifty plates in the next eight years. His prints were admitted to exhibitions from 1920 on and won two prizes in 1923.

The Whitney Studio Club gave him his first one-man show, of Paris oils, in January 1920, and in 1922 a show of Paris watercolor caricatures. From about 1920 he worked more in oil, and in 1923 began to paint watercolors. In November 1924 Frank K. M. Rehn, New York, gave the first exhibition of recent watercolors, which was a success. Four one-man shows were held in the next few years: at the St. Botolph Club, Boston, prints and watercolors, in April 1926; the Rehn Gallery, four oils, twelve watercolors, and prints, in February 1927; the Morgan Memorial, Hartford, twelve watercolors, in November 1928; and the Rehn Gallery, twelve oils, ten watercolors, and drawings, in January 1929. He was included in "Paintings by Nineteen Living Americans" at the Museum of Modern Art, December 1929. A number of articles on or by him appeared in these years.

154

He married the painter Josephine Verstille Nivison, July 9, 1924. From then on they lived in the winters at 3 Washington Square North, New York, where Hopper had lived since 1913. Summers were spent mostly in New England: at Gloucester in 1923, 1924, 1926, and 1928; at Rockland, Maine, in 1926; and at Cape Elizabeth, Maine, in 1927 and 1929. In 1925 they made their first trip West, to Santa Fé; and in 1929 they visited Charleston, S. C. In 1930 they built a house in South Truro, Cape Cod, which was their summer home thereafter. They visited the White River Valley of Vermont in 1936, 1937, and 1938. In 1941 they made an automobile trip to the West Coast; and in the summers of 1943, 1946, 1953, and 1955 they traveled to Mexico. Hopper painted watercolors on almost all these trips. Six months, December 1956 to June 1957, were spent at the Huntington Hartford Foundation, Pacific Palisades, California.

From the late 1920's he was represented regularly in the chief national exhibitions. Since 1930 the most important one-man exhibitions were: Museum of Modern Art, New York, Retrospective Exhibition, November 1933, most of it shown at the Arts Club of Chicago, January 1934. Carnegie Institute, Paintings, Water Colors and Etchings, March 1937. Art Institute of Chicago, twenty-one oils included in the 54th Annual Exhibition of American Paintings and Sculpture, October 1943. Whitney Museum of American Art, Retrospective Exhibition, February–March 1950, later shown at the Museum of Fine Arts, Boston, April 1950, and the Detroit Institute of Arts, June 1950. Currier Gallery of Art (November 1959), Rhode Island School of Design (December 1959), and Wadsworth Atheneum (January 1960), Watercolors and Etchings. Philadelphia Museum of Art, Complete Graphic Work, October 1962, later shown at the Worcester Art Museum. University of Arizona Art Gallery, Retrospective Exhibition, 1963. Munson-Williams-Proctor Institute, Oils and Watercolors, May 1964. In New York Frank K. M. Rehn, Inc., held a series of one-man shows in the 1940's: early paintings, January 1941; watercolors, December 1943; and paintings, January 1948. Hopper was one of four artists chosen by the American Federation of Arts to represent the United States in the Venice Biennale of 1952, the others being Calder, Davis, and Kuniyoshi. In September–November 1964 the Whitney Museum of American Art held a large retrospective exhibition, shown later at the Art Institute of Chicago, December 1964–January 1965, Detroit Institute of Arts, February–March 1965, and City Art Museum of St. Louis, April–May 1965. He was the central figure in the United States exhibition at the Bienal de São Paulo 9, 1967.

He was elected a member of the National Institute of Arts and Letters in 1945, and of the American Academy of Arts and Letters in 1955.

Awards and honors: U.S. Shipping Board Poster Prize, 1918. Logan Prize, Chicago Society of Etchers, 1923. W. A. Bryan Prize, Fourth International Print Makers Exhibition, Los Angeles, 1923. Honorable Mention and cash award, First Baltimore Pan-American Exhibition, 1931. Temple Gold Medal, Pennsylvania Academy of the Fine Arts, 1935. First Purchase Prize in watercolor, Worcester Art Museum, 1935. First W. A. Clark Prize and Corcoran Gold Medal, Corcoran Gallery of Art, 1937. Ada S. Garrett Prize, Art Institute of Chicago, 1942. Logan Art Institute Medal and Honorarium, Art Institute of Chicago, 1945. Honorable Mention, Art Institute of Chicago, 1946. Honorary degree, Doctor of Fine Arts, Art Institute of Chicago, 1950. Honorary degree, Doctor of Letters, Rutgers University, 1953. First Prize for Watercolor, Butler Art Institute, 1954. Gold Medal for Painting presented by the National Institute of Arts and Letters in the name of the American Academy of Arts and Letters, 1955. Huntington Hartford Foundation fellowship, 1956. New York Board of Trade, Salute to the Arts award, 1957. First Prize, Fourth International Hallmark Art Award, 1957. *Art in America* Annual Award, 1960. Award, St. Botolph Club, Boston, 1963. M. V. Kohnstamm Prize for Painting, Art Institute of Chicago, 1964. Honorary degree, Doctor of Fine Arts, Philadelphia College of Art, 1965. Edward MacDowell Medal, 1966.

Edward Hopper died in his studio, 3 Washington Square North, New York, on May 15, 1967.

INDEX